MANHWA MANIA

HOW TO
DRAW
KOREAN
COMICS

MANHWA MANIA

CHRISTOPHER HART

WATSON-GUPTILL PUBLICATIONS/NEW YORK

For all the *Manga Mania* fans.

Thanks to:
Alisa Palazzo, Bob Ferro, Candace Raney,
Ellen Greene, Bob Fillie, and MADA Design, Inc.

CONTRIBUTING ARTISTS:

Jang Seok Kim: 16–19, 30 (right), 31 (right two figures), 32 (right two figures), 33 (right two figures), 38–42, 43 (right), 50, 51 (right), 52–55, 58, 59 (bottom right), 60, 61 (right), 62, 63 (right), 64, 65 (bottom right)

Cheol Joo Lee: front and back cover, 6, 116, 117 (bottom right), 118, 119, 120 (bottom left and right), 121, 122, (bottom left and right), 123–133, 134 (bottom left and right), 135, 136 (bottom right), 137, 138 (bottom left and right), 139, 140 (bottom left and right), 141–143

Sunny Lee: 44–45, 47–49, 102–111, 113–115

Jae-ho Son: 1, 8–15, 34–37, 56, 57, 66–77

Park Sung-Pal ("Kichul"): 4, 20–29, 78–101

Color: MADA Design, Inc.

Front cover color: Cheol Joo Lee and MADA Design, Inc.

Page 102 color: Bob Fillie

Senior Editor: Candace Raney
Project Editor: Alisa Palazzo
Designer: Bob Fillie, Graphiti Design, Inc.
Production Manager: Ellen Greene

Published in 2004
by Watson-Guptill Publications
a division of VNU Business Media, Inc.
770 Broadway, New York, NY 10003
www.watsonguptill.com

Copyright © 2004 Christopher Hart

Library of Congress Cataloging-in-Publication Data
Hart, Christopher.
 Manhwa mania : how to draw Korean comics /
Christopher Hart.
 p. cm.
Includes index.
 ISBN 0-8230-2976-X (pbk.)
 1. Comic books, strips, etc.—Korea
—Technique. 2. Cartooning—Technique.
3. Comic strip characters—Korea. I. Title.
 NC1764.5.K6H37 2004
 741.5'095195—dc22
 2004008289

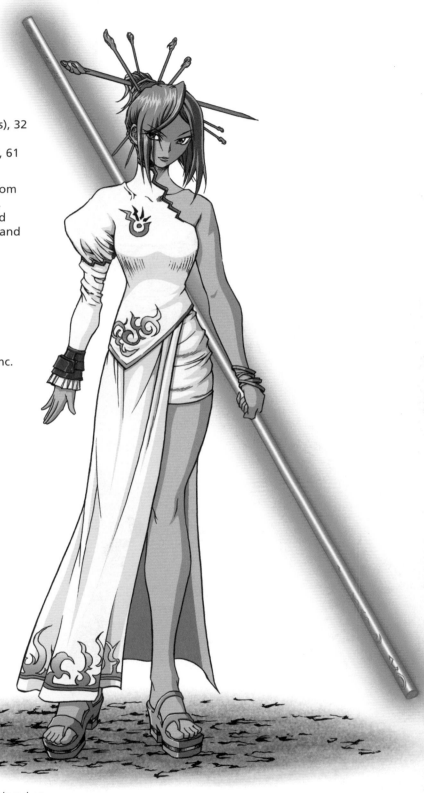

VISIT US AT
www.artstudiollc.com

CONTENTS

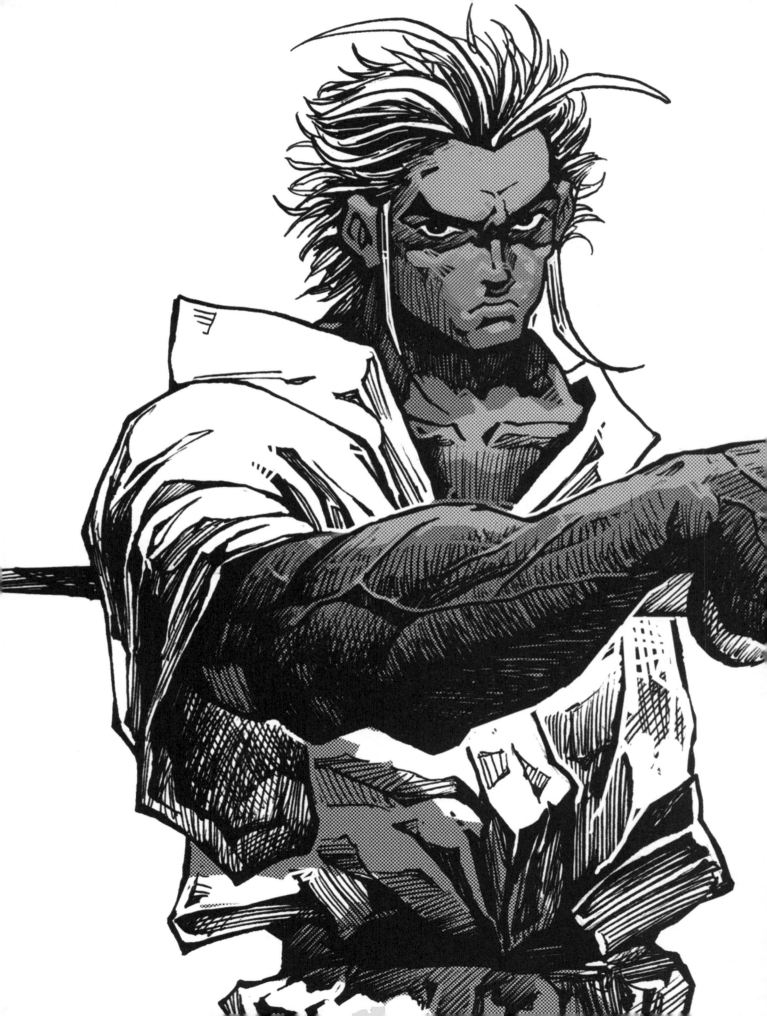

INTRODUCTION

Are you on the prowl for the newest thing in Asian-style comics? In my never-ending quest to bring you the best art instruction available, we're about to push the envelope one step further. You'll want to stick around for this. This is going to put you way ahead of the pack, adding valuable new techniques to your skill set so that you can create awesome new characters that will stun your friends.

Your new tool is manhwa! *Manhwa* is the term for Korean comics. Although manhwa has been around for some time, it's only just now being discovered outside of Korea—and is fast becoming the new wave of Asian comics. Manhwa is currently being imported into the United

States, as well as other countries, by major publishers of manga (Japanese comics). In fact, many manga fans don't realize that their favorite comics—such as *Priest, Ragnarock,* and *Island*—are actually Korean manhwa!

The manhwa invasion is in full swing, and it's time for you to jump on board. Don't be left standing on the docks when this ship sets sail. Stay on the cutting edge, where you belong as an artist. Although manhwa and manga share similarities, the stylistic

differences between them give manhwa its distinct flair. The costumes of manhwa are based on Korean culture, both traditional and contemporary. The trademarks of manga—the sharp spiked hair, huge eyes, and pointed noses and chins—are adjusted in manhwa to create a uniquely Korean style of comics. Action—and lots of it—is the key word in manhwa. And, manhwa boasts some of the coolest, scariest monsters in the world of illustrated art.

This book starts out with a comparison between the two styles, manga and manhwa, which is a must-read for all manga fans. Then, it moves on to drawing techniques and tutorials. You'll learn how to draw manhwa's leading men, beautiful women, and giant beasts, all in an easy-to-follow, step-by-step process. You'll be exposed to the most popular genres of manhwa, such as Hard-Boiled Sci-Fi Action, School Drama, Girls/Teens, Martial Arts, Fantasy, and more. In order to help you develop as an artist, I cover all the basics, such as lessons on anatomy and how to draw hands. Extreme fighting characters are explored in depth. There's also a great chapter on drawing the beautiful women of manhwa and their trendy fashions. I also include an important chapter that shows you exactly how to design comic book panels and pages so that you can create your own manhwa.

If you want to know about the latest trend in comics, you need to know manhwa. Whether you aspire to draw manhwa, manga, or American-style comics, this book aims to greatly enhance your skills as an artist.

MANGA vs. MANHWA

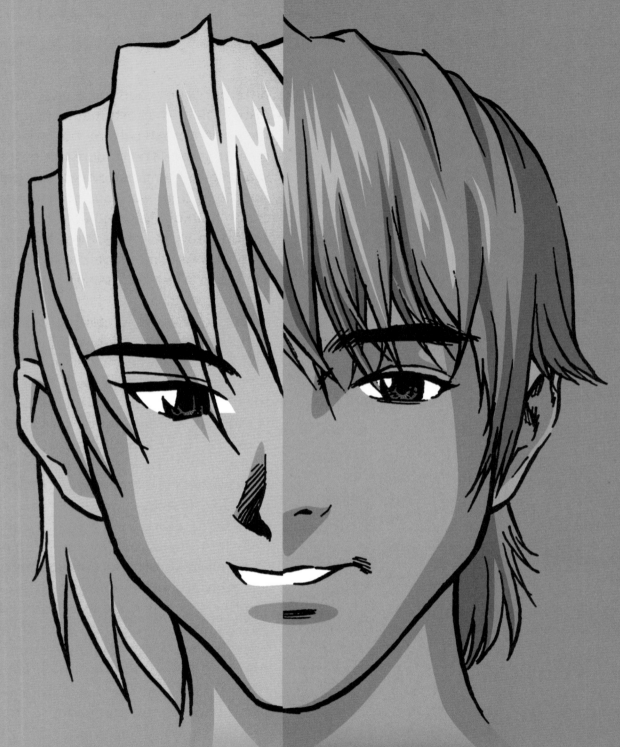

Manhwa is a distinct Korean art form but it does exhibit many similarities to its Japanese counterpart, manga. Beyond these shared aspects, however, there are distinct differences. Comparing the two styles will give you a good feel for them.

Manga vs. Manhwa: The Adolescent Head

Manga characters are noted for their outrageous, spiked hairstyles; their pointy noses and chins; and, of course, their spectacular huge eyes.

You can immediately see the difference when you look at the manhwa counterpart. The hair falls naturally over the head, surrounding the face in a relaxed manner, and is drawn with more detail. Hair highlights are understated, whereas the shine on manga hair is overstated. The manhwa nose and chin are rounded, not pointed. The nostrils and the bottom lip are more delineated. In fact, the lips are often fuller and more detailed in general. The eyes, though still large, are more realistically proportioned, and on manhwa boys, are more masculine—whereas the eyes of the manga boy are androgynous. The eyeballs are round, not big ovals. Some popular styles of manhwa also employ spectacular, large eyes; but even then, stylistic differences still remain between manga and manhwa (see pages 23–25).

And, here's an interesting twist for you observant manga fans: manhwa characters show a hint of Asian ethnicity, while manga characters have no apparent ethnicity at all.

The manga approach results in a catchy style and a bold drawing. The manhwa style is less cartoony and, therefore, more realistic. The gentle, soulful nature of the manhwa girl, for example, draws the reader in, and yet manhwa characters are some of the most rugged in all of comics, as you'll get to see in upcoming chapters. At first, the manhwa style may look challenging, but it's just like drawing manga—only with softer lines.

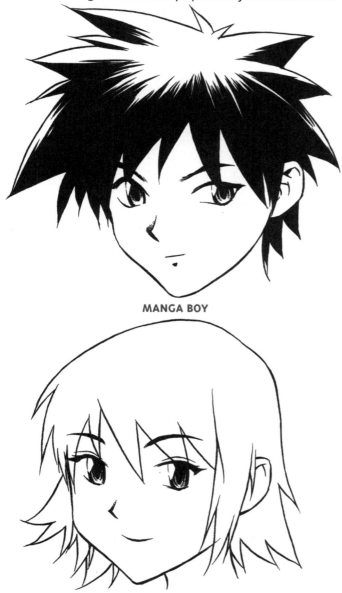

MANGA BOY

MANGA GIRL

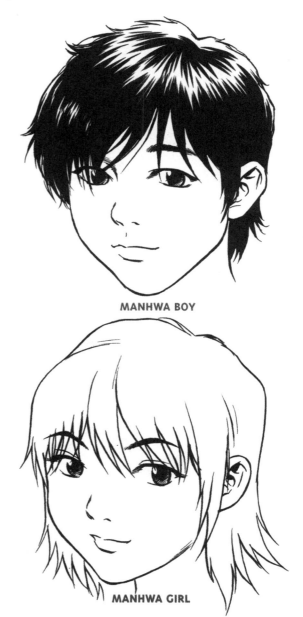

MANHWA BOY

MANHWA GIRL

Manga vs. Manhwa: Adolescent Clothes

Manga costumes are often flashy and flamboyant. Manhwa clothes are contemporary-just what you'd expect to see real tweens or teenagers wearing. Subtle shading is used to make the characters look more realistic.

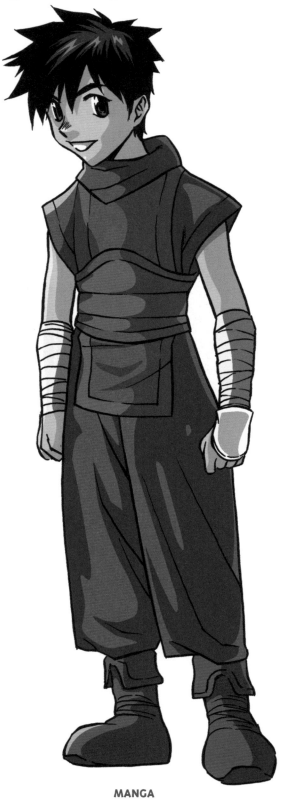

MANGA

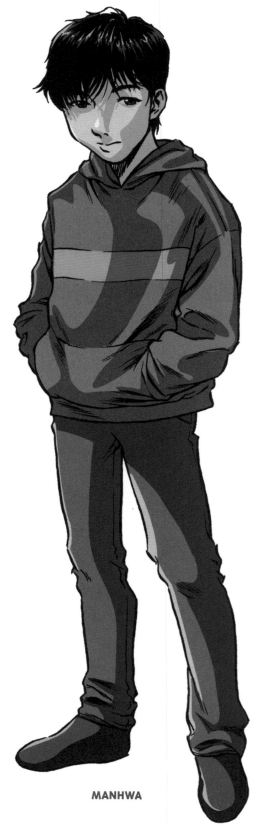

MANHWA

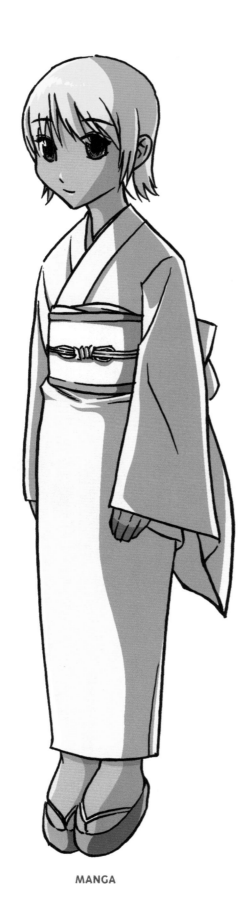

MANGA

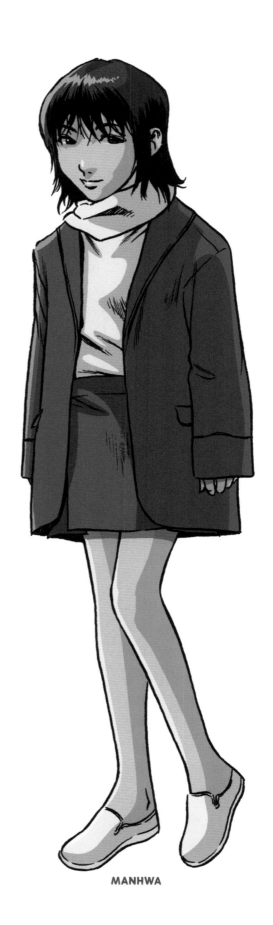

MANHWA

Manga vs. Manhwa: Adults

The adult male manhwa character—with his fuller chin, thicker neck, and thicker eyebrows—looks more mature, physically, than his manga counterpart, who has a younger appearance.

While both the manga and the manhwa adult female characters are quite pretty, the manga character de-emphasizes all of the features except for the eyes, which are highly exaggerated. Manhwa goes for a more balanced design so that no one feature is overpowering.

MANGA

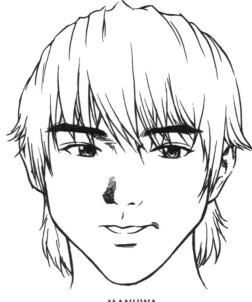

MANHWA

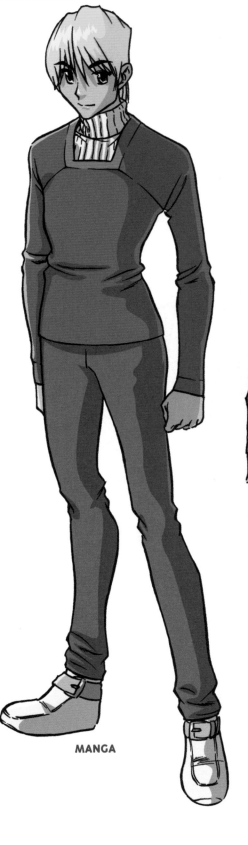

MANGA

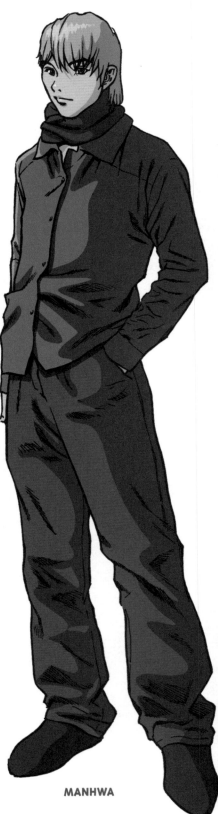

MANHWA

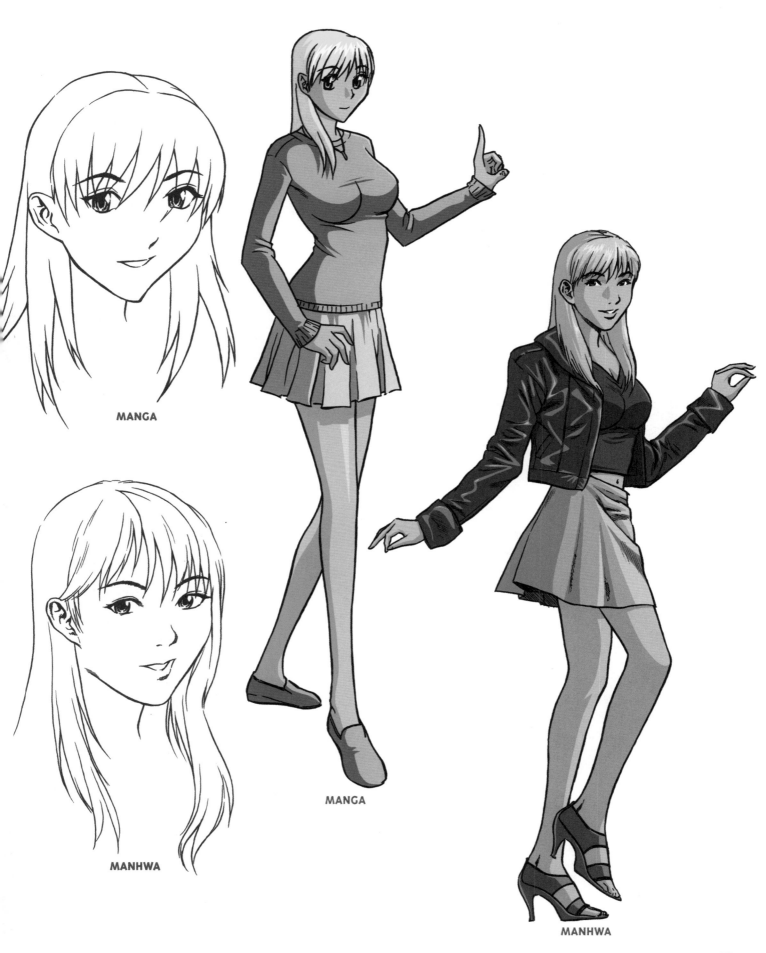

MANGA

MANHWA

MANGA

MANHWA

Manga vs. Manhwa: Overall Style

Manhwa artists differ from manga artists even in their approach to the same genres. Take the popular Fantasy Fighters genre as an example. This category is a favorite of comic book readers. Rather than go for the mechanized, armor-wearing look you typically see in manga, manhwa displays a dashing, traditional look of the upper classes. It's less of a hard-edged, sci-fi look and more of a fantasy look.

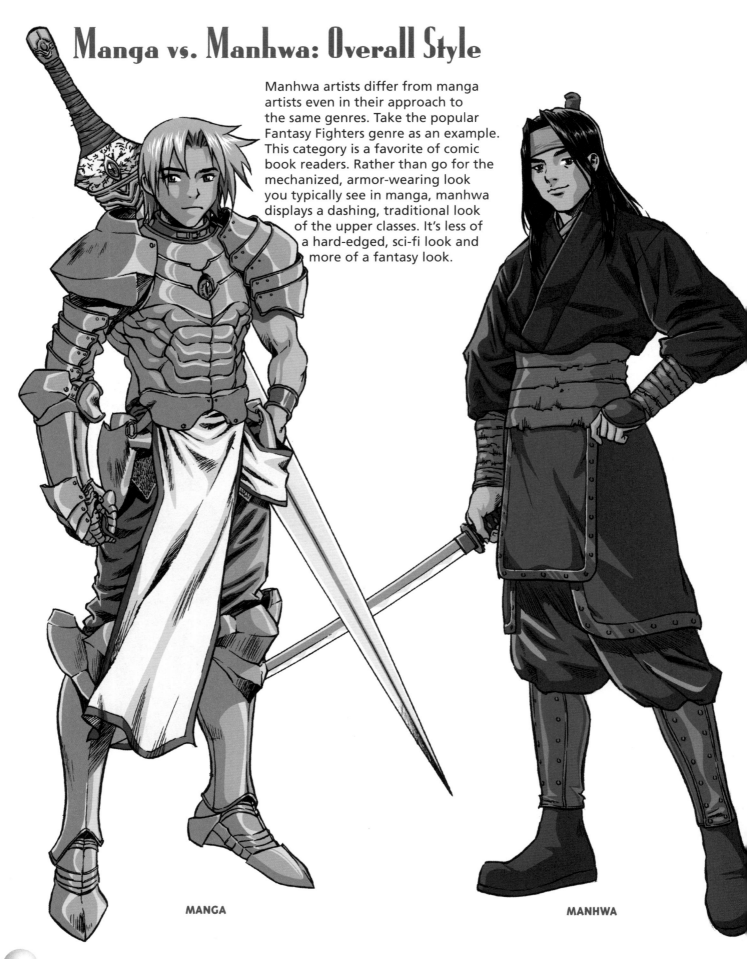

MANGA

MANHWA

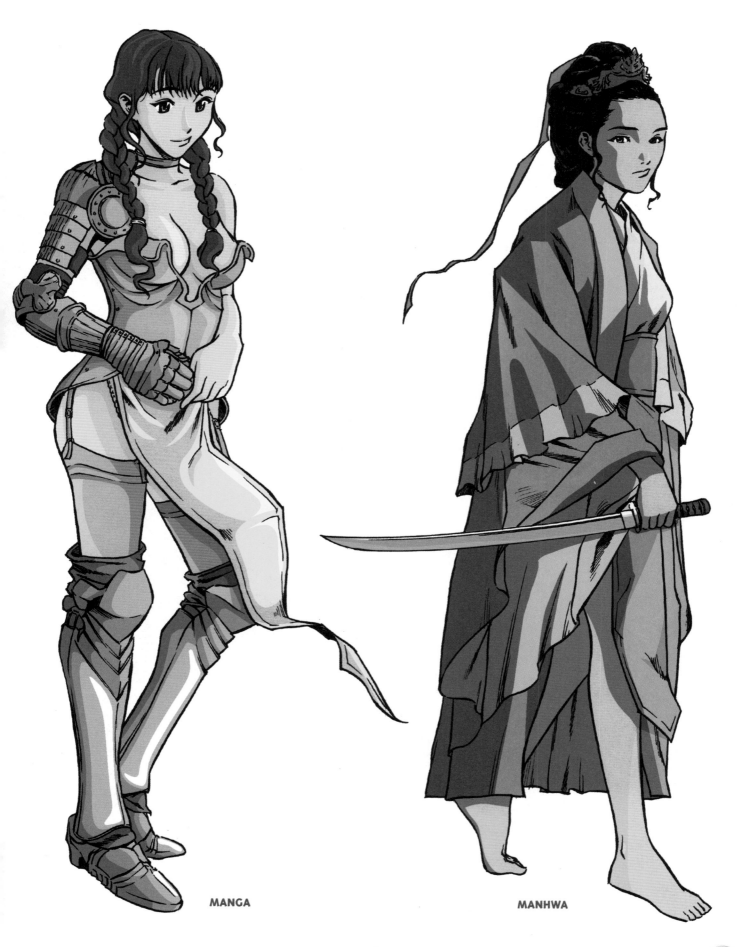

MANGA

MANHWA

DRAWING MANHWA

Get your pencils out! As you copy the drawings in the step-by-step tutorials, continually glance at each step rather than trying to draw it from memory. When professional artists draw from models, they spend more time looking at the model than they do drawing. In this case, these steps are your model! What you're learning here is the correct way to draw: start with basic shapes, then work toward the details.

The Male Manhwa Head

These drawings showcase a trendier style of manhwa characters. The expressions are intense, the eyes are searing, and the hair looks like flames. Trendy characters can get away with having an edgy, rough appearance but can still be good guys.

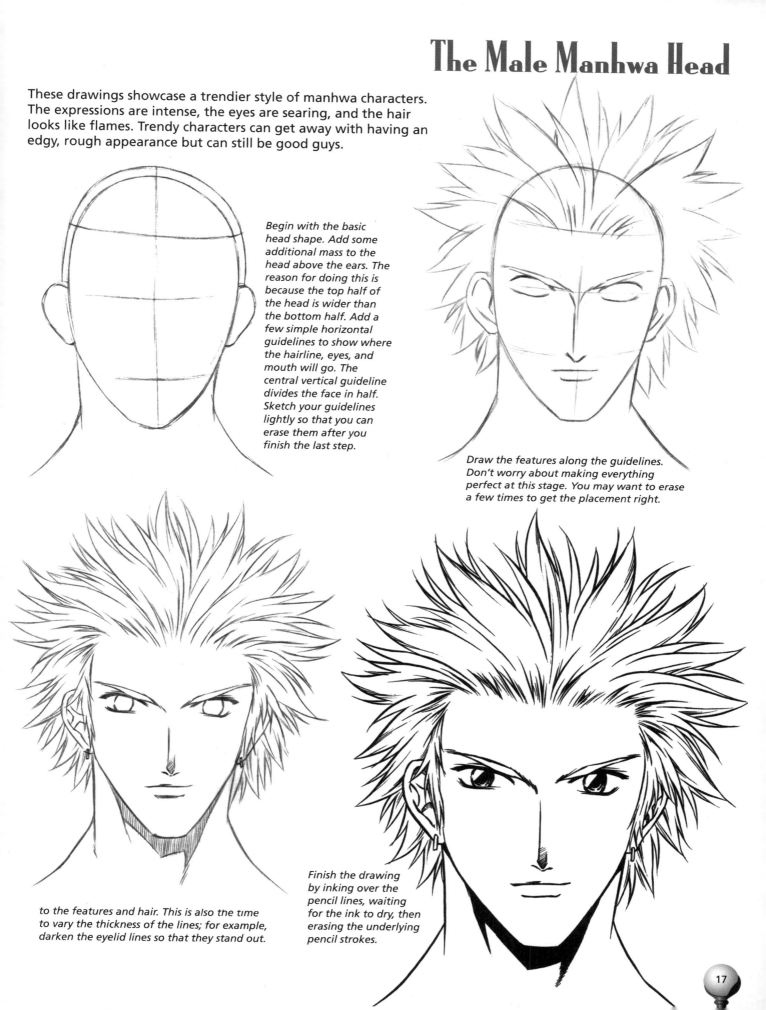

Begin with the basic head shape. Add some additional mass to the head above the ears. The reason for doing this is because the top half of the head is wider than the bottom half. Add a few simple horizontal guidelines to show where the hairline, eyes, and mouth will go. The central vertical guideline divides the face in half. Sketch your guidelines lightly so that you can erase them after you finish the last step.

Draw the features along the guidelines. Don't worry about making everything perfect at this stage. You may want to erase a few times to get the placement right.

to the features and hair. This is also the time to vary the thickness of the lines; for example, darken the eyelid lines so that they stand out.

Finish the drawing by inking over the pencil lines, waiting for the ink to dry, then erasing the underlying pencil strokes.

17

PROFILE

Some artists make the mistake of altering a character's hairstyle when they turn the figure to the side. Perhaps the new angle inspires them to draw a cool, new idea for the hair. Don't do it. You just can't do that with your characters; they must have the same hair, no matter which direction they face. In fact, all the features must remain unchanged. If your leading man has a long, slender nose in the front view, he has to have the same nose in profile. If his eyebrows press down on his eyes in the front view, they must do the same in profile. Take your cue from the front view when drawing your characters in other angles.

In the side view, the back of the head extends way past the ear, and the bridge of the nose is quite long. From the tip of the nose to the tip of the chin, the face slopes inward on a diagonal. The distance from the bottom of the nose to the upper lip is always small. The top lip is always drawn with a slight overbite. And the line that creates the mouth is very short.

3/4 VIEW

This angle is a good one for portraying a reflective mood. It isn't a flat angle, like the front view and profile, and therefore, makes the character look round, lifelike, and appealing. Be sure to make the far eye slightly smaller than the near one, since it's farther away.

Note: Even though manhwa characters often have spiked hair like manga characters, the manhwa hair appears softer, while the manga hair seems hard.

A NOTE ABOUT THE FOREHEAD

When you're drawing the head in a 3/4 view, it's important to realize that the forehead always changes direction at the eyebrow. Look at the eyebrow on the far side of the face in these drawings to see what I mean. From the hairline to the tip of that eyebrow, the line travels slightly outward; then, at the eyebrow it changes direction and travels inward. Continuing to follow that line, you can see how it curves outward again at the cheekbone, before changing direction yet again and traveling more sharply inward on a diagonal to the chin.

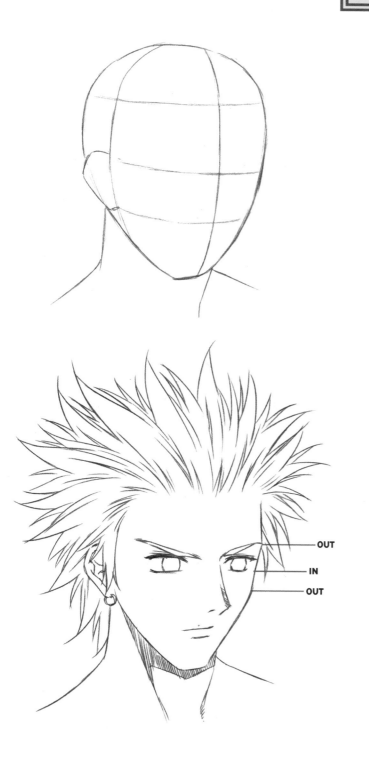

OUT
IN
OUT

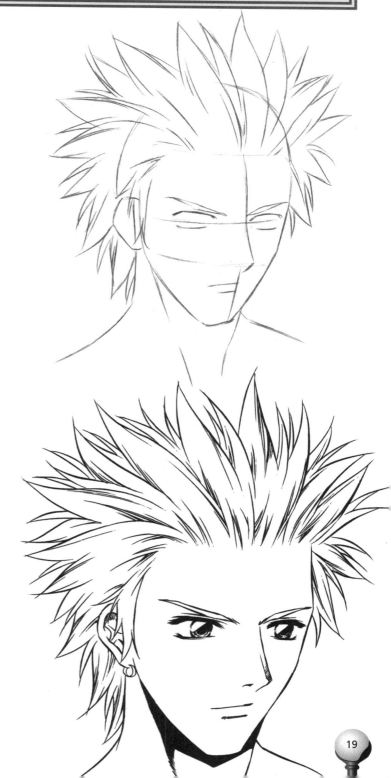

The Female Manhwa Head

The typical manhwa young woman has a stylish look. Although there are big-eyed manhwa characters, which echo the manga style, the typical manhwa eye is generally almond-shaped, producing in a sleeker look. The eyelids droop slightly over the eyeballs, resulting in a sensual stare. Eyelashes appear not only on the outer sides of the eyelids, but also on the inner sides. The hair is feathered and usually of medium length—not built up as much as manga hairdos.

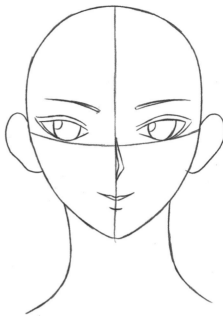

Start with the basic head shape. The chin should end in a soft point. Give the character a generous neck—a common beginner mistake is to draw the female neck too thin and frail. Add a vertical guideline that divides the face in half, and a horizontal one that indicates the bottom of the eyes.

Place the eyes and the nose on the horizontal guideline so that the bottom of each eye and the bridge of the nose fall along the line. Space the eyes well apart, and indicate the eyebrows. Even though the mouth is small, be sure to show the indentation in the middle of the upper lip. Check to make sure that both ears are at the same level, with the tops of the ears falling at about the same spot as the horizontal guideline.

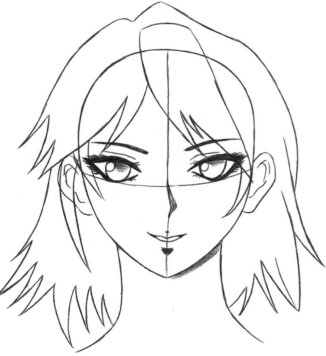

Darken the eyelids and eyebrows, and start to add details to the features. Add a good amount of eyelashes, and outline the hair.

Instead of using a pen to finish the drawing, you can simply draw over it with a darker pencil line and erase the underlying guidelines. Or, use tracing paper and a light box to trace over the original.

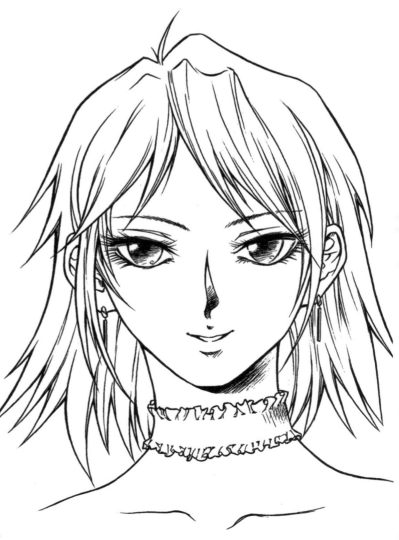

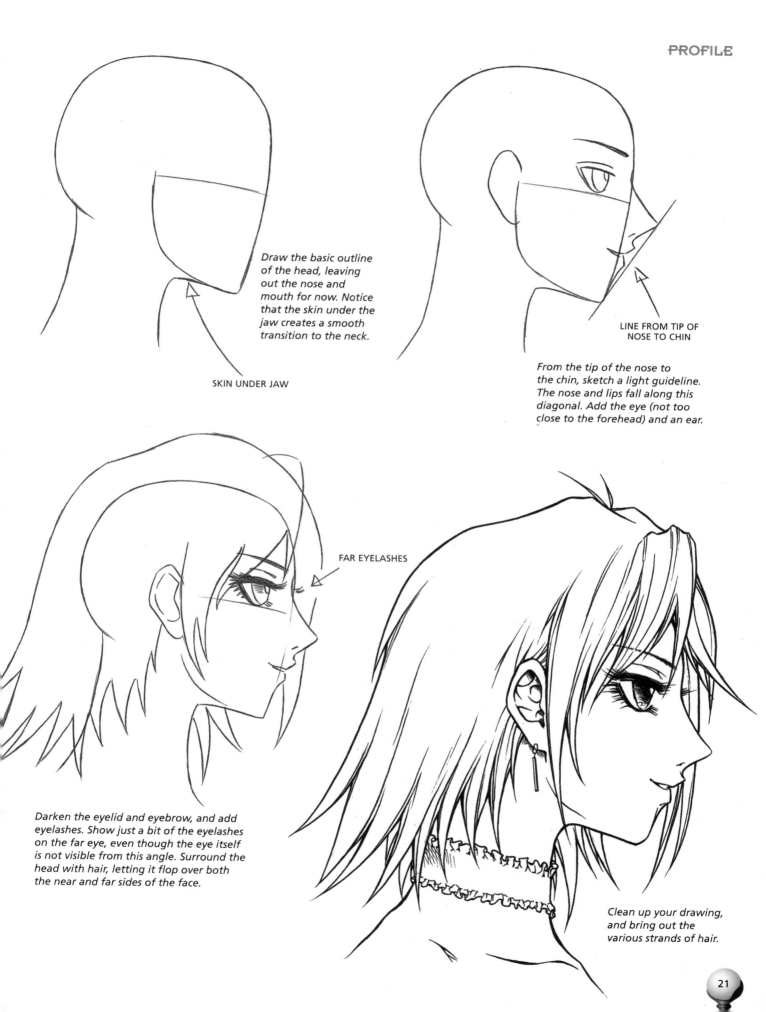

Draw the basic outline of the head, leaving out the nose and mouth for now. Notice that the skin under the jaw creates a smooth transition to the neck.

SKIN UNDER JAW

LINE FROM TIP OF NOSE TO CHIN

From the tip of the nose to the chin, sketch a light guideline. The nose and lips fall along this diagonal. Add the eye (not too close to the forehead) and an ear.

FAR EYELASHES

Darken the eyelid and eyebrow, and add eyelashes. Show just a bit of the eyelashes on the far eye, even though the eye itself is not visible from this angle. Surround the head with hair, letting it flop over both the near and far sides of the face.

Clean up your drawing, and bring out the various strands of hair.

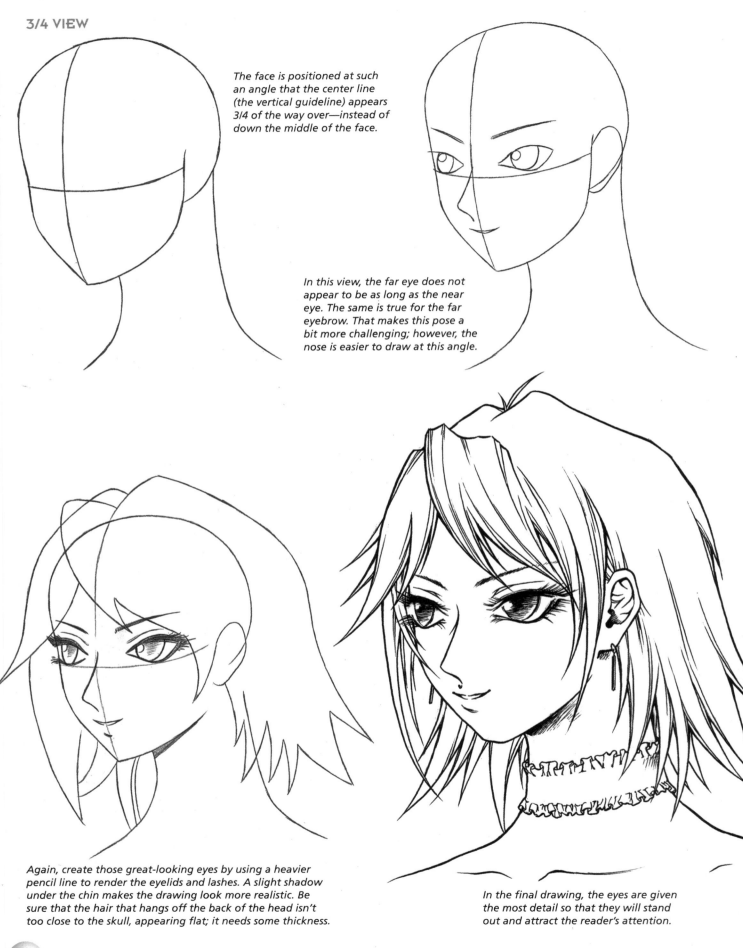

The face is positioned at such an angle that the center line (the vertical guideline) appears 3/4 of the way over—instead of down the middle of the face.

In this view, the far eye does not appear to be as long as the near eye. The same is true for the far eyebrow. That makes this pose a bit more challenging; however, the nose is easier to draw at this angle.

Again, create those great-looking eyes by using a heavier pencil line to render the eyelids and lashes. A slight shadow under the chin makes the drawing look more realistic. Be sure that the hair that hangs off the back of the head isn't too close to the skull, appearing flat; it needs some thickness.

In the final drawing, the eyes are given the most detail so that they will stand out and attract the reader's attention.

Usually considered a manga trait, big eyes also sometimes appear in manhwa. Here's an example. The big eyes add glamour. Take a close look at the eye shines. They are triangular in shape, and the diagonal edges of the shines are sharp. There are also smaller

secondary shines in addition to the largest one. The eyebrows angle down toward the nose, giving her a purposeful expression. Note her hairstyle: it's wild and carefree. as if windblown.

Start with the basic head shape and placement guidelines. Add a little extra mass to the left side of the drawing, since she's turned ever so slightly to right side of the page. Professional artists frequently "cheat" the front view a little, like this—so that the face doesn't look quite so "dead on"—in order to avoid a flat look. Give it a try.

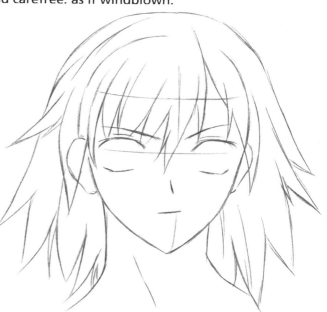

Draw the hairline, eyes, and mouth along the horizontal guidelines. Placing both eyes on the eye line ensures that they are even.

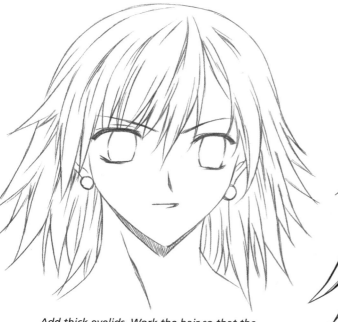

Add thick eyelids. Work the hair so that the groups of strands come together at the ends.

Instead of using a pen to finish the drawing, you can simply draw over it with a darker pencil line and erase the guidelines. Or, use tracing paper to trace over the original.

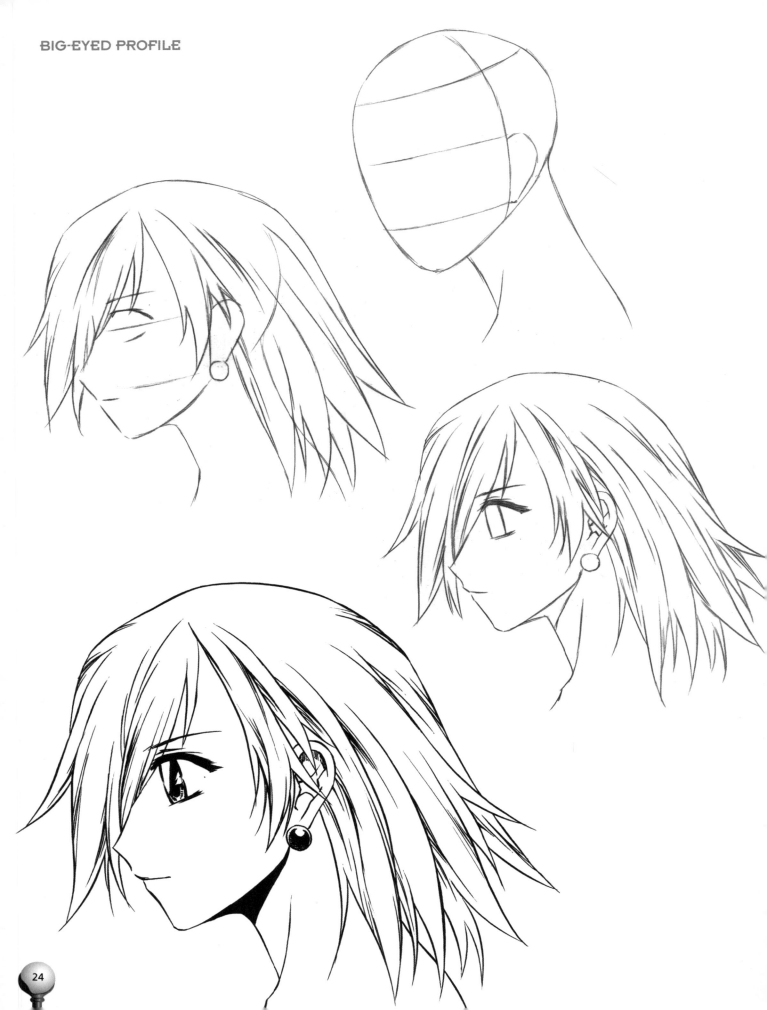

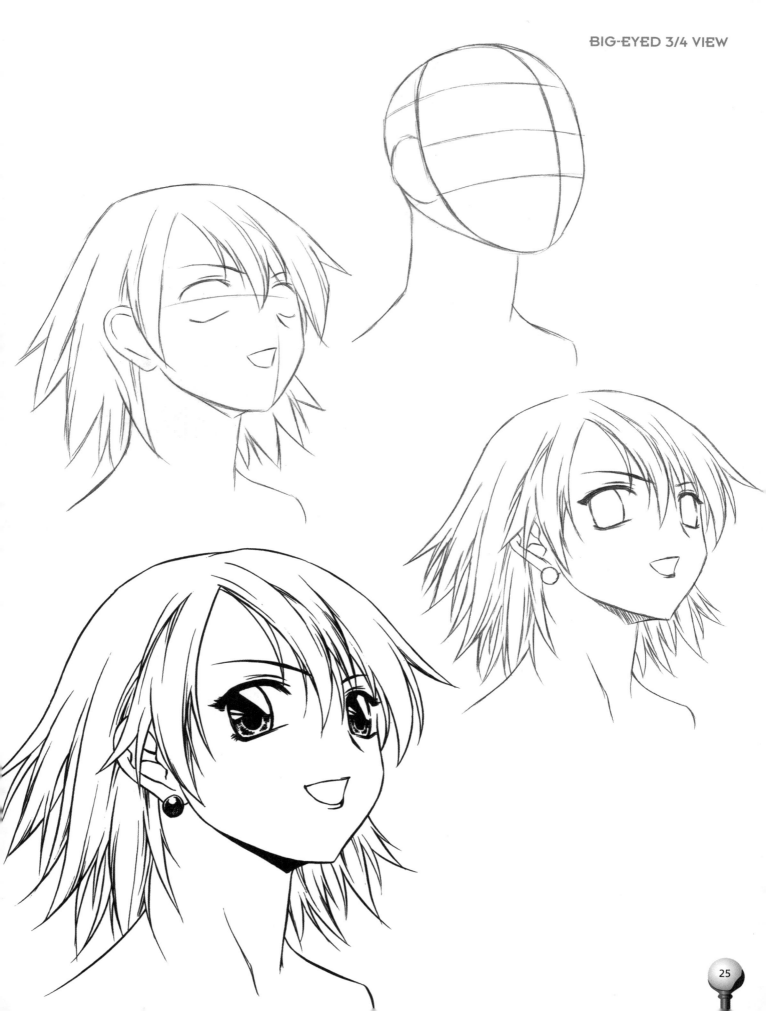

Basic Anatomy

Before jumping into drawing the full figure, it's good to get an overview of the basic muscle groups. The male figure offers a better illustration of this because the muscles on female characters must remain subtle and muted. Women have a higher percentage of body fat, which masks muscular definition. This doesn't mean manhwa women are overweight. Far from it! They're gorgeous. And part of the reason for this is that their bodies are long and lithe—not bulky, like men.

It's important to be familiar with anatomy even if your character wears a costume. (If the underlying figure isn't constructed correctly, your poses won't look good and clothing won't lie right; clothing also won't camouflage incorrect underlying structure.) Costumes often reveal parts of the body. Some reveal the torso, while others showcase the arms. On others, the legs are shown. And, many costumes are tight enough for the muscles to show through.

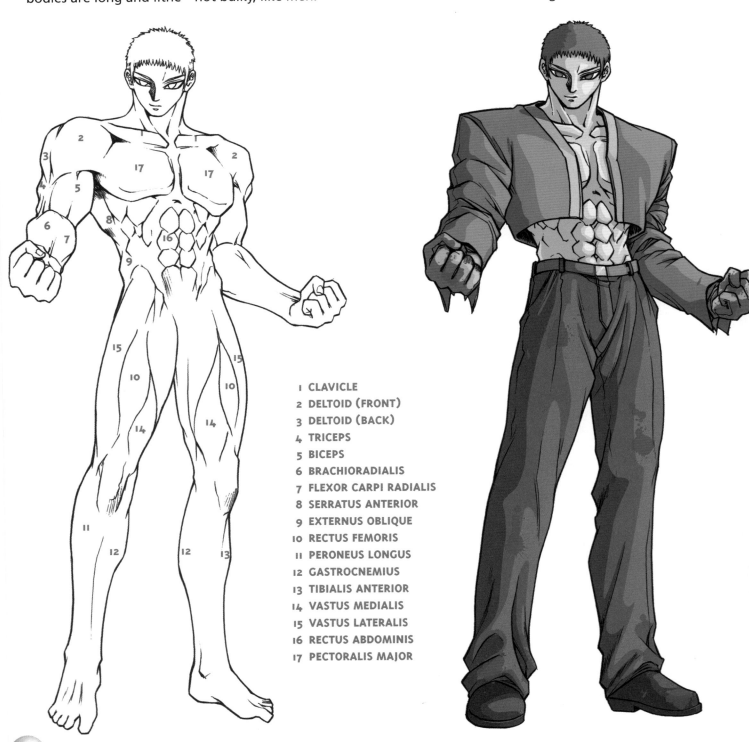

1 CLAVICLE
2 DELTOID (FRONT)
3 DELTOID (BACK)
4 TRICEPS
5 BICEPS
6 BRACHIORADIALIS
7 FLEXOR CARPI RADIALIS
8 SERRATUS ANTERIOR
9 EXTERNUS OBLIQUE
10 RECTUS FEMORIS
11 PERONEUS LONGUS
12 GASTROCNEMIUS
13 TIBIALIS ANTERIOR
14 VASTUS MEDIALIS
15 VASTUS LATERALIS
16 RECTUS ABDOMINIS
17 PECTORALIS MAJOR

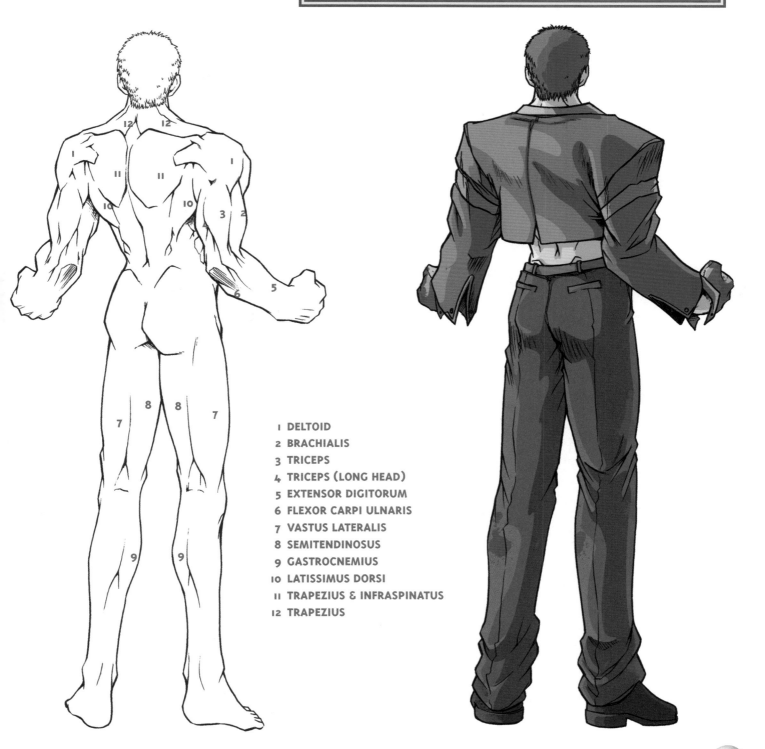

1 **DELTOID**

2 **BRACHIALIS**

3 **TRICEPS**

4 **TRICEPS (LONG HEAD)**

5 **EXTENSOR DIGITORUM**

6 **FLEXOR CARPI ULNARIS**

7 **VASTUS LATERALIS**

8 **SEMITENDINOSUS**

9 **GASTROCNEMIUS**

10 **LATISSIMUS DORSI**

11 **TRAPEZIUS & INFRASPINATUS**

12 **TRAPEZIUS**

Female Curves

For female characters, concentrate less on the individual muscle groups and more on the overall outline of the figure, which should be curvy and graceful. Be sure not to draw the limbs as straight lines; they must always be shapely but understated. Look to accentuate the spots where the body curves in and out.

Sometimes in skintight outfits, the lower back shows two indentations, which are part of the pelvic bone.

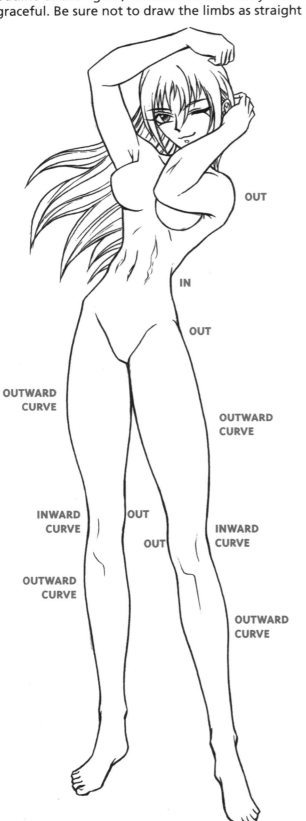

OUT

IN

OUT

OUTWARD
CURVE

OUTWARD
CURVE

INWARD
CURVE

OUT

OUT

INWARD
CURVE

OUTWARD
CURVE

OUTWARD
CURVE

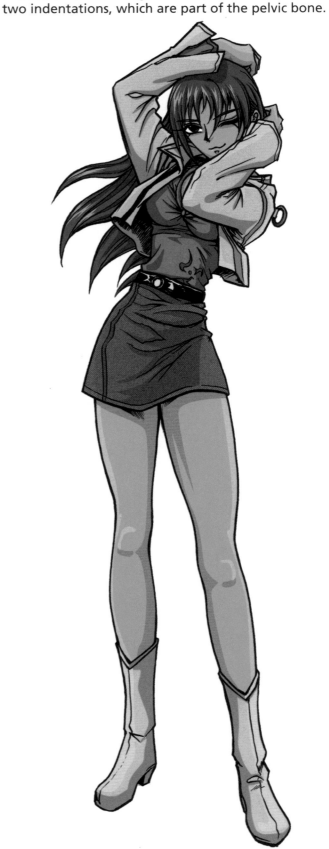

The line of the spine also may appear because it adds definition to the back without making it look too bony. Notice that the torso is slighter than the legs, which are well muscled. Skinny legs are not attractive.

In fact, contrary to what you see in fashion magazines, skinny women are not attractive. Those magazines trade on female insecurities about body image. Real women look vibrant and healthy.

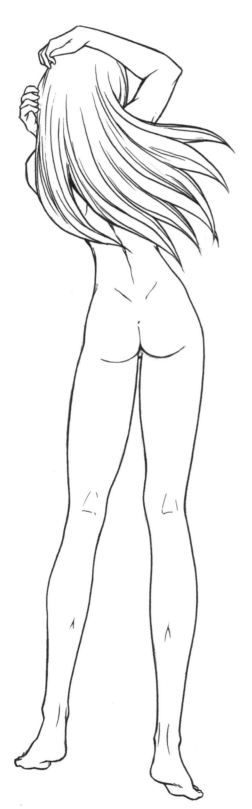

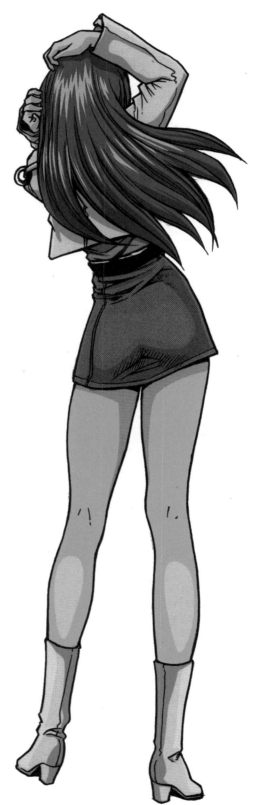

The Clothed Male Manhwa Body

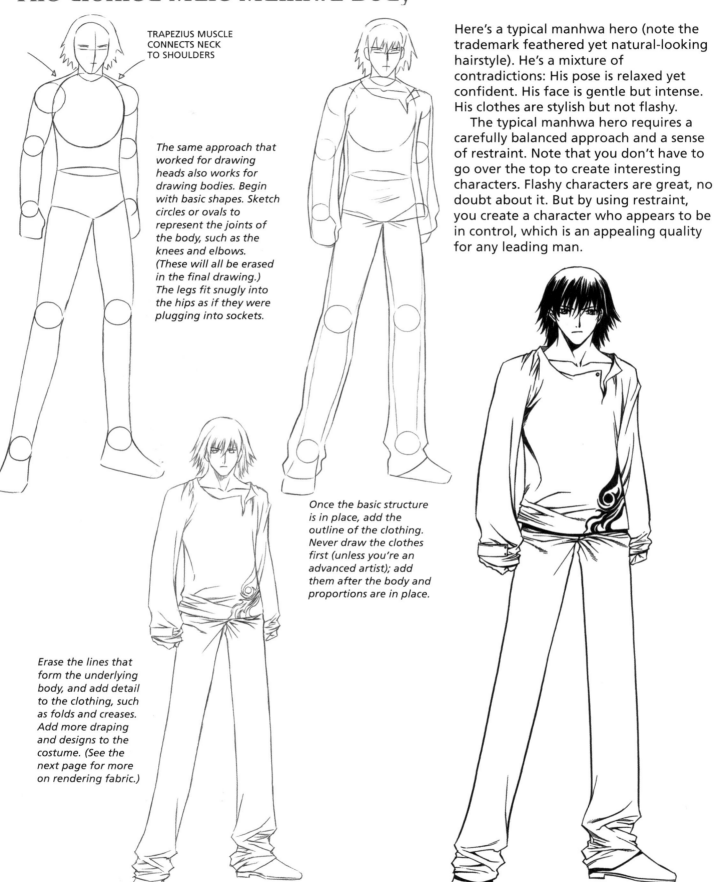

TRAPEZIUS MUSCLE CONNECTS NECK TO SHOULDERS

The same approach that worked for drawing heads also works for drawing bodies. Begin with basic shapes. Sketch circles or ovals to represent the joints of the body, such as the knees and elbows. (These will all be erased in the final drawing.) The legs fit snugly into the hips as if they were plugging into sockets.

Here's a typical manhwa hero (note the trademark feathered yet natural-looking hairstyle). He's a mixture of contradictions: His pose is relaxed yet confident. His face is gentle but intense. His clothes are stylish but not flashy.

The typical manhwa hero requires a carefully balanced approach and a sense of restraint. Note that you don't have to go over the top to create interesting characters. Flashy characters are great, no doubt about it. But by using restraint, you create a character who appears to be in control, which is an appealing quality for any leading man.

Once the basic structure is in place, add the outline of the clothing. Never draw the clothes first (unless you're an advanced artist); add them after the body and proportions are in place.

Erase the lines that form the underlying body, and add detail to the clothing, such as folds and creases. Add more draping and designs to the costume. (See the next page for more on rendering fabric.)

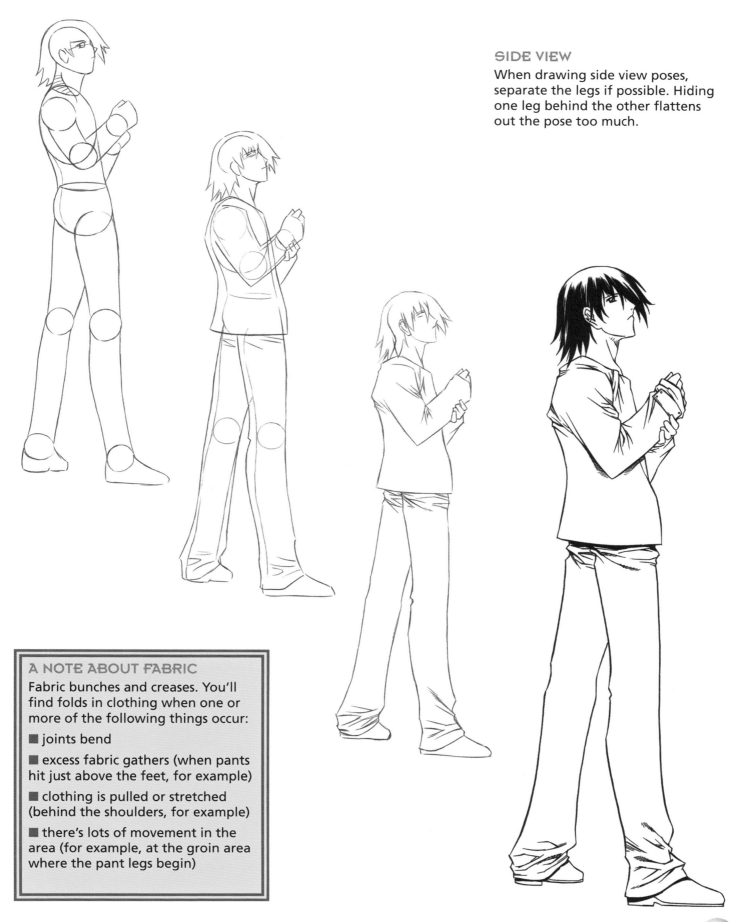

When drawing side view poses, separate the legs if possible. Hiding one leg behind the other flattens out the pose too much.

A NOTE ABOUT FABRIC
Fabric bunches and creases. You'll find folds in clothing when one or more of the following things occur:

■ joints bend

■ excess fabric gathers (when pants hit just above the feet, for example)

■ clothing is pulled or stretched (behind the shoulders, for example)

■ there's lots of movement in the area (for example, at the groin area where the pant legs begin)

The Clothed Female Manhwa Body

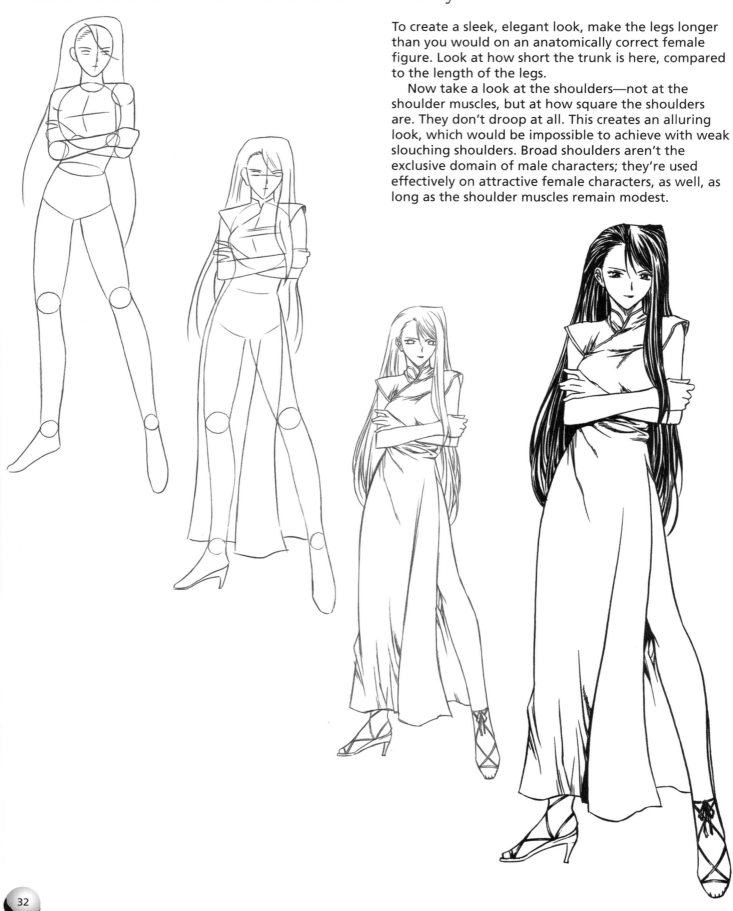

To create a sleek, elegant look, make the legs longer than you would on an anatomically correct female figure. Look at how short the trunk is here, compared to the length of the legs.

Now take a look at the shoulders—not at the shoulder muscles, but at how square the shoulders are. They don't droop at all. This creates an alluring look, which would be impossible to achieve with weak slouching shoulders. Broad shoulders aren't the exclusive domain of male characters; they're used effectively on attractive female characters, as well, as long as the shoulder muscles remain modest.

SIDE VIEW

You know the saying real estate brokers always spout: "Location, location, location!" For drawing attractive women, it's: "Attitude, attitude, attitude." The body language has to communicate something to the reader. Just look at this pose. The face is half covered with hair, but the sex appeal still comes through. Artists make specific choices when creating such poses: The head is purposely tilted down—always a seductive look. The arms are pulled back, accentuating the chest. One leg is supports the weight while the other is bends playfully, which is a provocative stance.

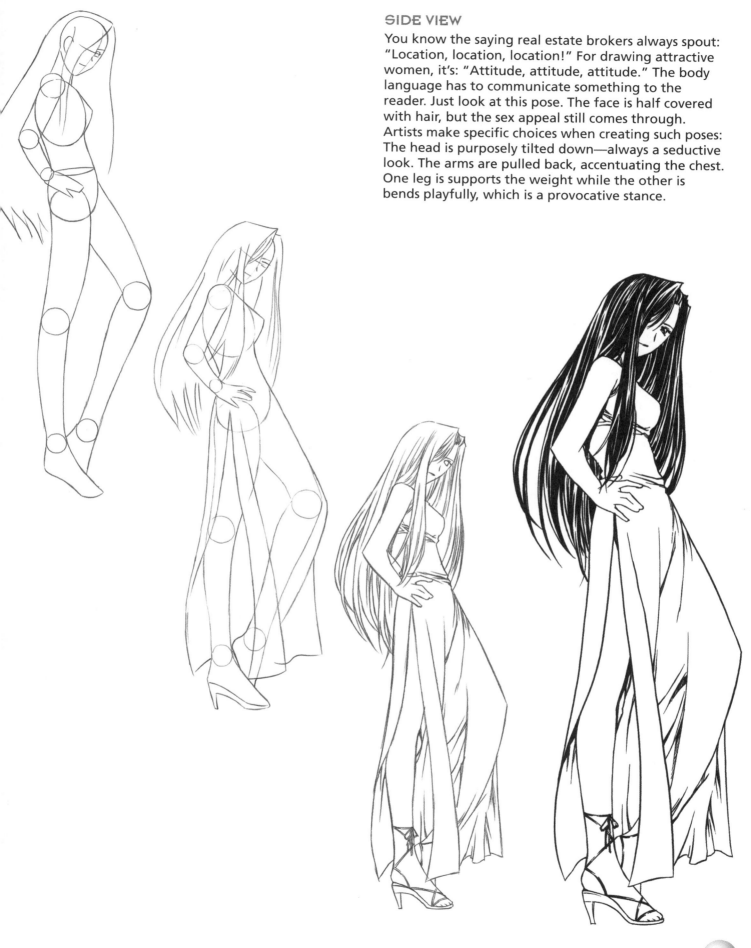

Hands

Don't shy away from drawing hands, even if they are, at first, somewhat challenging. It's really like learning to ride a bicycle: the first few starts are bumpy, but once you get it you'll never forget it, and it becomes second nature. And, you don't have to wear a helmet to draw them, unless you're kind of a dork. All you need is practice, so be patient with yourself. Try making some rough sketches of these examples. This four-page section should give you a good amount of reference material. When you feel a little shaky about the hands you're drawing, flip back to these pages and make the needed adjustments.

It helps you if you practice drawing most of the basic hand poses, such as palm-side-up, palm-side-down, and the two side views (inner and outer). You should also definitely practice drawing a fist, a few women's hands, and a couple of hand positions with varied finger placement. But there's no need to tackle every hand pose right away. Again, use this section as a reference resource as needed.

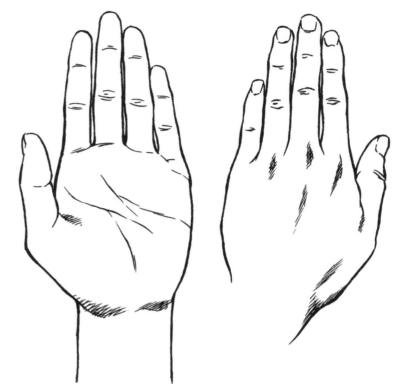

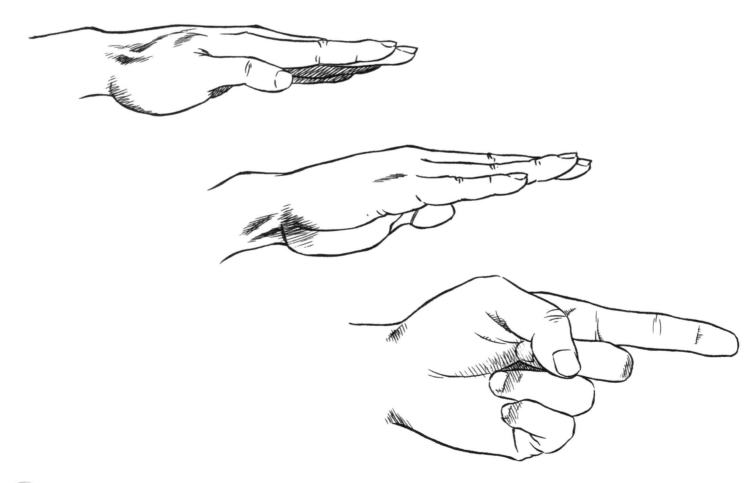

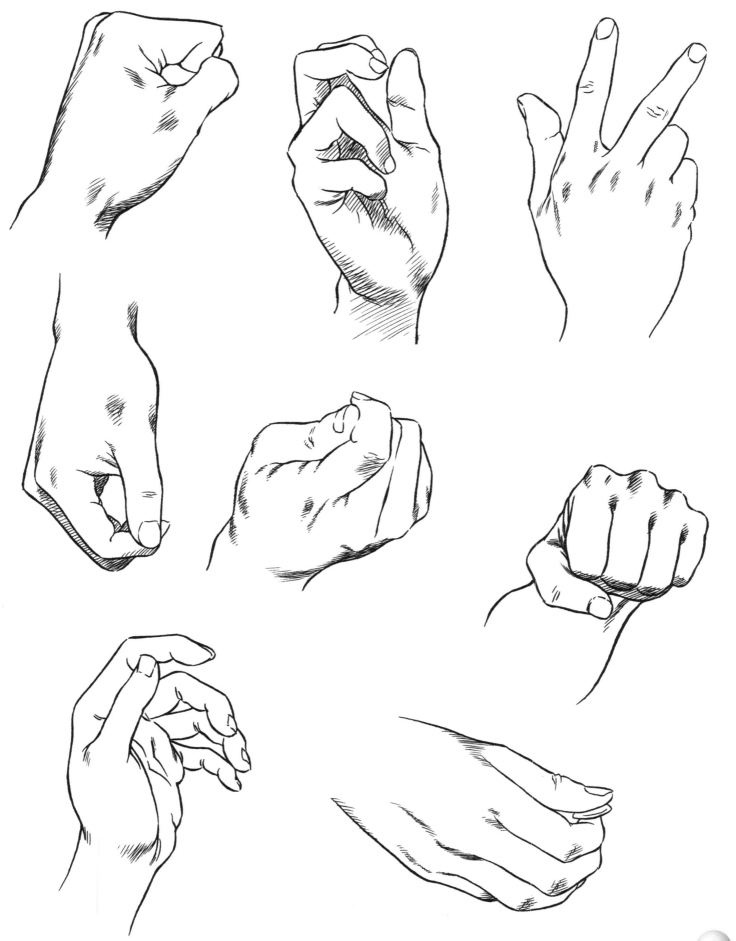

Women's Hands

The female palm is not as wide as the male palm. The fingers are thin and tapered. The base of the thumb is thinner, too, as is the wrist. To make the hand feminine, decrease the size of the knuckles and keep the bony definition to a minimum. Many beginners make the fingernails pointy and sharp; you should make them rounded instead. Female hands should always look relaxed. Unless it's a fight scene, the fingers should not be pressed tightly together, grasping hard, or making a fist.

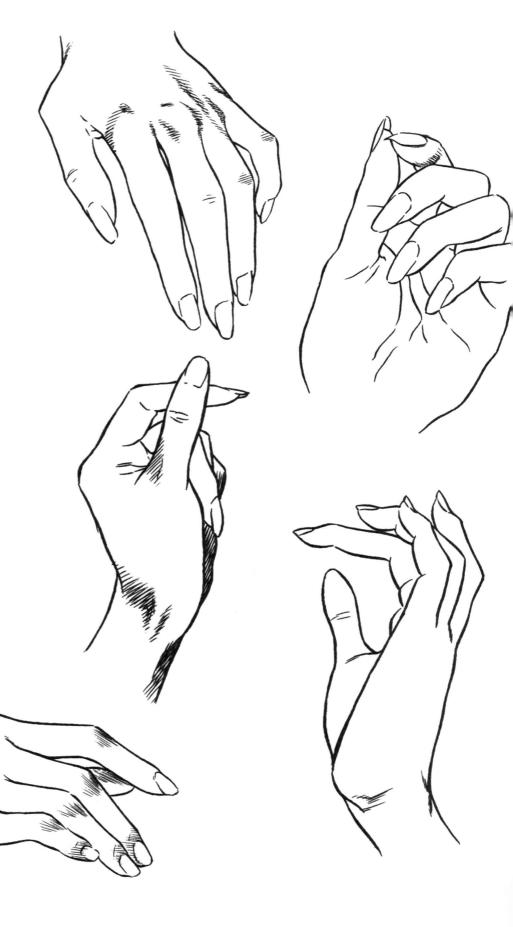

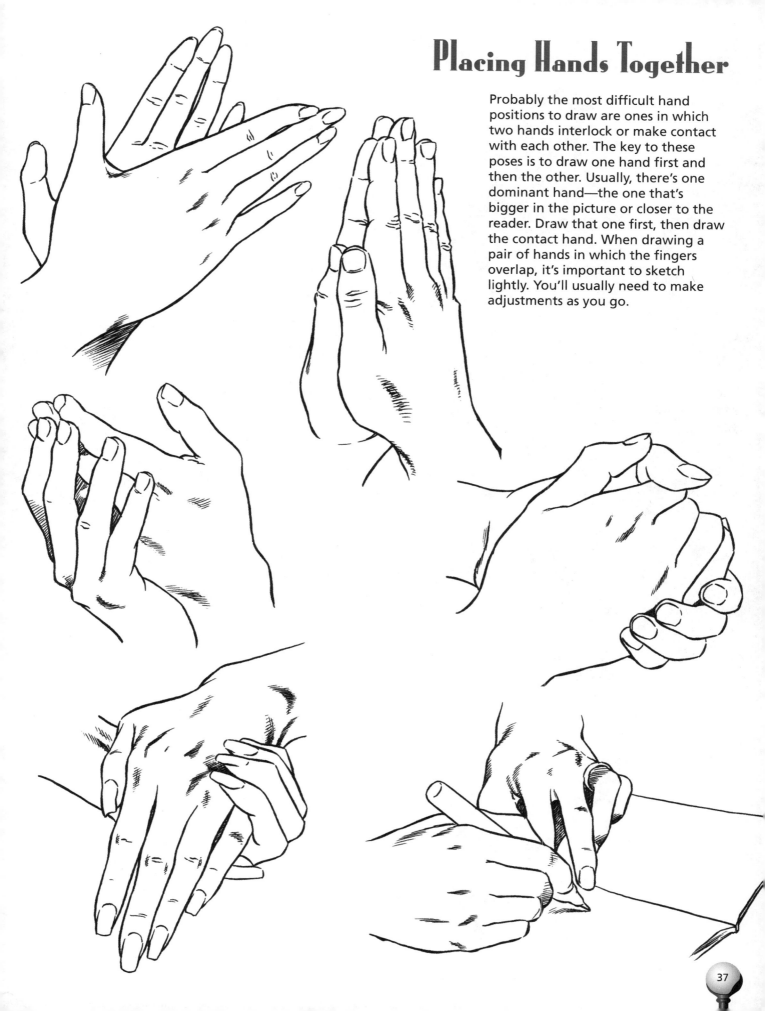

Placing Hands Together

Probably the most difficult hand positions to draw are ones in which two hands interlock or make contact with each other. The key to these poses is to draw one hand first and then the other. Usually, there's one dominant hand—the one that's bigger in the picture or closer to the reader. Draw that one first, then draw the contact hand. When drawing a pair of hands in which the fingers overlap, it's important to sketch lightly. You'll usually need to make adjustments as you go.

POPULAR MANHWA GENRES

Manhwa boasts a great range of popular genres. This wide spectrum is what makes manhwa such a cool art form. You might prefer to work exclusively in one favorite style. You might like to draw many, or all, of them. Or, you might combine genres to create something new and cutting edge.

If you want exciting action, look no further than the martial arts genre. Tae kwon do (Korean karate) is the national sport of Korea, where it's taught in schools just like baseball is taught in America. Therefore, martial arts is as much a staple of manhwa as it is of manga. There are several approaches to drawing martial arts costumes. Torn uniforms are great because they show that the characters have recently been fighting, which makes them more formidable.

In addition, the jagged edges of the torn uniforms add flash and excitement to the illustration.

Manhwa artists also borrow elements from kung fu, the Chinese martial art, and from the samurai (Japanese warriors). The *Hakama* pants (which look like long dresses) are used on master sword fighters who carry long blades. Fist fighters wear karate-style uniforms with wraps around the forearms, waist, and legs. Kung fu–style slippers serve as footwear.

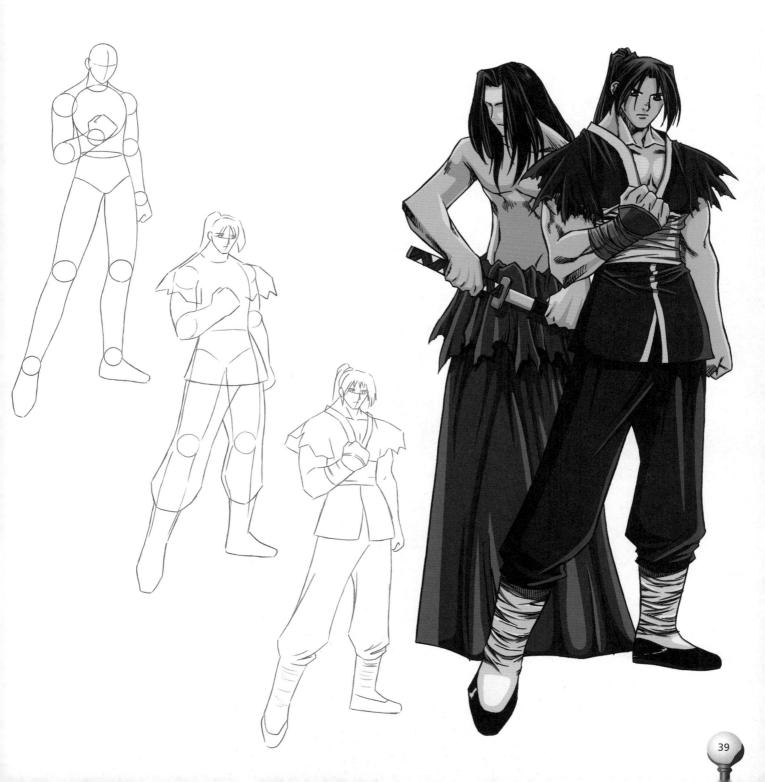

Hard-Boiled Sci-Fi Action

This style can be compared to modern film noir. It features a bleak, hard, urban world filled with amoral characters, violence, and betrayal. Dazzling costumes are replaced by a world of shadows. Men wear dark suits and sunglasses. They pack guns and know how to use them. They're nihilists, surviving without reason, fighting without hope. To them, violence is a way of life, part of the job. They know no other way. Sometimes these guys are part of a secret government project that involves a secret agency within a secret agency. Other times, they're part of a clandestine network of underworld crime. But even if they work for the government, you would never call them good guys—they're too cynical.

Looking alert is necessary if your credo is kill or be killed. These guys never relax. They always button their suits. They wear ties, like any employee, even if their job is wiping out their enemies. The sunglasses ensure that their expressions reveal nothing.

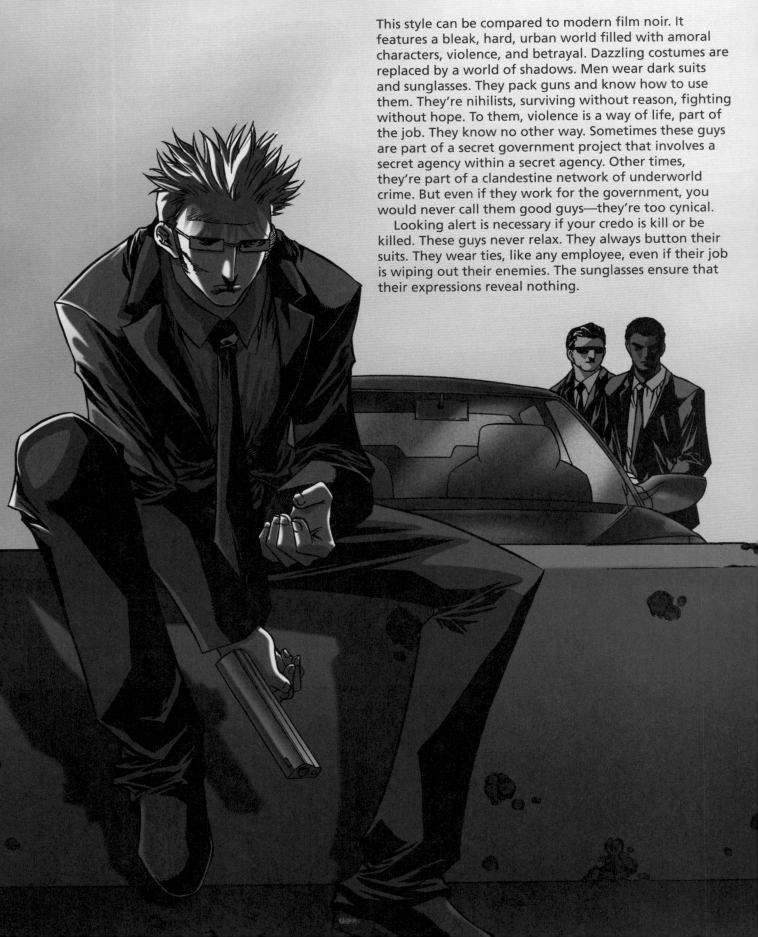

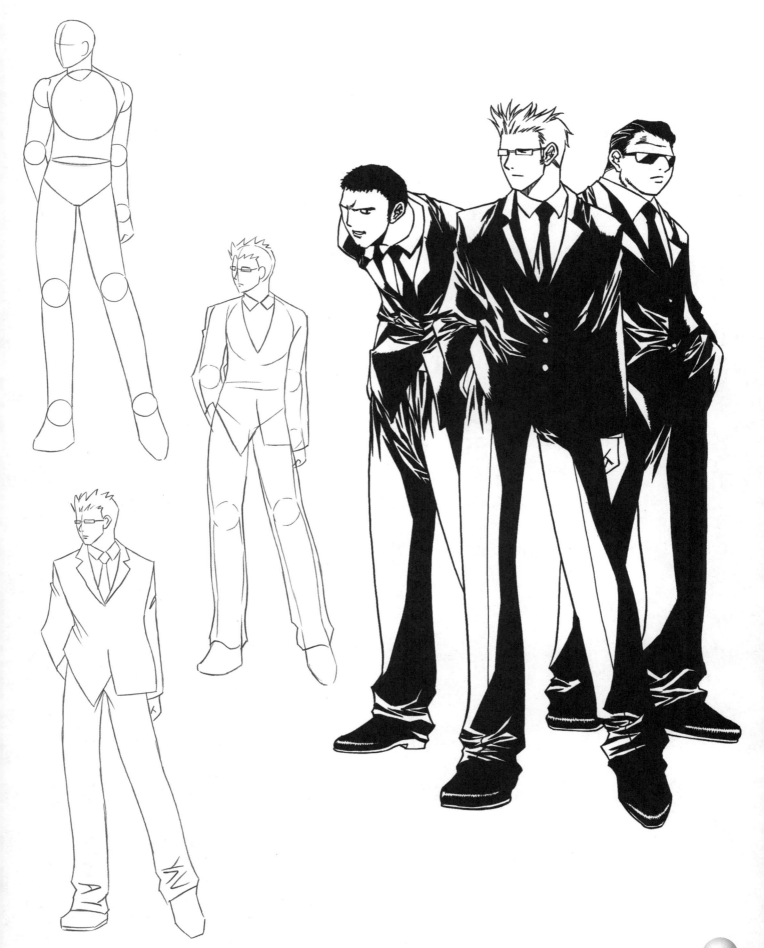

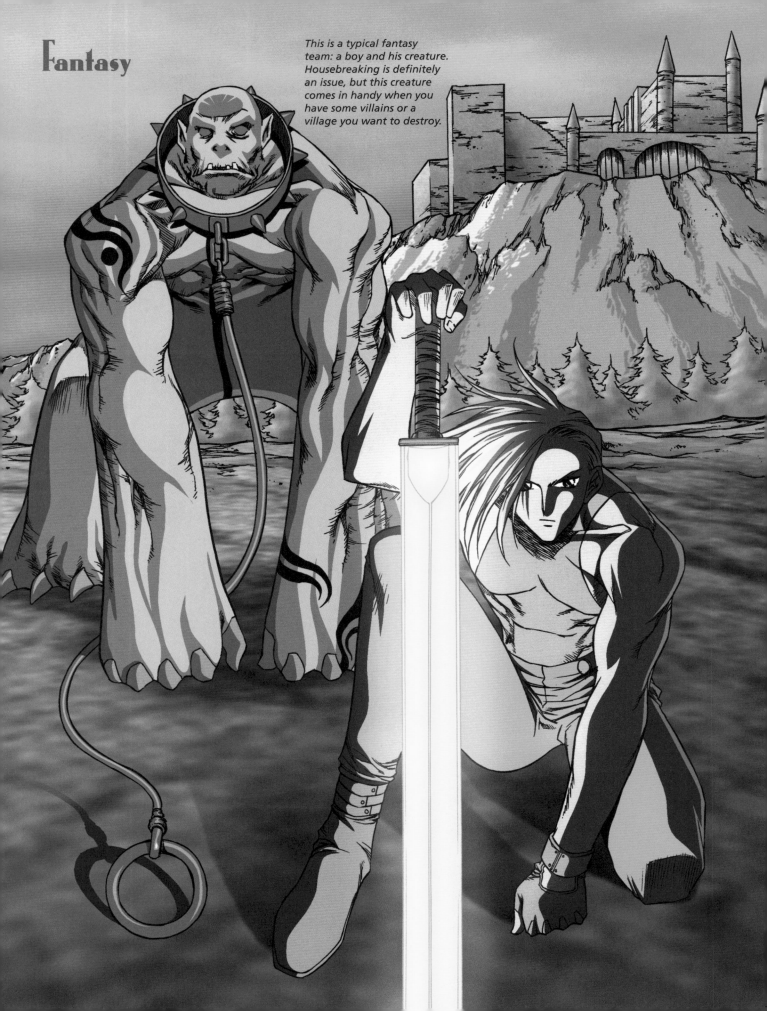

Fantasy

This is a typical fantasy team: a boy and his creature. Housebreaking is definitely an issue, but this creature comes in handy when you have some villains or a village you want to destroy.

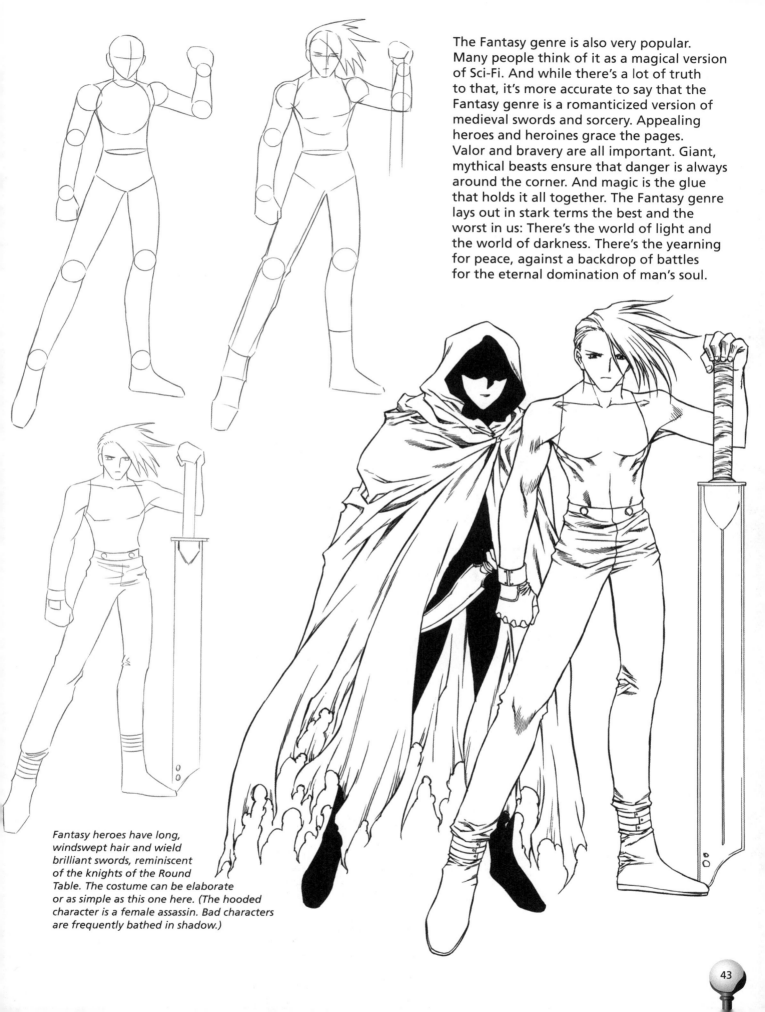

The Fantasy genre is also very popular. Many people think of it as a magical version of Sci-Fi. And while there's a lot of truth to that, it's more accurate to say that the Fantasy genre is a romanticized version of medieval swords and sorcery. Appealing heroes and heroines grace the pages. Valor and bravery are all important. Giant, mythical beasts ensure that danger is always around the corner. And magic is the glue that holds it all together. The Fantasy genre lays out in stark terms the best and the worst in us: There's the world of light and the world of darkness. There's the yearning for peace, against a backdrop of battles for the eternal domination of man's soul.

Fantasy heroes have long, windswept hair and wield brilliant swords, reminiscent of the knights of the Round Table. The costume can be elaborate or as simple as this one here. (The hooded character is a female assassin. Bad characters are frequently bathed in shadow.)

DEMIGODS, GODDESSES, AND THE SUPERNATURAL

The demigod is another popular character in the Fantasy genre. He's an androgynous type. Everything about him should look godly, from his billowing robe to his graceful long hair and magical staff. His body has extremely long proportions. The eyes have an empty quality, which adds to the all-knowing, all-powerful appearance. To achieve this, don't shade the iris in completely; if you do, the figure will look more like a real person than a ghostly presence. The demigod character is posed, almost exclusively, floating above the ground, surveying the humans below. His attitude is one of peaceful, unemotional detachment.

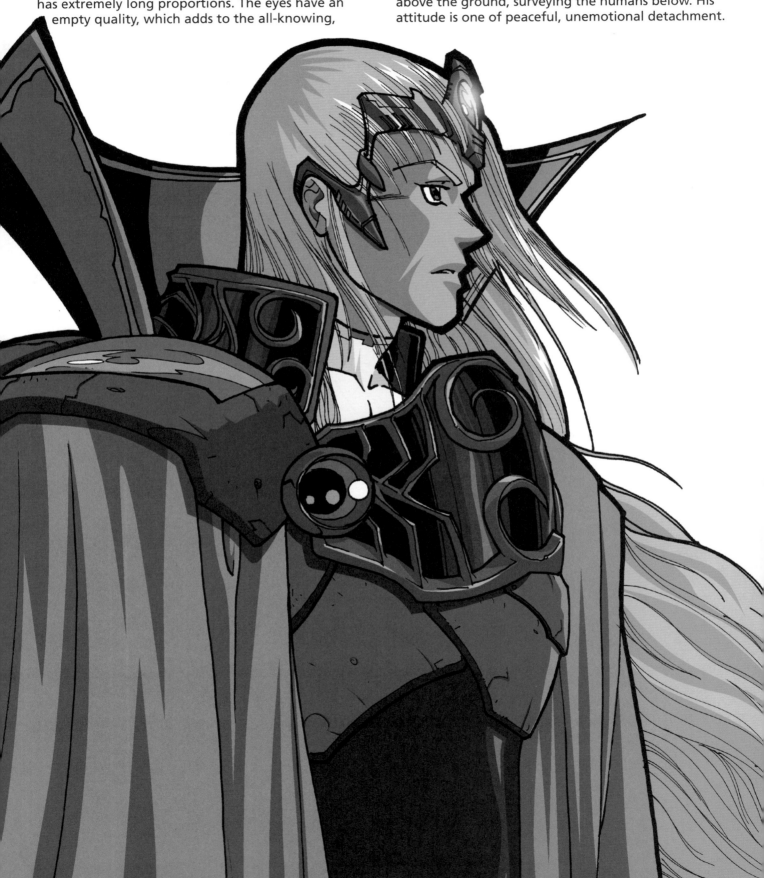

Goddess characters are always pretty, ethereal beings. They must be drawn with a light touch, in order to appear airy and with the ability to float above the ground. Ornamentation is very important. It adds a sense of magic and mystery. The accessories should have a slightly primitive, tribal look. The hair must be long and flowing.

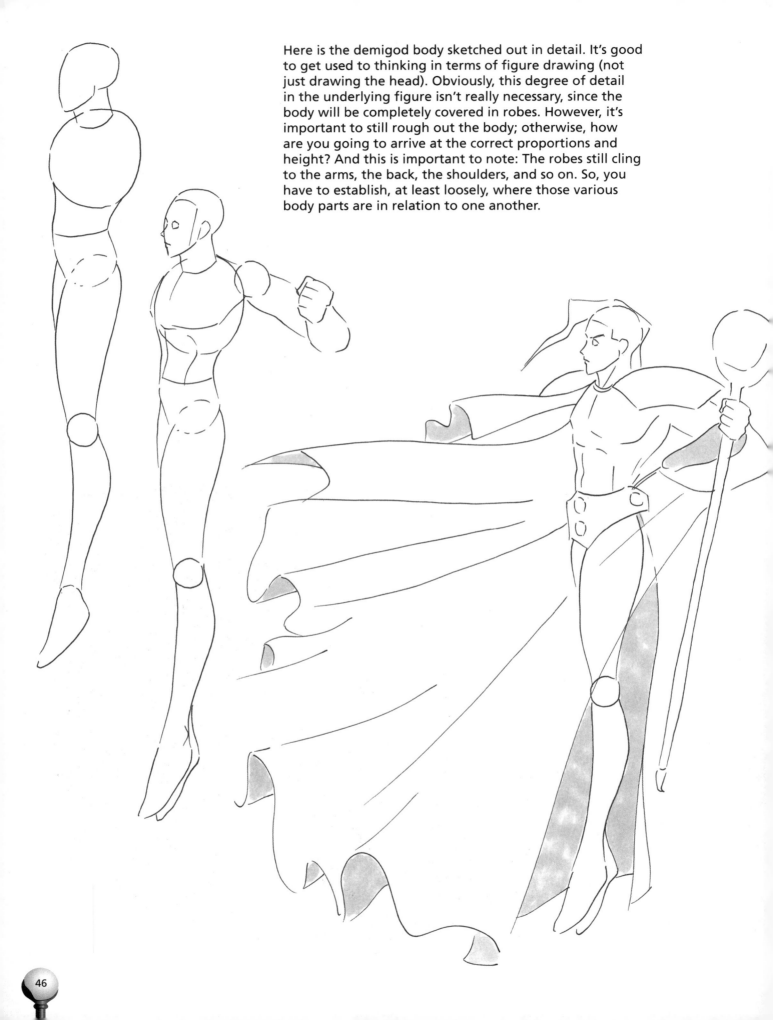

Here is the demigod body sketched out in detail. It's good to get used to thinking in terms of figure drawing (not just drawing the head). Obviously, this degree of detail in the underlying figure isn't really necessary, since the body will be completely covered in robes. However, it's important to still rough out the body; otherwise, how are you going to arrive at the correct proportions and height? And this is important to note: The robes still cling to the arms, the back, the shoulders, and so on. So, you have to establish, at least loosely, where those various body parts are in relation to one another.

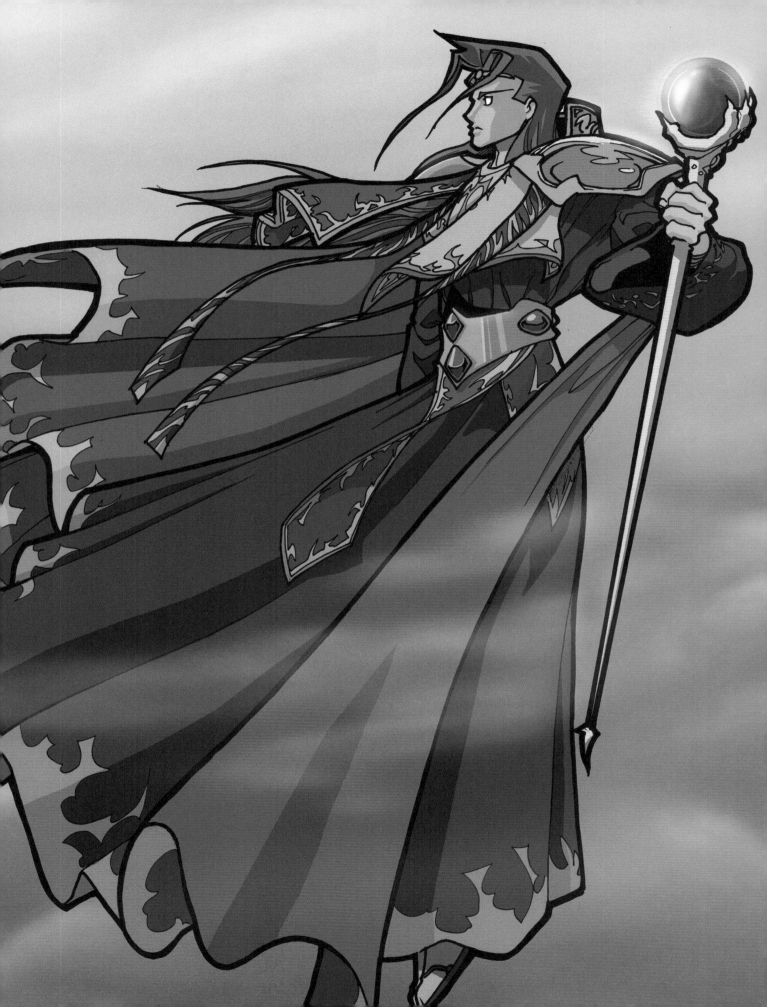

SUPERNATURAL PROPORTIONS

All goddesses—no matter how different they may appear from one another, no matter how different the costumes—share the same proportions. Their bodies are far longer than those of normal female characters. They also have slighter builds. Whereas most manhwa characters are eight head lengths tall, goddesses are at least nine and sometimes even twelve heads tall. (Real people are six to seven heads tall; the increased height in comics—and in fashion illustration—is an idealized characterization.)

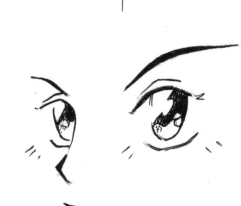

GODDESS HEAD
Long and narrow.

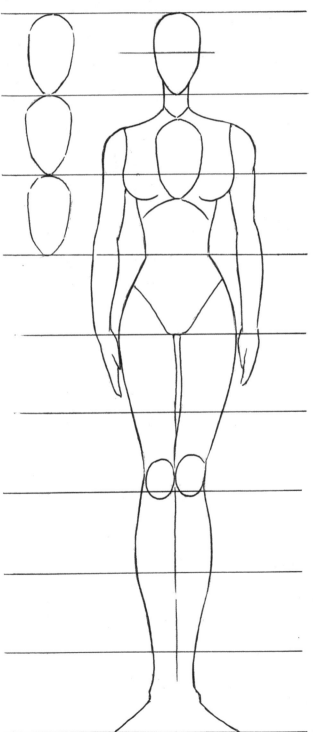

MANGA EYES
Large, round, and more vertical than horizontal.

MANHWA GODDESS EYES
Almond-shaped and narrow, with heavy mascara. Lashes and eyebrows are long and thin.

GODDESS HAIR
Always long and flowing—never curly!—with thin strands.

NORMAL HAIR
Bigger on top, and looks more contemporary.

Everything about the goddess character is sweeping and gracious: her hair, her cape, and her sleeves. In contrast, her pose should be restrained and simple. She should appear almost aloof, above worldly matters. Her costume needs to be dramatic, but not busy. Go for layered gowns and drapery.

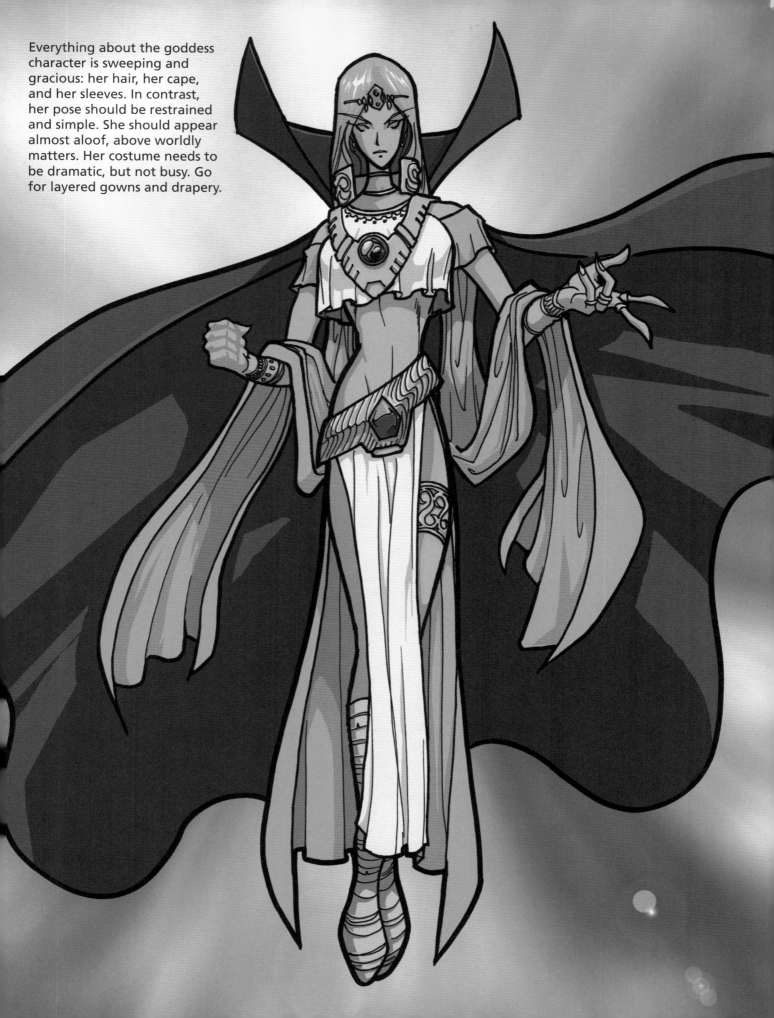

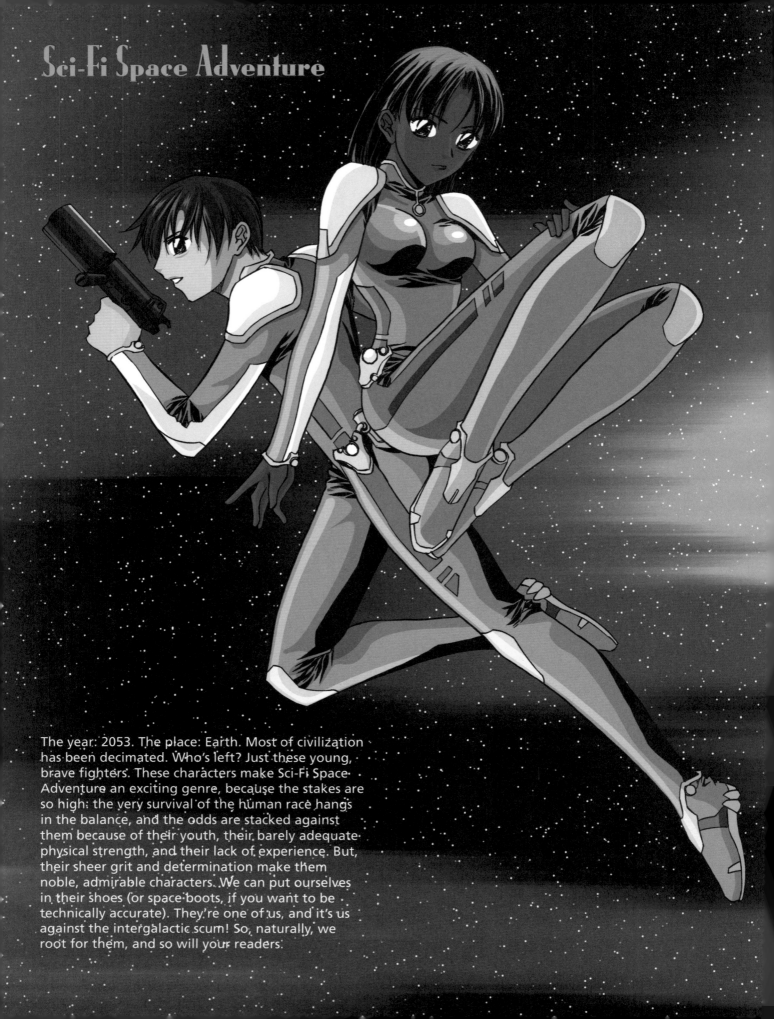

Sci-Fi Space Adventure

The year: 2053. The place: Earth. Most of civilization
has been decimated. Who's left? Just these young,
brave fighters. These characters make Sci-Fi Space
Adventure an exciting genre, because the stakes are
so high: the very survival of the human race hangs
in the balance, and the odds are stacked against
them because of their youth, their barely adequate
physical strength, and their lack of experience. But,
their sheer grit and determination make them
noble, admirable characters. We can put ourselves
in their shoes (or space boots, if you want to be
technically accurate). They're one of us, and it's us
against the intergalactic scum! So, naturally, we
root for them, and so will your readers.

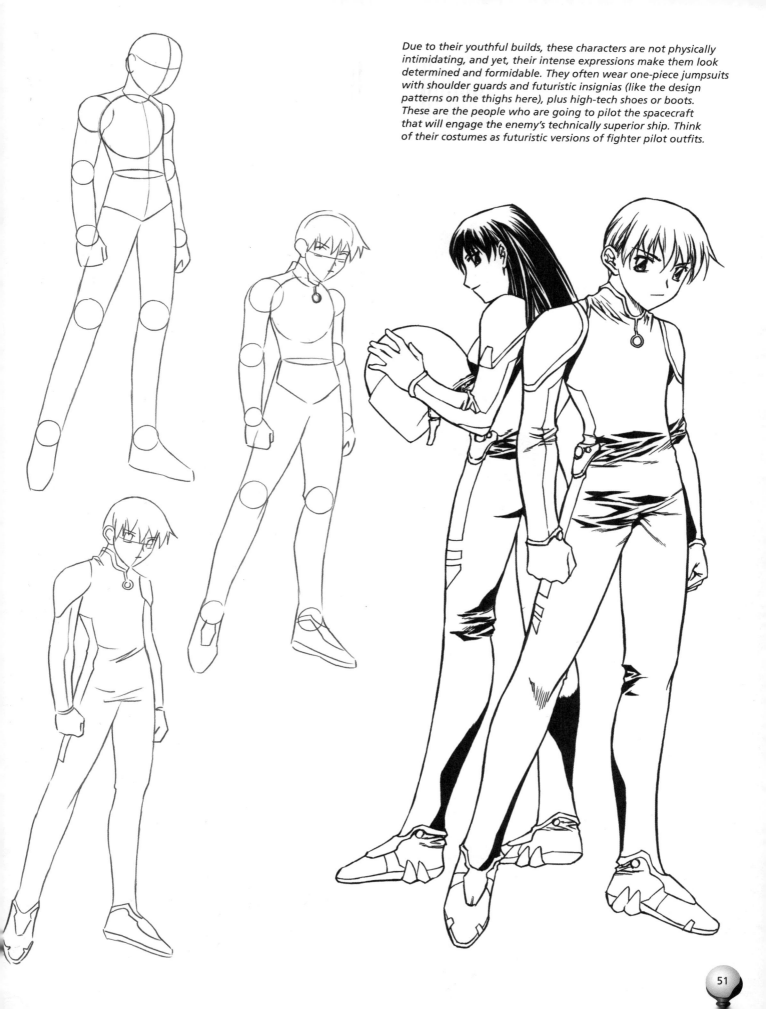

Due to their youthful builds, these characters are not physically intimidating, and yet, their intense expressions make them look determined and formidable. They often wear one-piece jumpsuits with shoulder guards and futuristic insignias (like the design patterns on the thighs here), plus high-tech shoes or boots. These are the people who are going to pilot the spacecraft that will engage the enemy's technically superior ship. Think of their costumes as futuristic versions of fighter pilot outfits.

School Drama

Teenagers have stormy relationships, emotional struggles, and peer pressures. That's a lot to deal with, but these complexities are precisely what make this age group prime material for stories. School age characters can be the subject of drama, humor, and romance plots. The school environment provides a familiar, well-grounded setting. Plus, school is a place where a diverse group of kids interact and mingle, so there's a variety of character types: the snob, the clown, the achiever, the shy kid, the bully, the outcast, the athlete, and so on.

Teenagers are in a state of emotional discovery and flux. They're reflective, moody, and reactive. They can laugh one minute and storm off angrily the next. They can be lonely in a crowd. They can be misunderstood. They can have best friends who betray their secrets. All of this makes for compelling stories that people—especially teenagers—want to read, because kids like to read about kids.

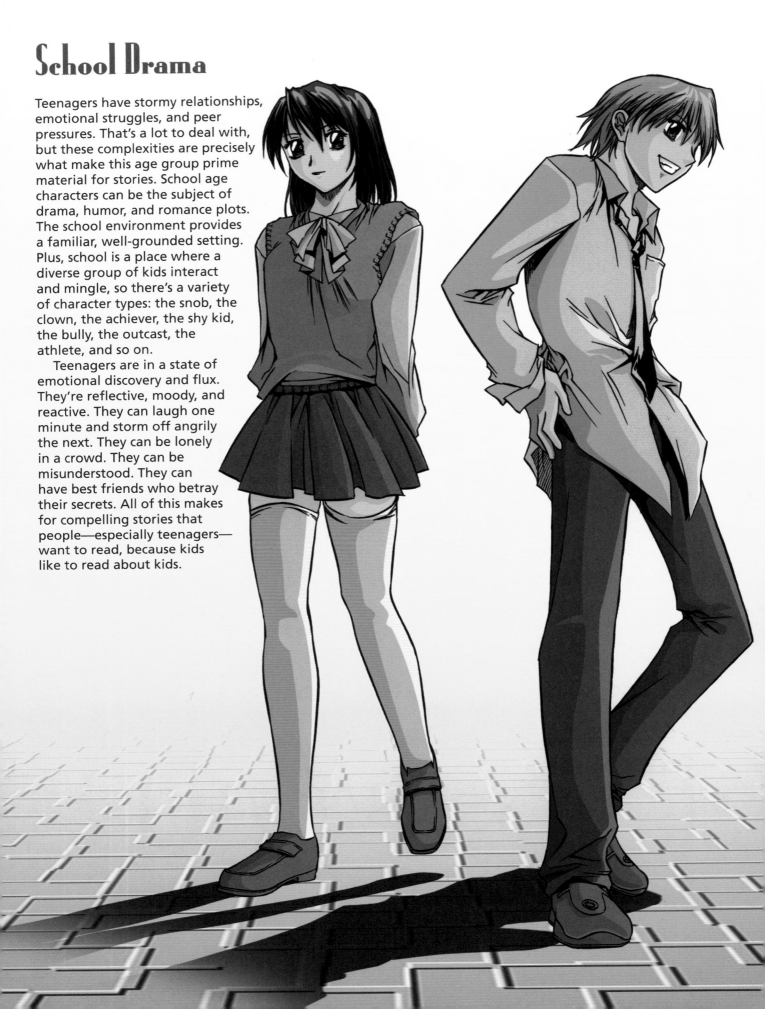

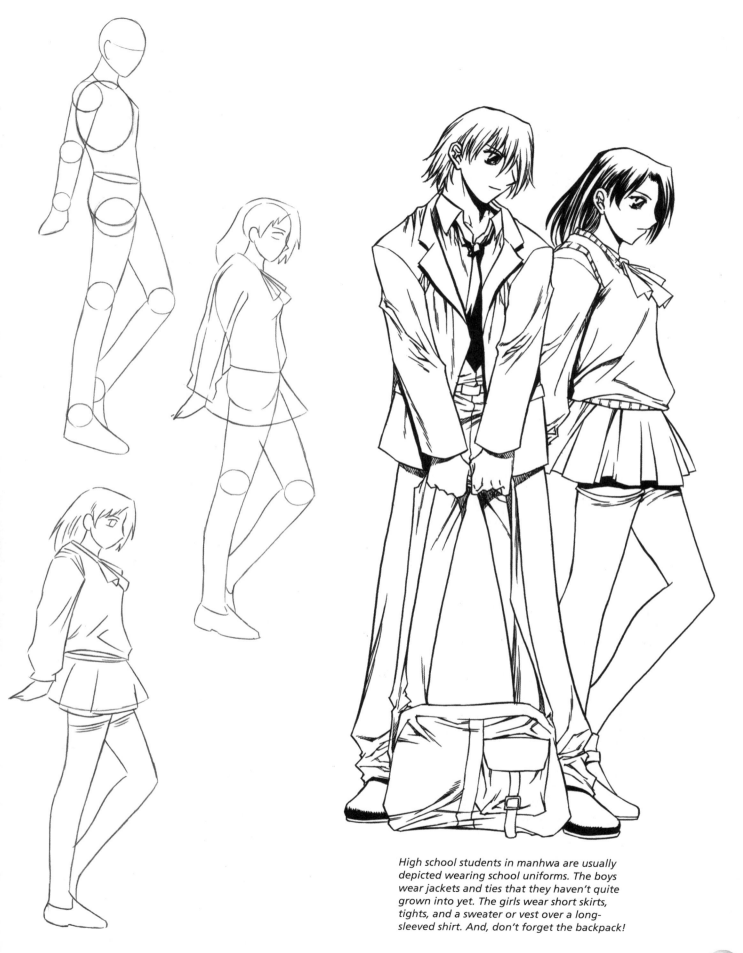

High school students in manhwa are usually depicted wearing school uniforms. The boys wear jackets and ties that they haven't quite grown into yet. The girls wear short skirts, tights, and a sweater or vest over a long-sleeved shirt. And, don't forget the backpack!

Girls/Teens

The emphasis here is on relationships and romantic involvement. The older the character, the vainer she's likely to be. In this genre, the characteristic of vanity is used to indicate a girl's interest in boys. But a girl's clique—her "peer pressure group"—is made up exclusively of girls. Family dynamics, jealousies, and sibling rivalries are always good material for Girls/Teens drama—and humor!

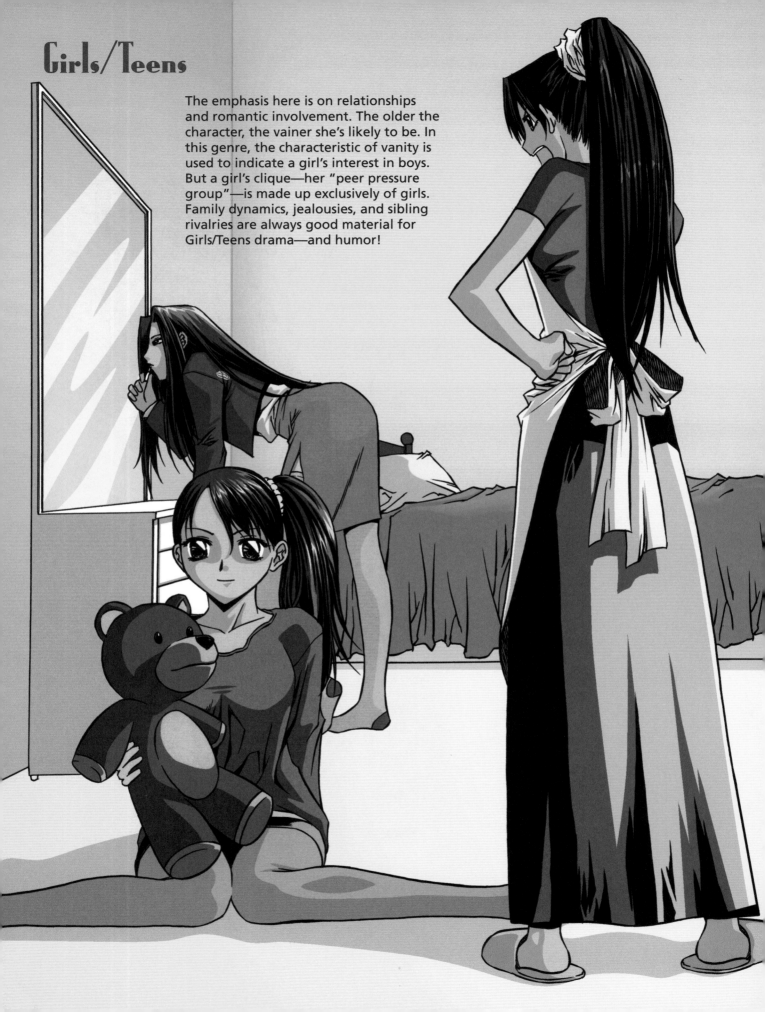

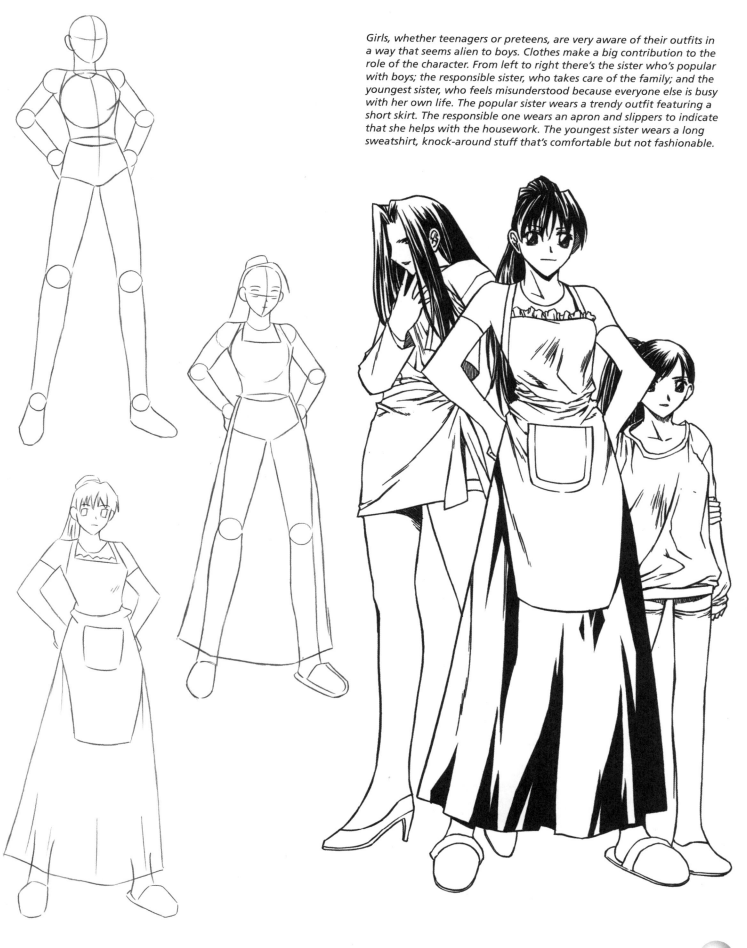

Girls, whether teenagers or preteens, are very aware of their outfits in a way that seems alien to boys. Clothes make a big contribution to the role of the character. From left to right there's the sister who's popular with boys; the responsible sister, who takes care of the family; and the youngest sister, who feels misunderstood because everyone else is busy with her own life. The popular sister wears a trendy outfit featuring a short skirt. The responsible one wears an apron and slippers to indicate that she helps with the housework. The youngest sister wears a long sweatshirt, knock-around stuff that's comfortable but not fashionable.

Action

The Action genre features characters who are just on this side of sanity. They are personalities on the edge—explosive characters who can go off at any given moment. Their unpredictable nature makes them interesting and dangerous.

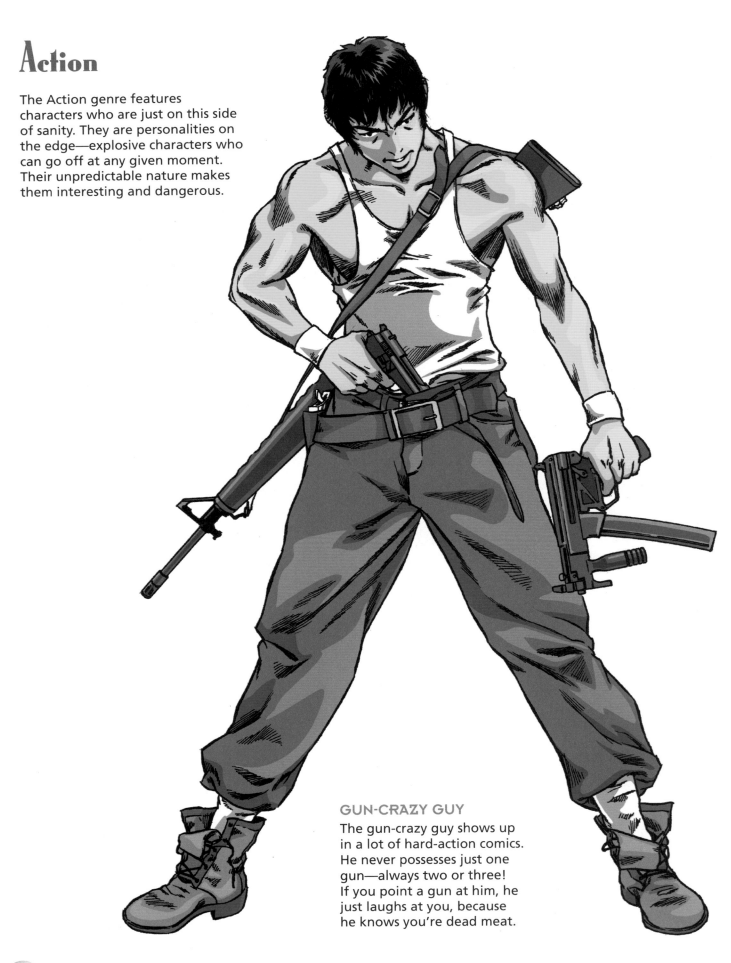

GUN-CRAZY GUY

The gun-crazy guy shows up in a lot of hard-action comics. He never possesses just one gun—always two or three! If you point a gun at him, he just laughs at you, because he knows you're dead meat.

TRADITIONAL WEAPONS MASTER

Blades and knives are the favored weapons of these traditional fighters. Some traditional weapons—such as throwing stars—might look flashier, but they can be hard to follow in a fight scene. A long blade looks impressive, is easy to see, and creates interesting diagonals when wielded in a scene.

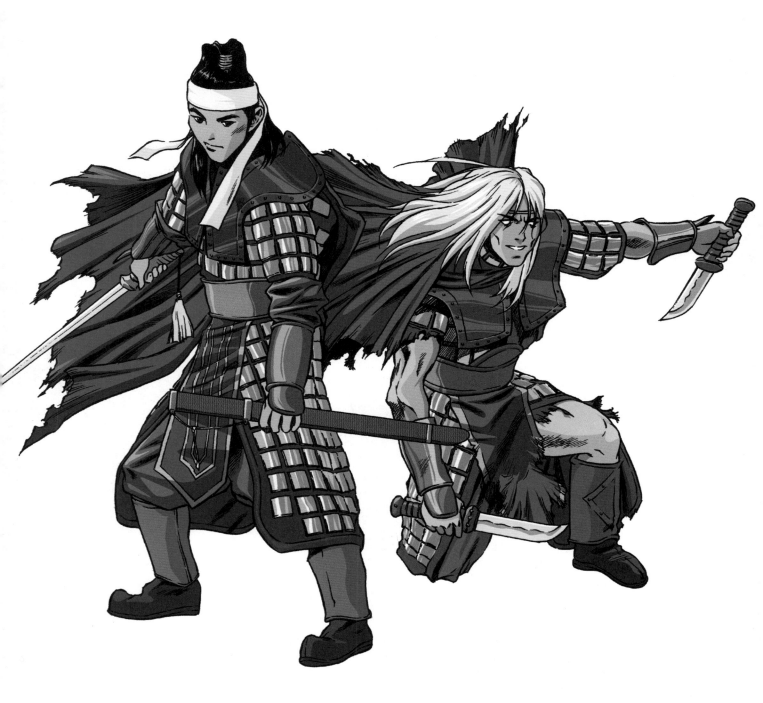

MANHWA'S LEADING MEN AND WOMEN

Leading characters are vital to any story, whether they are romantic leads, teenage fighter pilots, or heartthrobs. Manhwa boasts a wide variety of leading men and women, each with a distinct look and role, and each appealing to a different segment of the market.

The Heartthrob

Androgynous men are the romantic leads in many Girls/Teens comics. They have delicate, feminine features and long, flowing hair that is almost always parted down the middle. The common traits of most heartthrobs are: hair that cascades breezily off the shoulders, with one or two strands falling in front of the face; elongated eyes, with a heavy line indicating the upper eyelid, as if he wears mascara; thin, feminine eyebrows that are positioned close to the eyes (never, never use high, arching eyebrows on this type of character!); a long, slender bridge of the nose; a sleek and delicate face; and, a chin that comes to a point.

The heartthrobs of manhwa strike self-conscious poses of a wistful nature. The figure is long and lanky. Although the shoulders are wide, they're not powerful. Rather, the heartthrob should look like a character who wears stylish, Italian suits with shoulder pads. He's always a dapper dresser.

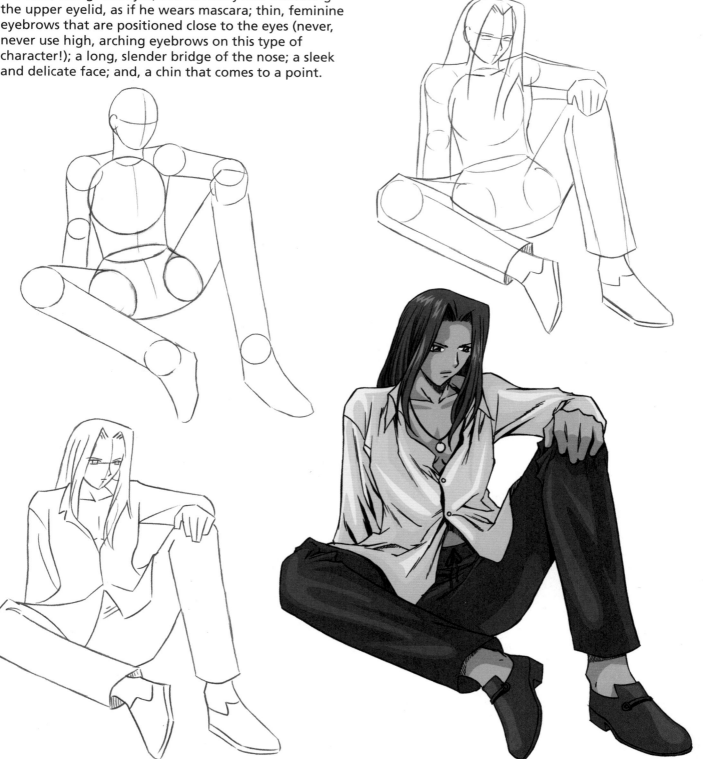

The Junior Executive

His corporate good looks and natty, businesslike attire make him a charmer around the office. In manhwa stories, many scenes take place in offices. Remember, a huge percentage of readers are adults! Even in the United States, the average age of the comic book reader is thirty! If you look carefully, you'll see that the junior executive is really just the heartthrob with his hair slicked back and wearing a suit.

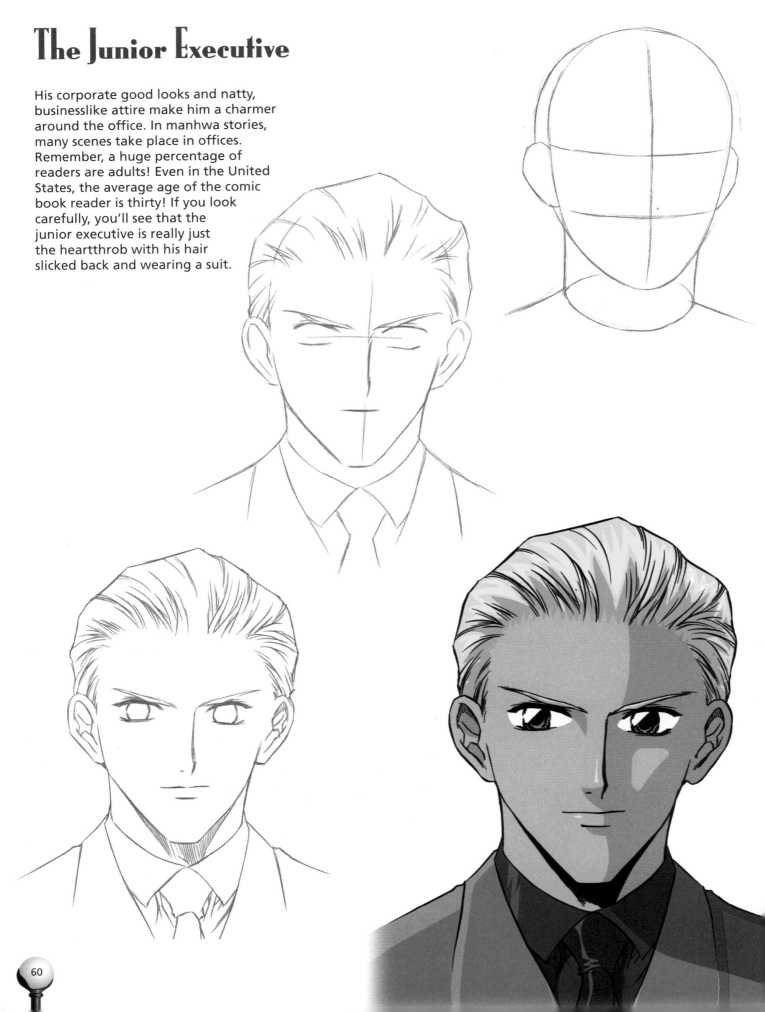

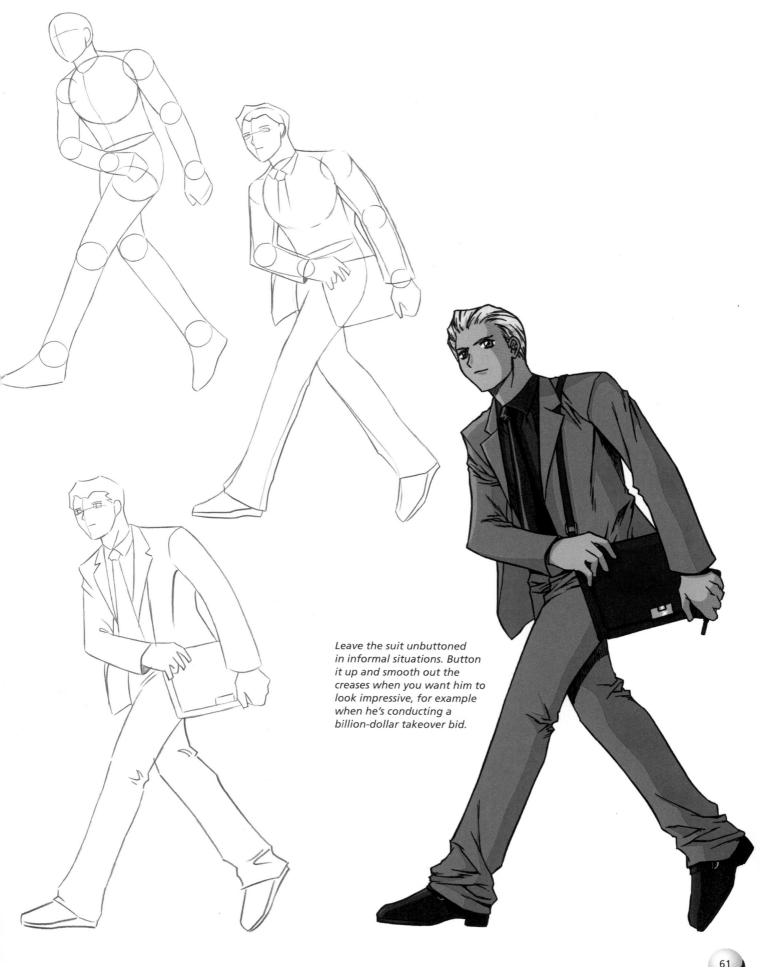

Leave the suit unbuttoned in informal situations. Button it up and smooth out the creases when you want him to look impressive, for example when he's conducting a billion-dollar takeover bid.

The Boyish Teen

Carefree and lacking pretense, the boyish teen is a different type of leading man. He has his share of female admirers, but he's not primarily a romantic lead. His role in the story is usually that of the hero, the underdog, or the understanding friend. Shaggy, medium-length hair is a good choice for this guy, although other hairstyles—if not too self-conscious or coiffed—are also acceptable, such as side- or middle-parted. Typical of youthful characters, his eyes are quite large with a big shine. He doesn't have the strong jawline you'd expect to see on more mature characters.

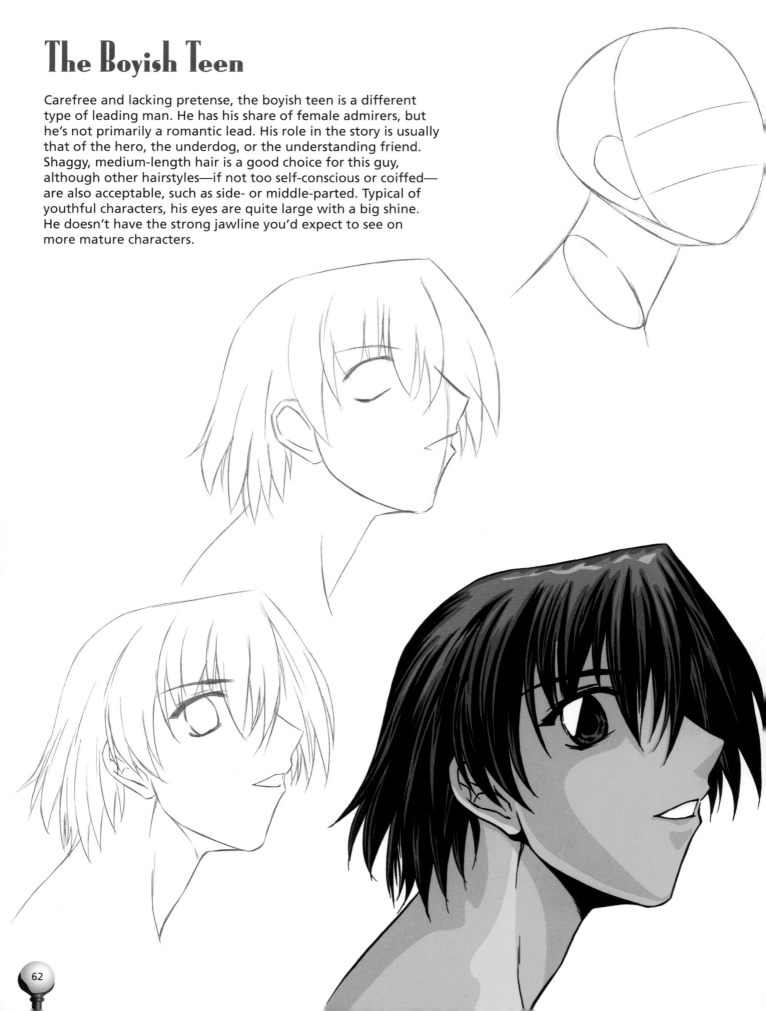

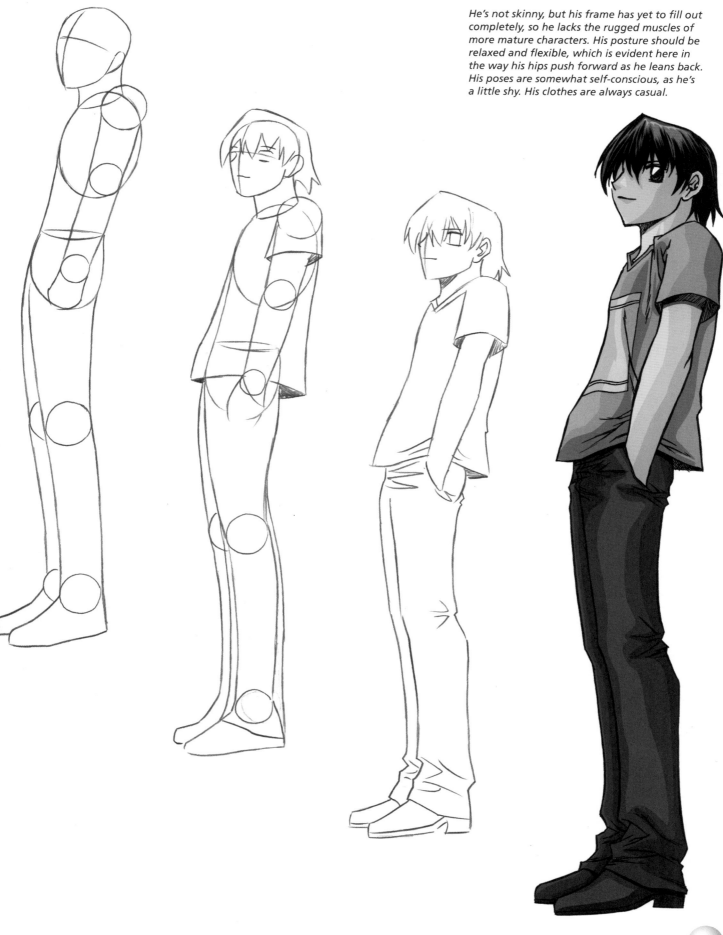

He's not skinny, but his frame has yet to fill out completely, so he lacks the rugged muscles of more mature characters. His posture should be relaxed and flexible, which is evident here in the way his hips push forward as he leans back. His poses are somewhat self-conscious, as he's a little shy. His clothes are always casual.

The Hip-Hop Youth

This is a physically strong character (notice his thick neck). His chin is more square than the boyish teen, making him look more intimidating physically, and his eyes aren't as big. His hair falls in front of his face, and he doesn't care. He has a way of looking at you, almost defiantly, just like rock stars posing for CD covers.

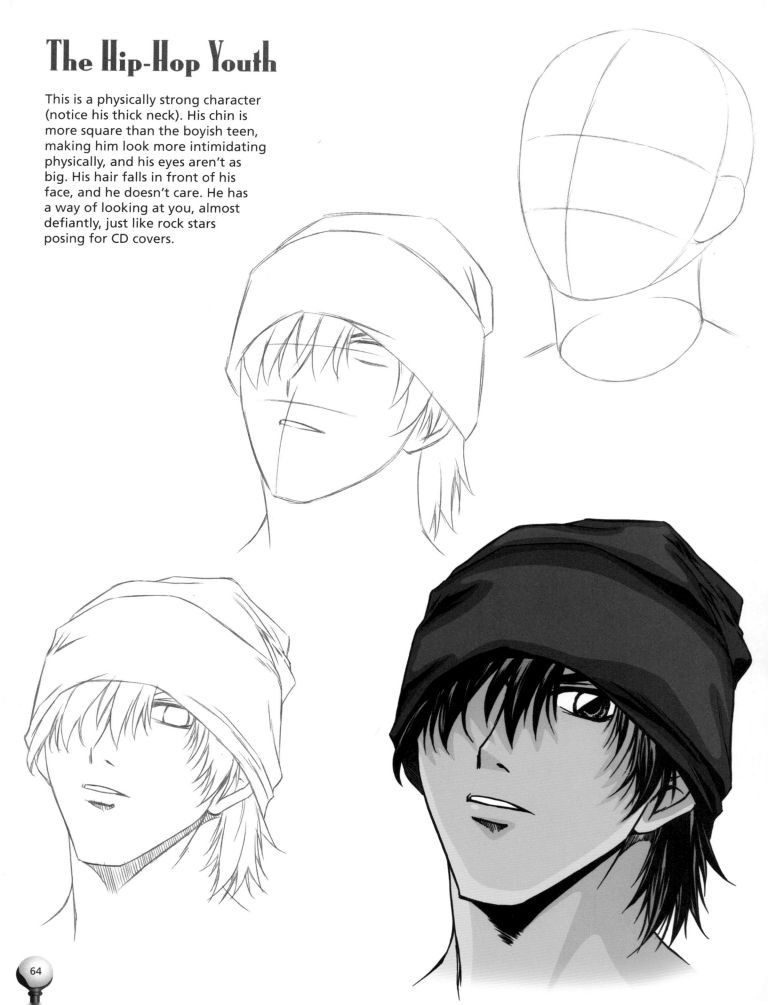

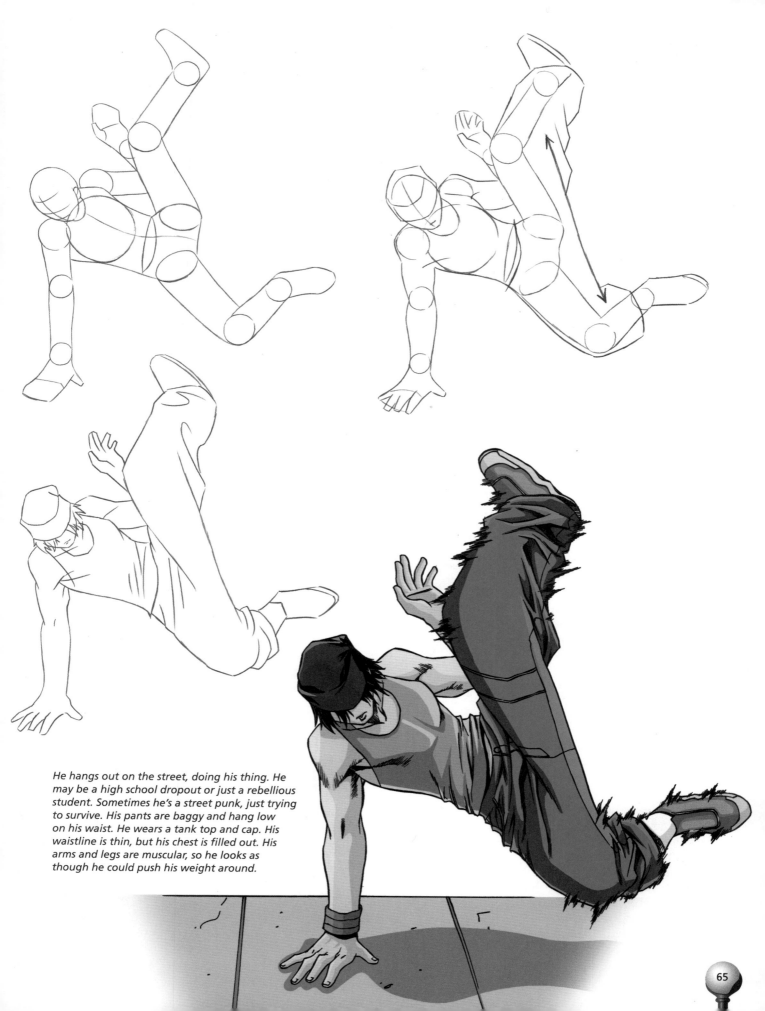

He hangs out on the street, doing his thing. He may be a high school dropout or just a rebellious student. Sometimes he's a street punk, just trying to survive. His pants are baggy and hang low on his waist. He wears a tank top and cap. His waistline is thin, but his chest is filled out. His arms and legs are muscular, so he looks as though he could push his weight around.

The Chic Hippie

The casual clothes of the sixties just sort of came together as eclectic outfits in a spontaneously uncalculated way, like a mish-mash from a secondhand store. This look has been reinvented by the most astute eyes in the fashion industry. The result is very expensive clothing made to look stylishly trashy. It's quite popular.

MODERN FEMALE CHARACTERS

Sexy and stylish, the women of manhwa command attention. Character types run the gamut from elegant figures in traditional Korean dress to seductive temptresses to extreme fighters. Pose and costume are both important elements. Pose is significant because a pretty character in a neutral pose lacks impact, but a sultry pose can set a scene on fire. Costume is important because it highlights the figure and creates a specific look for the character.

In addition to warrior women and traditionally dressed characters (see pages 15, 32–33, and 134–143), there are plenty of gorgeous, trendy, contemporary female characters in manhwa. And although the Fantasy genres of manhwa are very popular, most manhwa takes place in the present—in hip, metropolitan areas such as Seoul. You can, however, set your stories anywhere, from New York to Hollywood to Paris to London, and beyond.

When drawing clothes for these modern women, think of yourself as a fashion photographer on a photo shoot. Your job is to make your subject as appealing and stylish as possible. To grab your reader's attention, create clothes that you'd expect to see on a magazine cover.

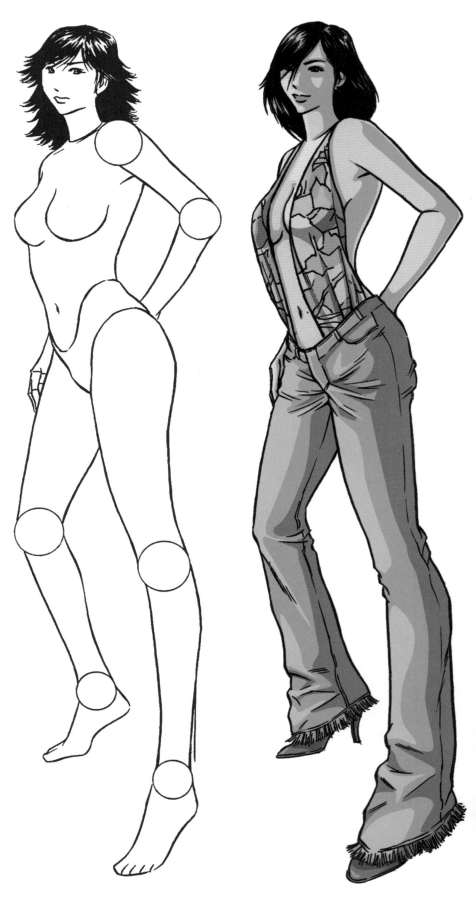

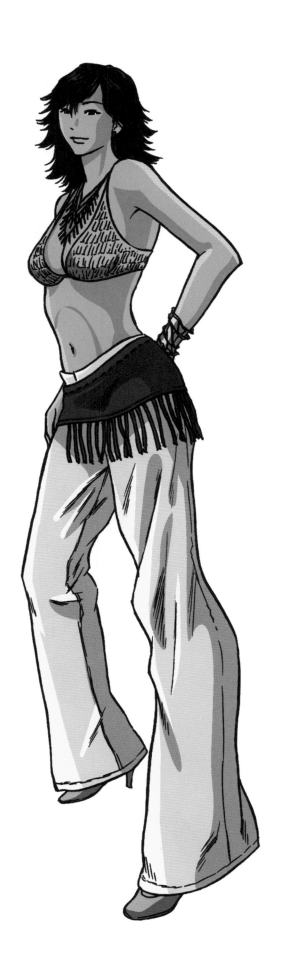
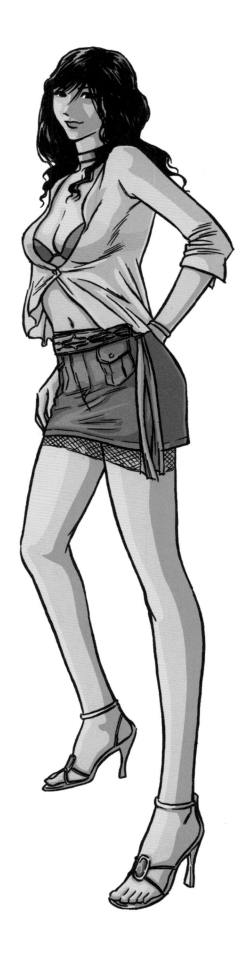

The Bohemian

This character displays a mild counter-culture look, but with a city edge. Revealed midriffs and short skirts punctuate this look, along with accessories like gloves, bracelets, and armbands. The high-fashion footwear adds glamour to the outfit and elevates the style.

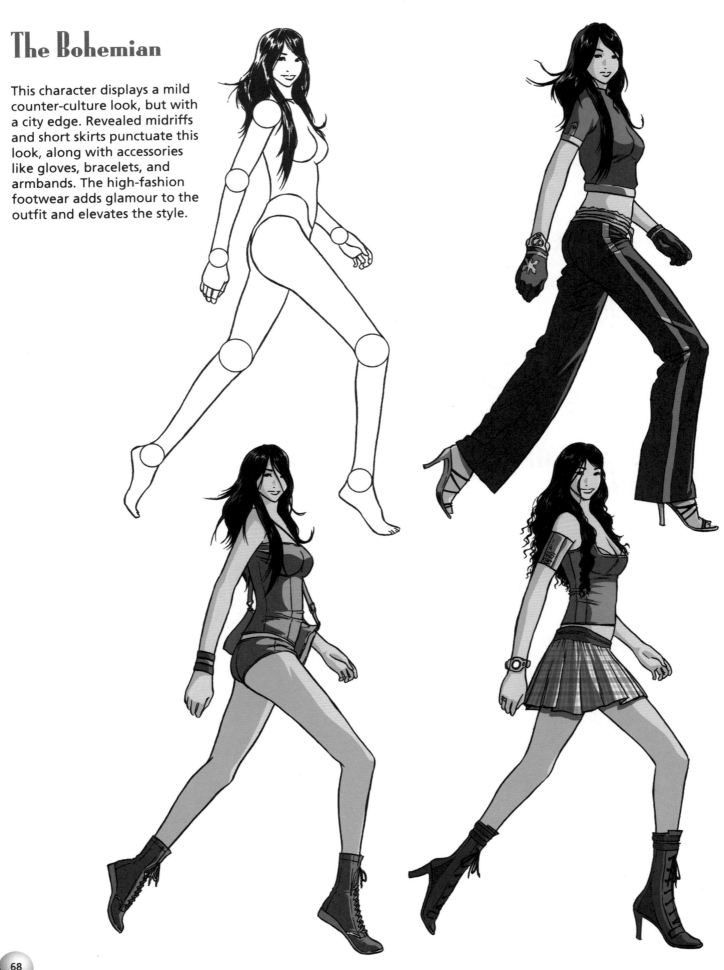

The Military Urbanite

Army fatigues and pseudo-military gear are a popular look in female fashion for city dwellers. They add a rugged sexiness to the character. Urban-chic clothes either feature camouflage designs or have many snapping and zipping compartments. Military-style caps, dog tags, and tank tops complement the look.

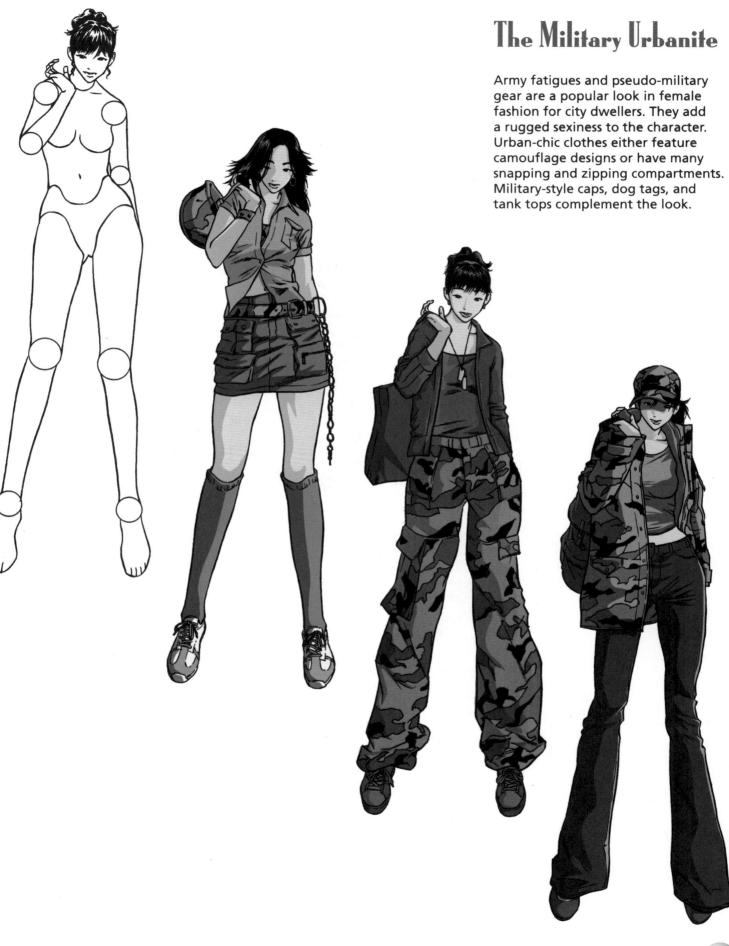

The Poolside Glamour Girl

Long gone are the days when swimsuits were just for swimming. Swimsuits have left the sporting goods stores and become part of designer fashion. They're often augmented by shirts and tops, which turns them into quasi-outfits that can be worn at the beach and at resorts.

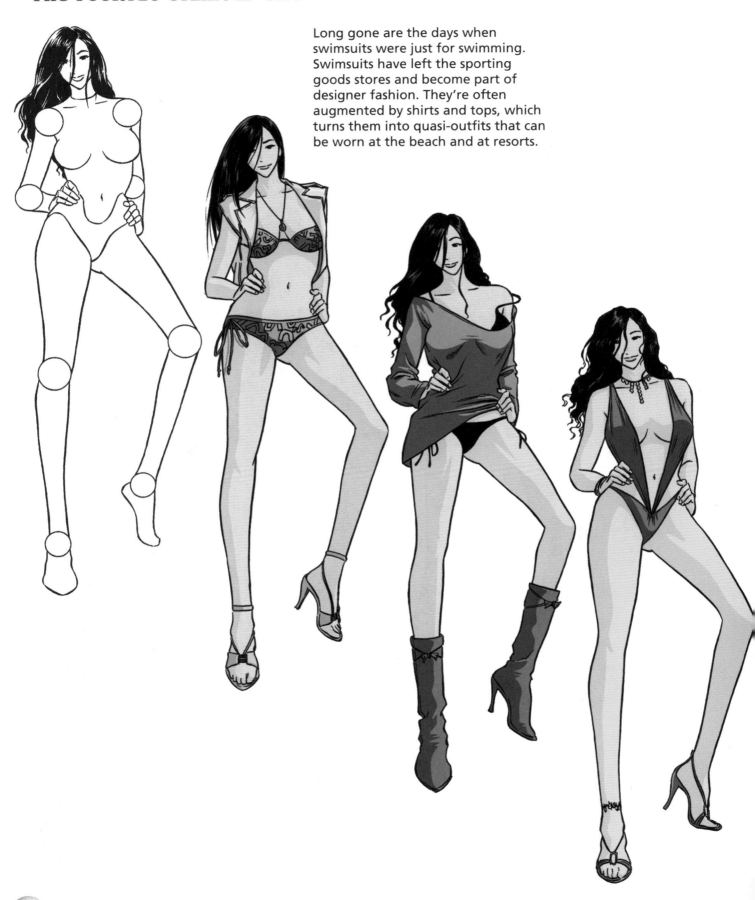

A Simple Change of Clothes

Clothes tell you a lot about character type. Conservative characters cover up more. Racier characters wear skimpier outfits. In addition to defining a character's world view, clothes also identify a character's role in the story. For example, a student is recognizable primarily by her jeans, T-shirt, and backpack.

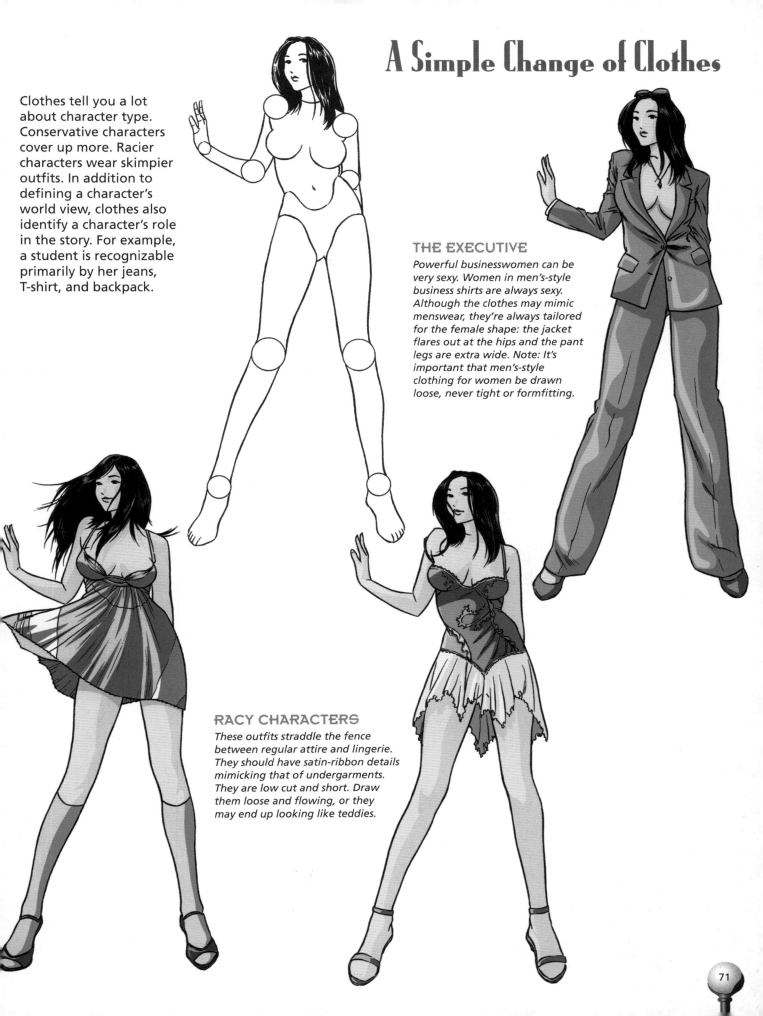

THE EXECUTIVE

Powerful businesswomen can be very sexy. Women in men's-style business shirts are always sexy. Although the clothes may mimic menswear, they're always tailored for the female shape: the jacket flares out at the hips and the pant legs are extra wide. Note: It's important that men's-style clothing for women be drawn loose, never tight or formfitting.

RACY CHARACTERS

These outfits straddle the fence between regular attire and lingerie. They should have satin-ribbon details mimicking that of undergarments. They are low cut and short. Draw them loose and flowing, or they may end up looking like teddies.

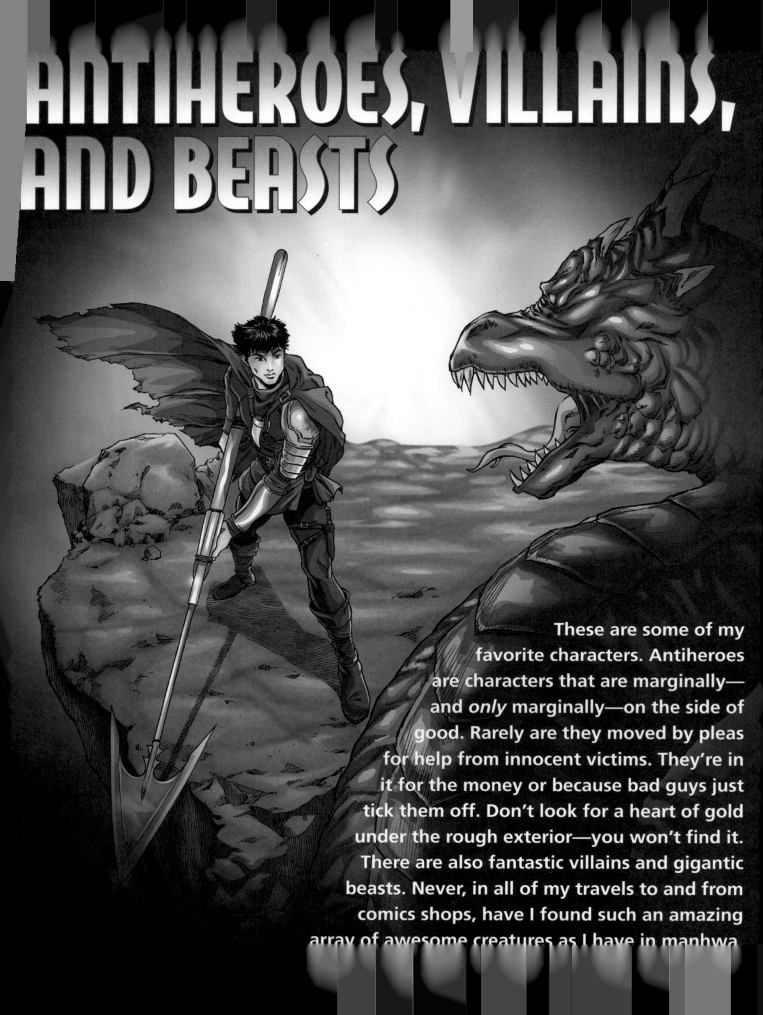

ANTIHEROES, VILLAINS, AND BEASTS

These are some of my favorite characters. Antiheroes are characters that are marginally— and *only* marginally—on the side of good. Rarely are they moved by pleas for help from innocent victims. They're in it for the money or because bad guys just tick them off. Don't look for a heart of gold under the rough exterior—you won't find it. There are also fantastic villains and gigantic beasts. Never, in all of my travels to and from comics shops, have I found such an amazing array of awesome creatures as I have in manhwa

The antihero is a cool character. He gives a story an edge. Usually, readers don't like characters to whom they can't relate, but the antihero is different because he has the guts to take on all enemies, and he has bad-boy charisma. Clint Eastwood's characters are examples of the quintessential antihero.

The antihero is a tough guy. His dress is nonconformist. Sometimes he wears flamboyant clothes. He has a king-size ego, but that doesn't mean he wants people to look up to him. Far from it. He's a loner, cursed to spend his life apart, on the streets, in the shadows. He can't love or be loved, and he knows it, which is why, if written correctly, he's almost a tragic character.

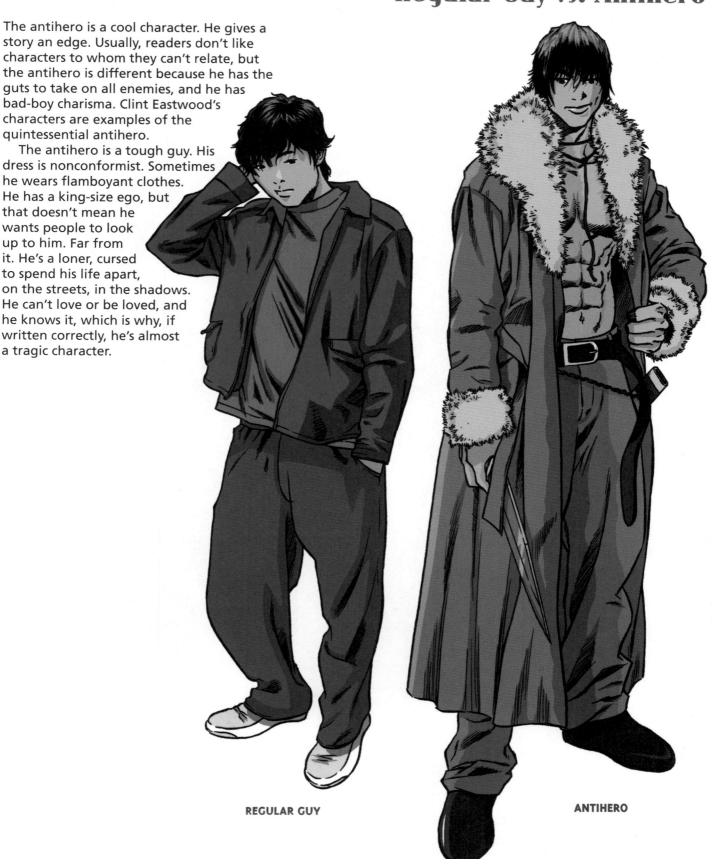

REGULAR GUY

ANTIHERO

Regular Gal vs. Antiheroine

The antiheroine is also a dangerous character. She has an unmistakable air of confidence. Like the antihero, she's fond of weapons and doesn't hesitate to use them. Although she's an attractive character, she's not a seductress or particularly flirtatious. She'd just as soon shoot you as kiss you. Her good looks seem almost incidental; but unimportant as her looks may be to her, she's always a good-looking character. She wears flashy, risqué garments; they don't always need to be revealing—sometimes a tight-fitting bodysuit does the trick.

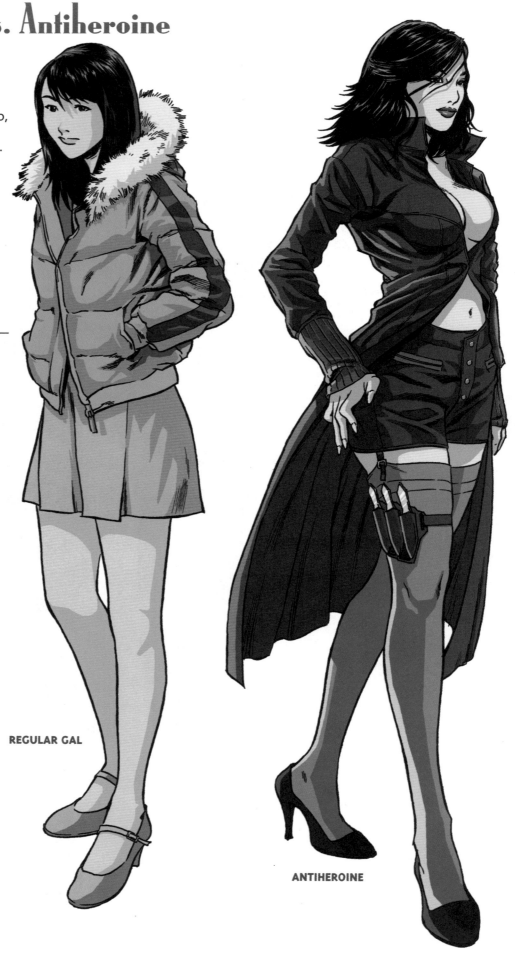

REGULAR GAL

ANTIHEROINE

Different Costumes, Different Looks

You can change your antihero's costume to create different looks for your character. Take a look at these variations.

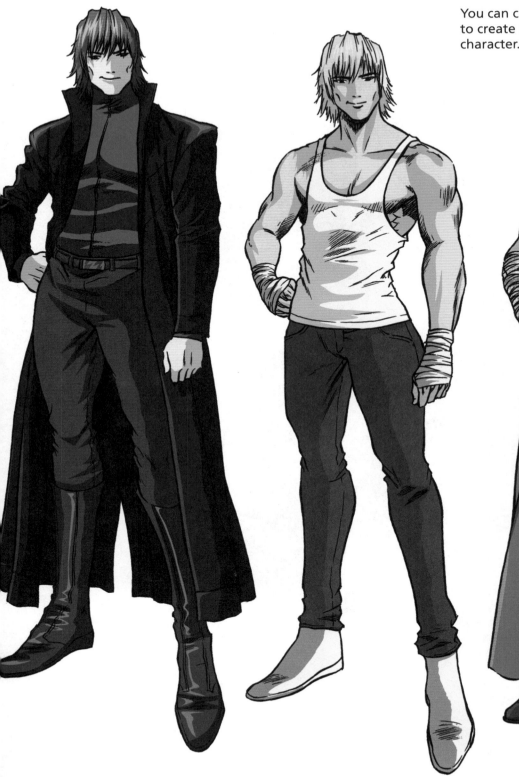

GOTH GUY
The trench coat makes a character hip, slick, and cool. It is very dramatic when worn with the collar up. High boots make this guy a racer.

TOUGH GUY
The tank top focuses attention on the character's impressive physique, which is powerful enough to intimidate. It's an egotistical display of aggression.

MARTIAL ARTS BRAWLER
This fighter is bad to the bone. Eschewing the traditional martial arts uniform, he goes shirtless, flouting the norms and disrespecting the art. But who's going to tell him to put his shirt back on?

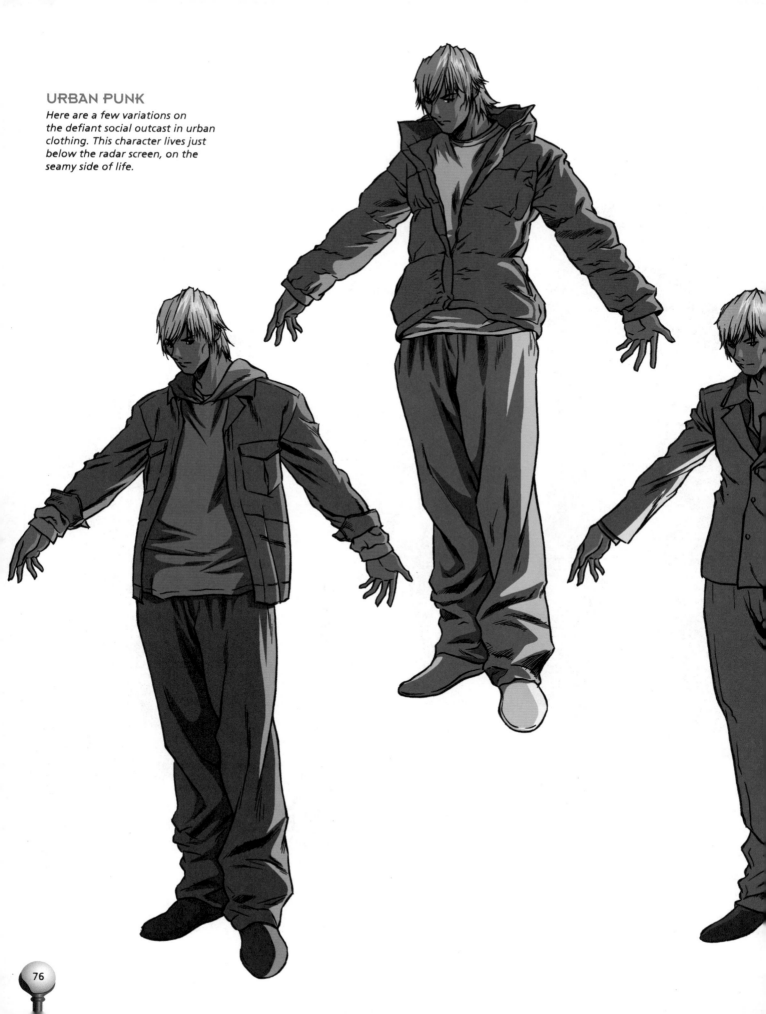

URBAN PUNK

Here are a few variations on the defiant social outcast in urban clothing. This character lives just below the radar screen, on the seamy side of life.

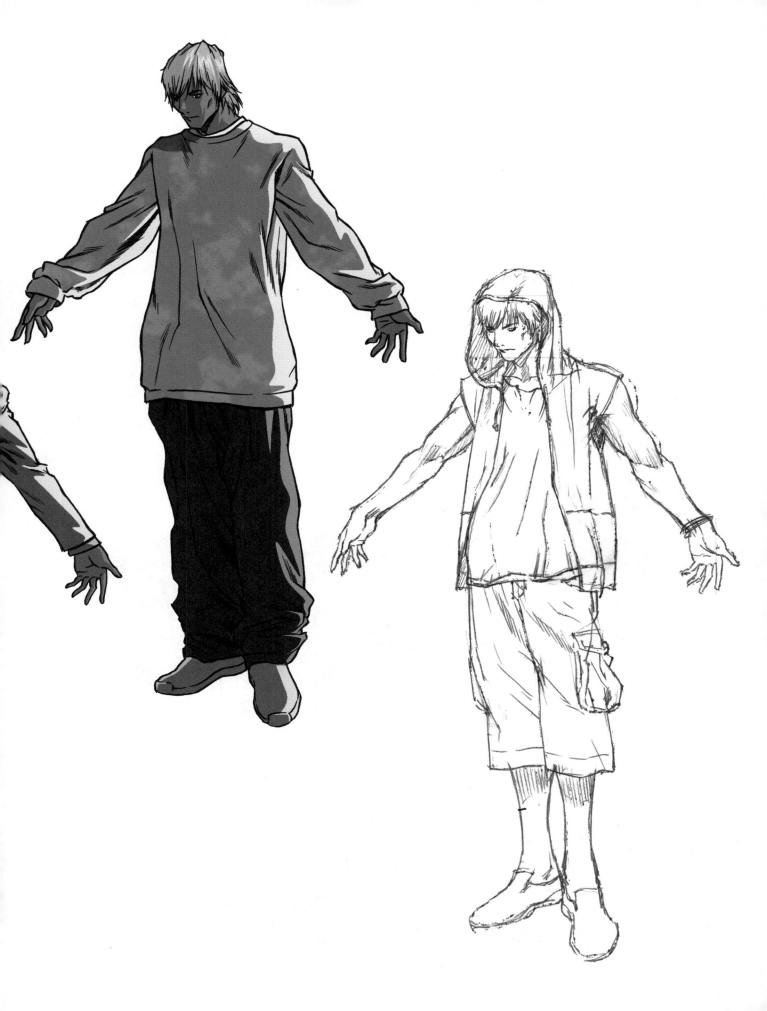

Antihero Transformations

Just like Dr. Jekyll and Mr. Hyde, an exterior force can turn an ordinary character into a hideous creature. These startling transformations are always a dramatic high point in a story. As characters begin to change, their bodies convulse. It's an excruciating, painful process as they fight in vain to hold onto their humanity, only to emerge as repulsive creatures. When the creature emerges, it is powerful, with a changed personality that actually enjoys its new form. It's also very, very evil. So don't pet it.

Transformations are as much about the premise—the reason—for the transformation, as they are about the metamorphosis itself. The buildup to the transformation is key. It creates the tension, and the transformation becomes the payoff. In addition, when a character transforms, he or she does so in steps. Hold onto the human form for as long as possible; a fast transformation will detract from the emotion of the scene. Make your reader agonize along with your character.

TRANSFORMATION BY EXPERIMENTAL SERUM

A secret formula has been developed at a laboratory. It's supposed to imbue the subject with super strength. But something isn't right with it. Testing on animals shows serious defects. It's not yet ready for testing on humans. An opportunist, unaware of the side effects, learns about the secret formula and desires it for himself so that he can have the incredible powers. Instead, the serum turns him into a hideous creature. Or a lawyer.

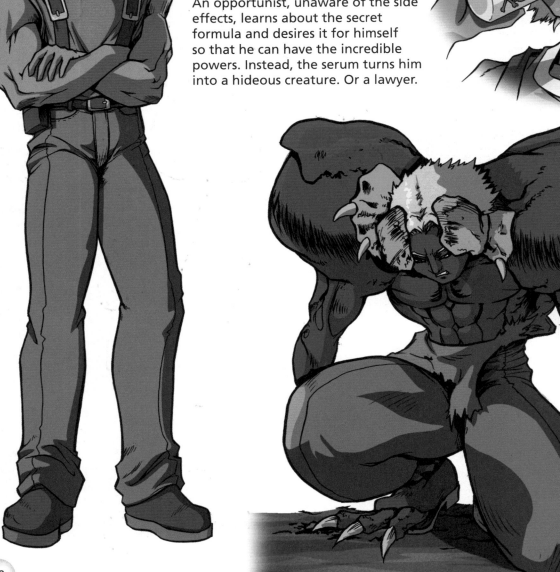

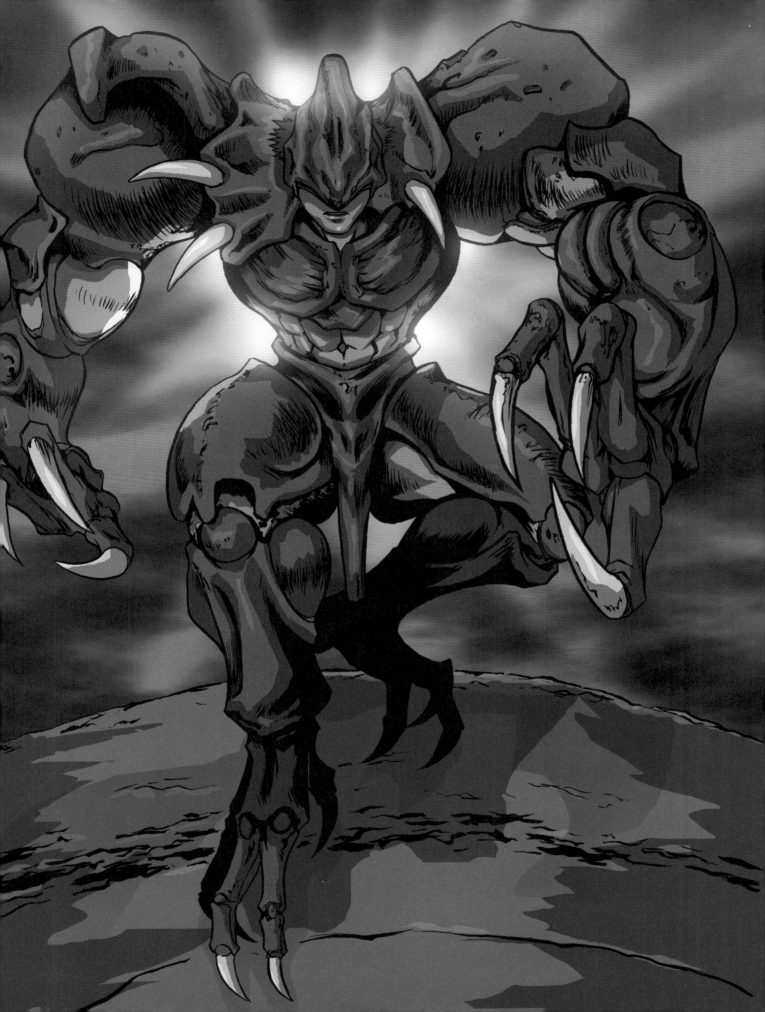

TRANSFORMATION BY INJECTION

In this case, the transformational agent is administered by a wicked scientist. Or a doctor from an HMO. The effects are monitored by the evil doctor/scientist, who cares only about his data. This type of transformation is done to create creature-slaves who do the scientist's bidding. The shots should be given in areas of the body that make the reader queasy, such as the back of the neck, the head, and the eyes.

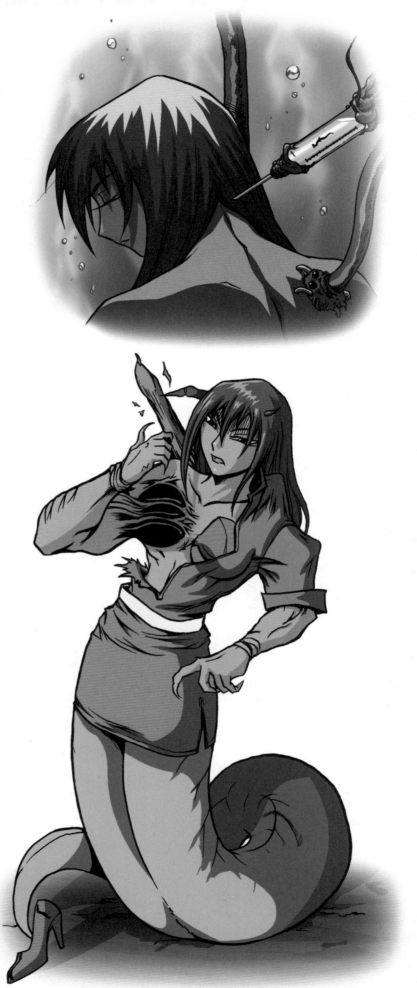

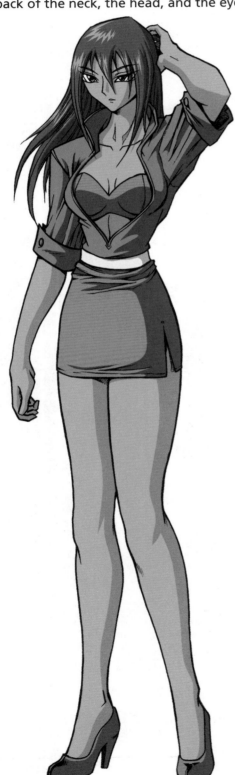

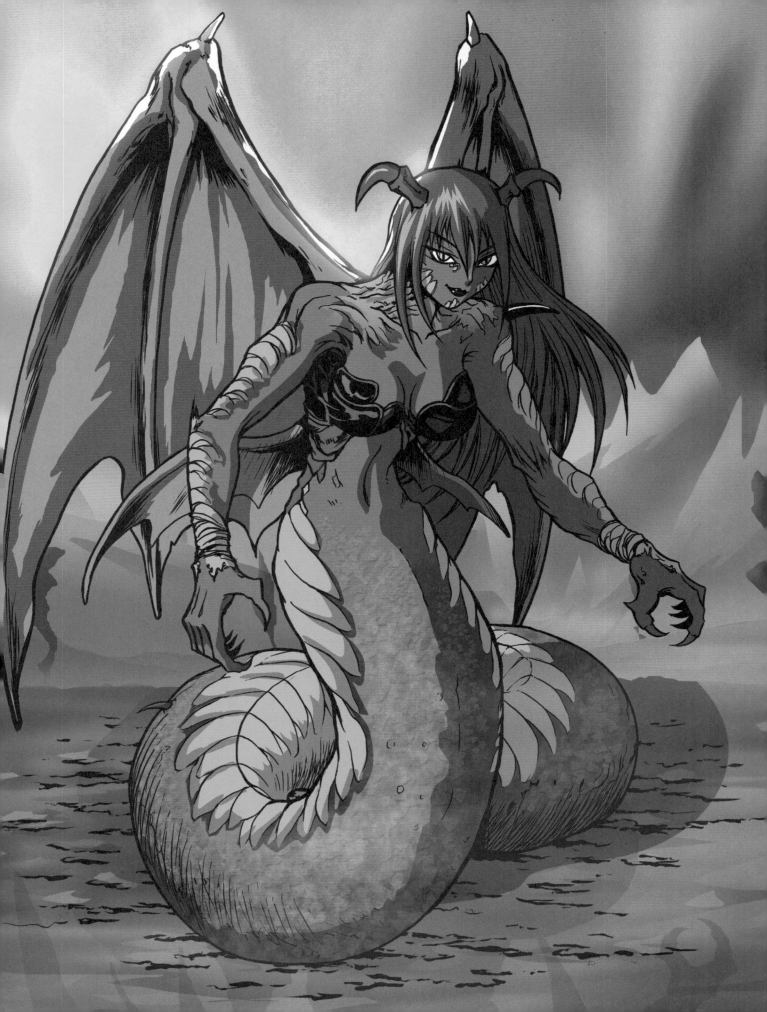

TRANSFORMATION BY BURST OF ENERGY

Here's a good suggestion for you:
If you're walking along the street,
and suddenly you see a burst of
radioactive plasma coming your way,
duck. Plasma is usually bad news.

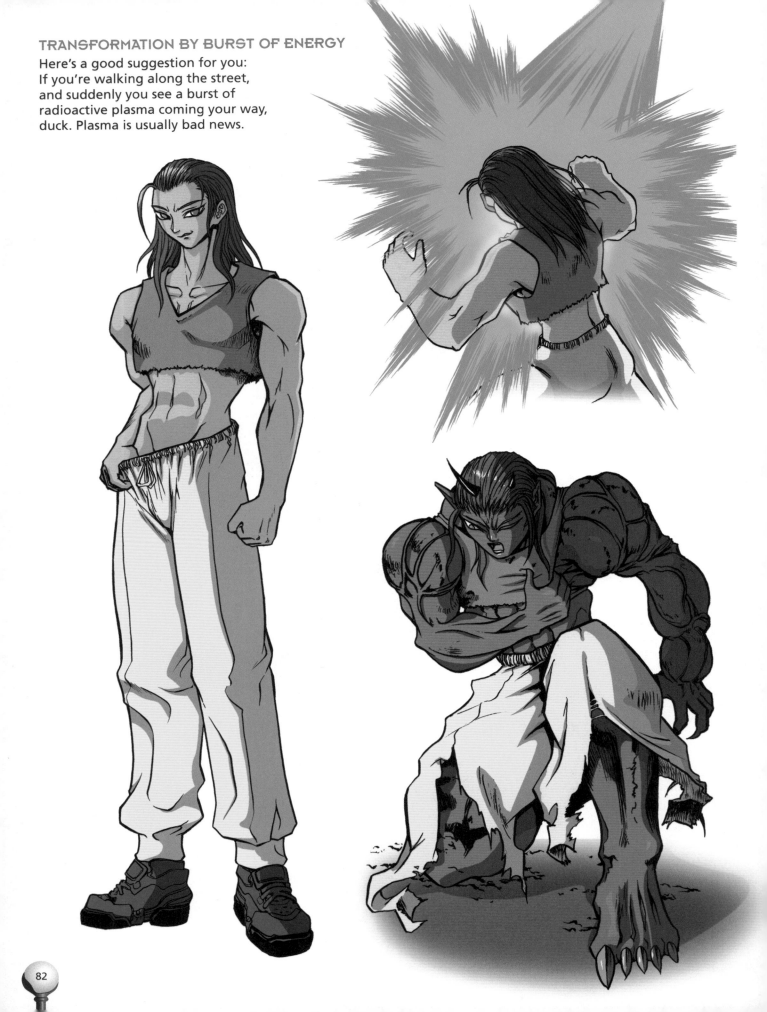

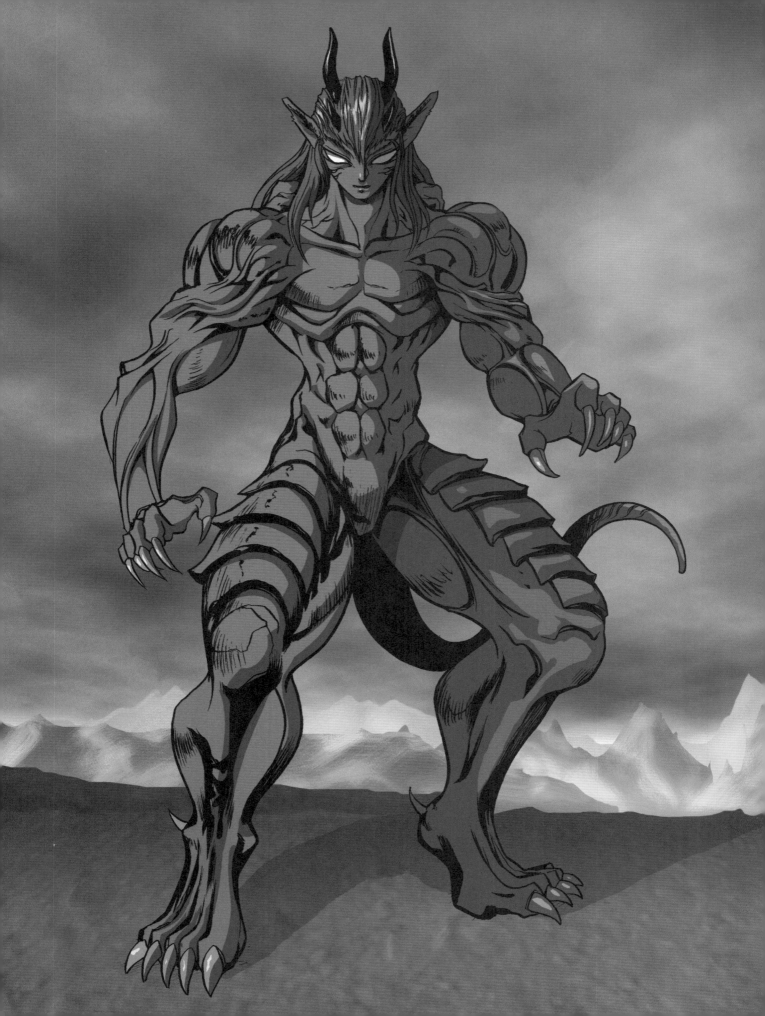

TRANSFORMATION BY TOUCH

Remember when you were a kid and your parents would say, "Don't touch that!" You should've listened. Touching things in an enchanted forest can get you into one heap of trouble. What looks like a beautiful blossom is actually a dangerous trap. Once touched, even by a fingertip, the plant takes over the human form, like a rapidly multiplying virus. It continues to replicate itself until it has completely taken over its host. Then it uses its human host to become ambulatory and, therefore, much more effective at spreading its particular brand of evil.

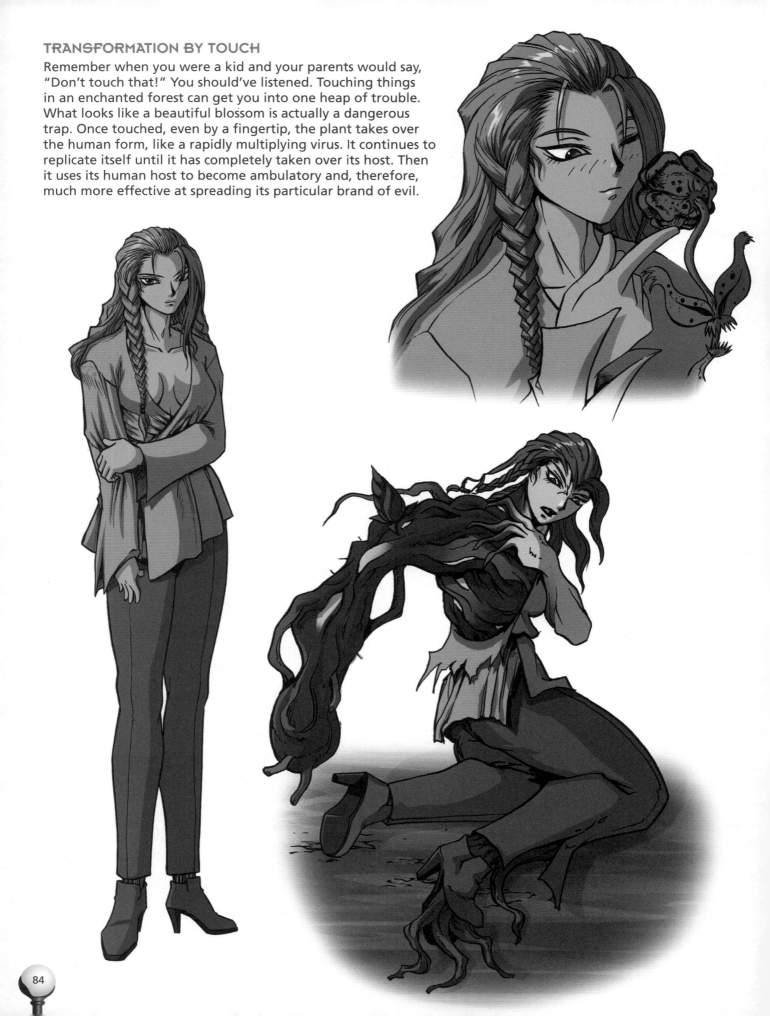

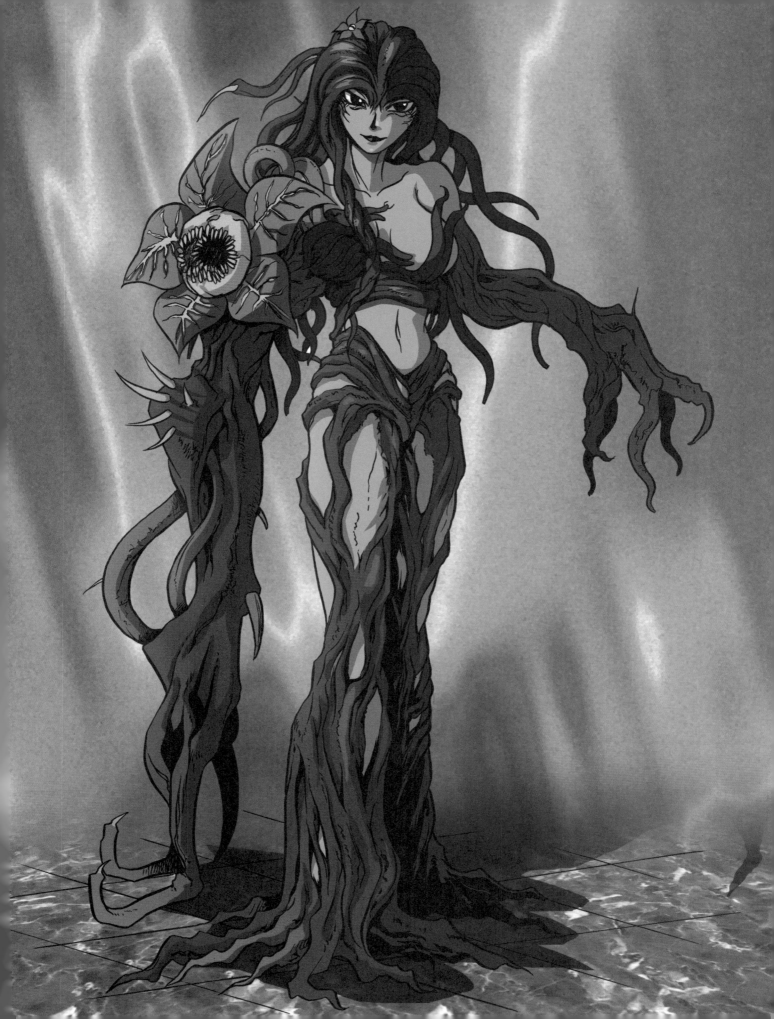

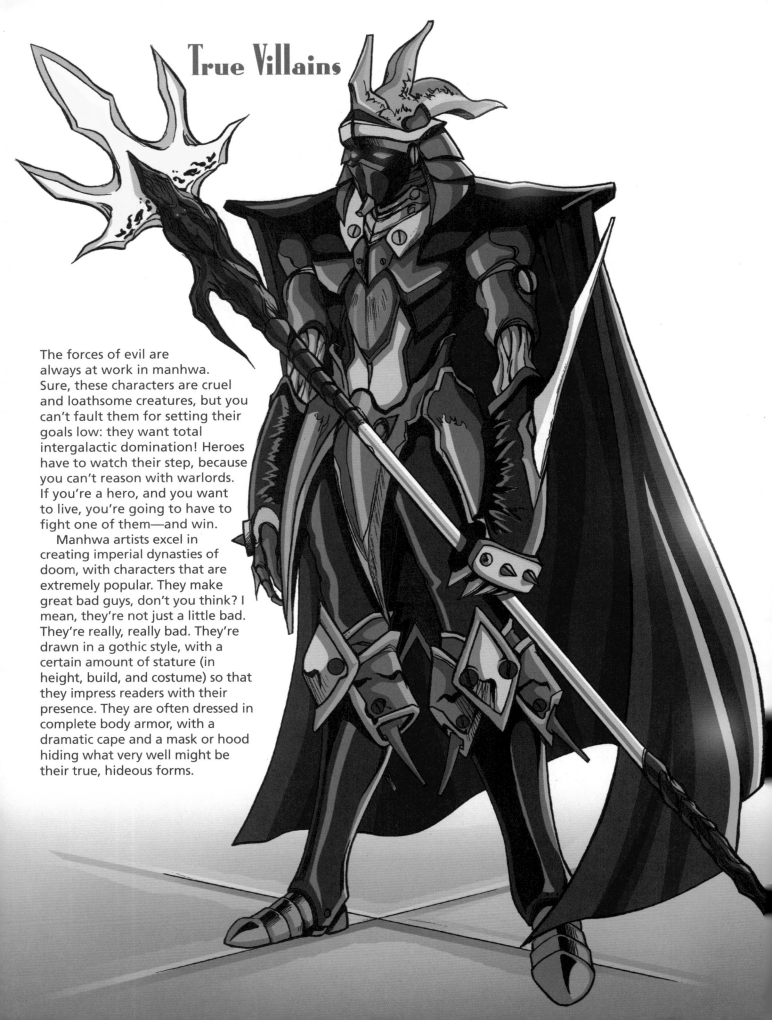

True Villains

The forces of evil are always at work in manhwa. Sure, these characters are cruel and loathsome creatures, but you can't fault them for setting their goals low: they want total intergalactic domination! Heroes have to watch their step, because you can't reason with warlords. If you're a hero, and you want to live, you're going to have to fight one of them—and win.

Manhwa artists excel in creating imperial dynasties of doom, with characters that are extremely popular. They make great bad guys, don't you think? I mean, they're not just a little bad. They're really, really bad. They're drawn in a gothic style, with a certain amount of stature (in height, build, and costume) so that they impress readers with their presence. They are often dressed in complete body armor, with a dramatic cape and a mask or hood hiding what very well might be their true, hideous forms.

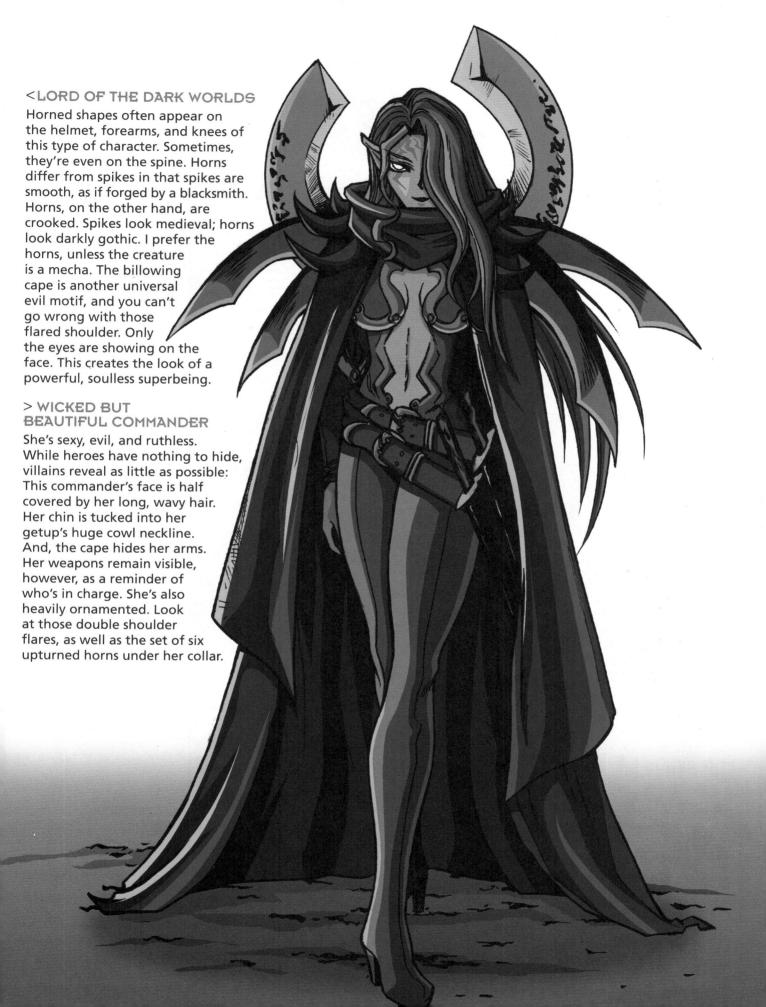

< LORD OF THE DARK WORLDS

Horned shapes often appear on the helmet, forearms, and knees of this type of character. Sometimes, they're even on the spine. Horns differ from spikes in that spikes are smooth, as if forged by a blacksmith. Horns, on the other hand, are crooked. Spikes look medieval; horns look darkly gothic. I prefer the horns, unless the creature is a mecha. The billowing cape is another universal evil motif, and you can't go wrong with those flared shoulder. Only the eyes are showing on the face. This creates the look of a powerful, soulless superbeing.

> WICKED BUT BEAUTIFUL COMMANDER

She's sexy, evil, and ruthless. While heroes have nothing to hide, villains reveal as little as possible: This commander's face is half covered by her long, wavy hair. Her chin is tucked into her getup's huge cowl neckline. And, the cape hides her arms. Her weapons remain visible, however, as a reminder of who's in charge. She's also heavily ornamented. Look at those double shoulder flares, as well as the set of six upturned horns under her collar.

SOLDIER OF DARKNESS

His armor can't be the type you'd
see on a knight of the Round Table.
The dark soldier's armor is twisted
and serpentine. It should look as if
it grows around him like a vine.
This makes it strange, weird, and
threatening. Is there a human under
that helmet? Maybe. But take a look
at the feet. Well, then maybe not.
Keep your readers guessing in
order to keep them on edge.

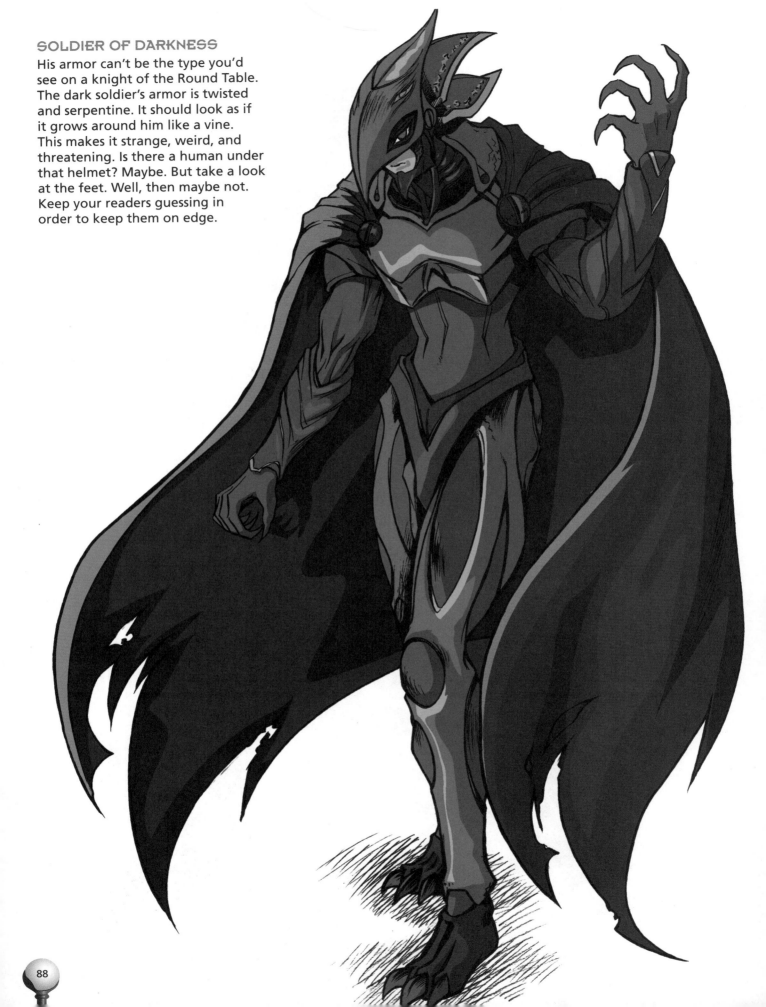

ARCHER

Every army of evil has got to have at least one decent archer. It's a union rule. And an archer doesn't even pick up her quiver unless she's paid time and a half. The long archer's bow is more dramatic than a crossbow because it's so much bigger. Note how it indents in the center where the grip is. This is called a belly bow, and it provides a lot more tension strength than a plain bow.

The archer is never as physically awesome as the other characters—she doesn't need to be. Her value lies in her keen eye and lightning fast reflexes. If she's fighting a giant beast covered in armor plates, guaranteed she hits him smack in the eye. And, what does she need that cape for? Because it looks good when she goes out on an evil date.

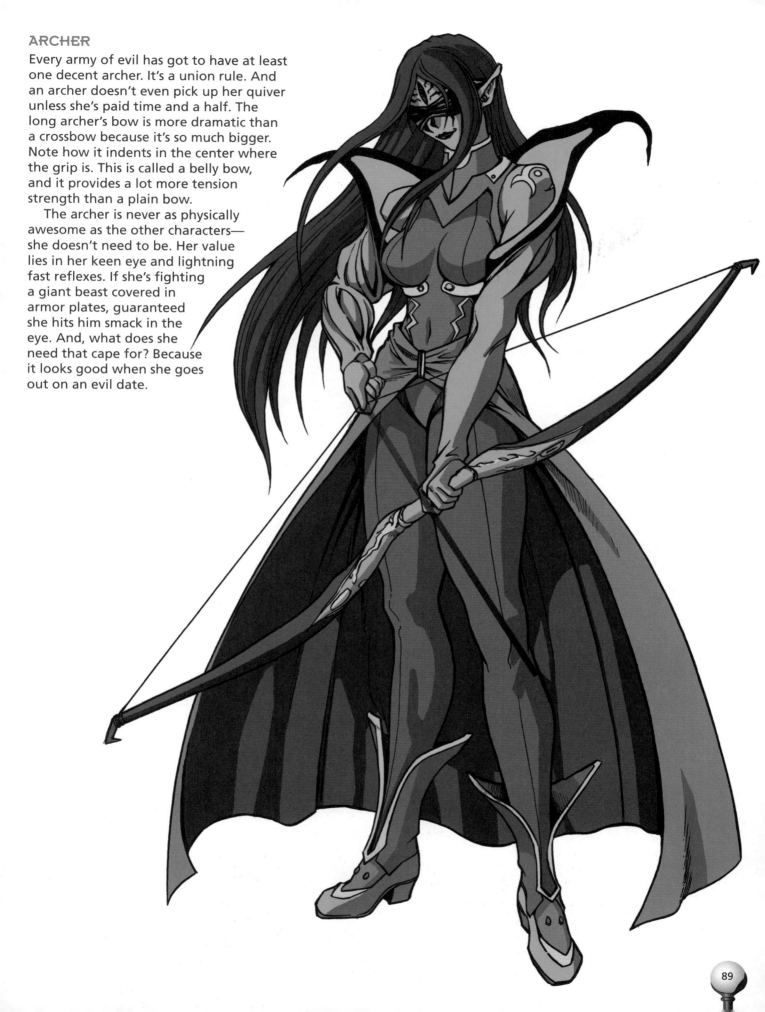

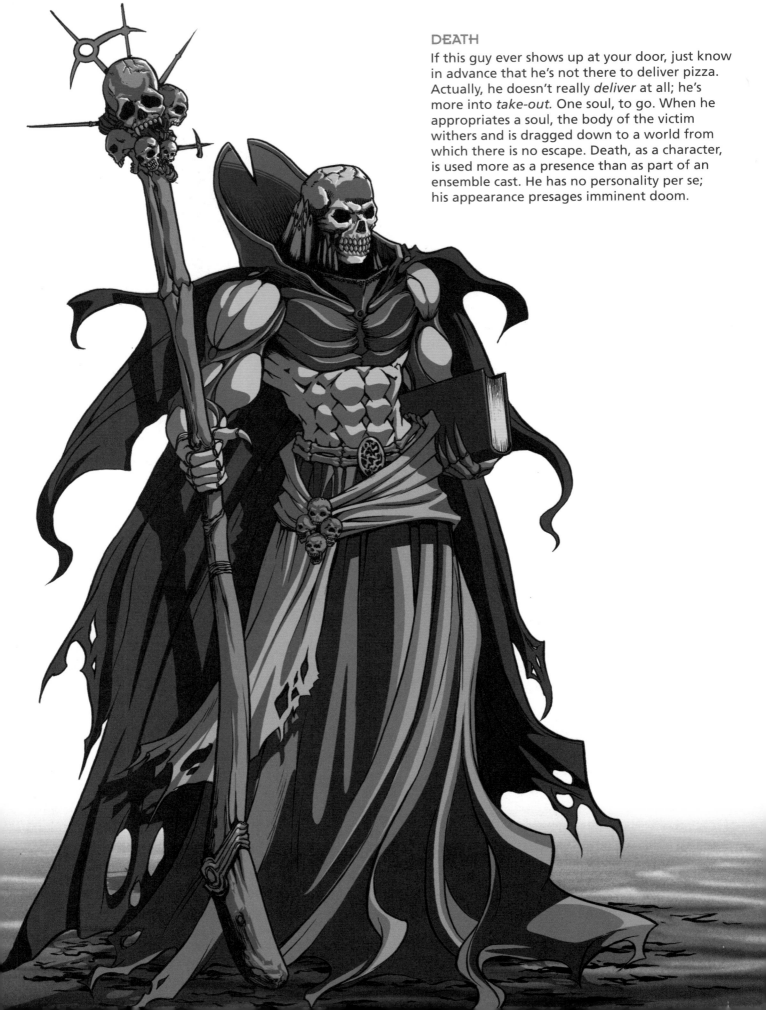

DEATH

If this guy ever shows up at your door, just know in advance that he's not there to deliver pizza. Actually, he doesn't really *deliver* at all; he's more into *take-out*. One soul, to go. When he appropriates a soul, the body of the victim withers and is dragged down to a world from which there is no escape. Death, as a character, is used more as a presence than as part of an ensemble cast. He has no personality per se; his appearance presages imminent doom.

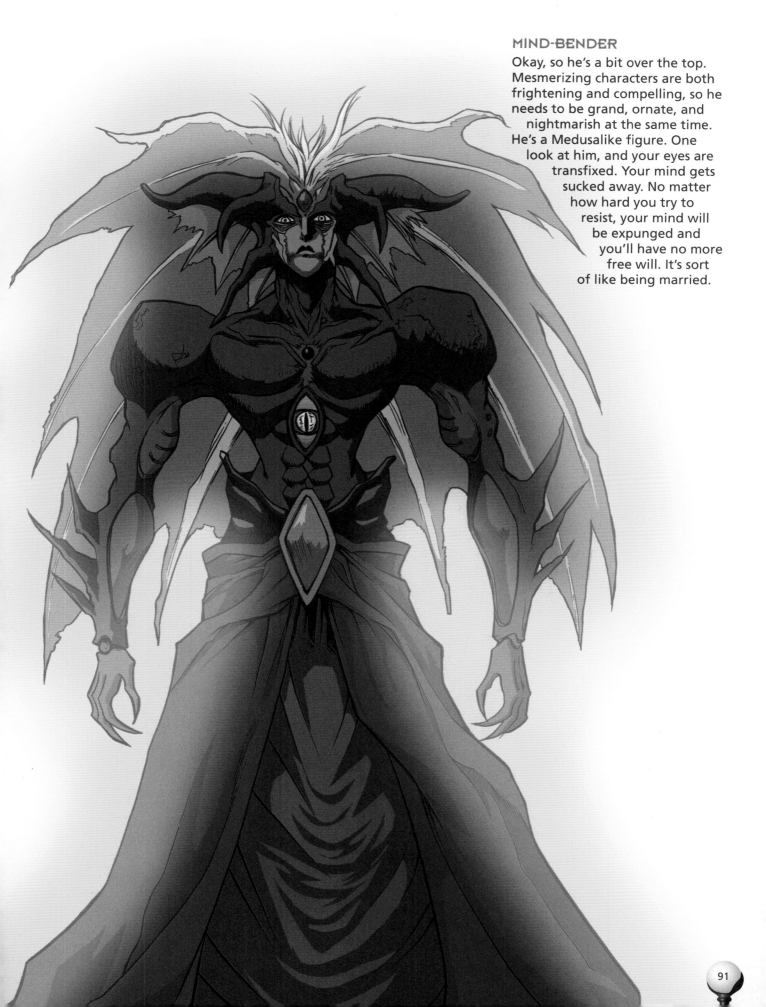

MIND-BENDER

Okay, so he's a bit over the top. Mesmerizing characters are both frightening and compelling, so he needs to be grand, ornate, and nightmarish at the same time. He's a Medusalike figure. One look at him, and your eyes are transfixed. Your mind gets sucked away. No matter how hard you try to resist, your mind will be expunged and you'll have no more free will. It's sort of like being married.

Anthropomorphism: Animals as Humans

The beasts of manhwa are shockingly oversized and chillingly destructive. Yet, they're drawn with a graceful and gothic quality that makes them into almost poetic figures. Since they're so cool and so intense, I had to include them in this book. What kind of an author would I be if I didn't?

A popular category of beast is the anthropomorphized animal. Anthropomorphism is the attribution of human characteristics to that which is not human; simply put in terms of animals, the animal takes on human traits.

However, instead of beginning with a human form and then adding animal traits (as you'd see in Western comics and mutants), manhwa artists create beasts by using a kind of *reverse* anthropomorphism, starting off with an animal and adding human traits. So, manhwa beasts are basically animal, not human. These strange but deadly creatures fascinate Korean readers and make great characters.

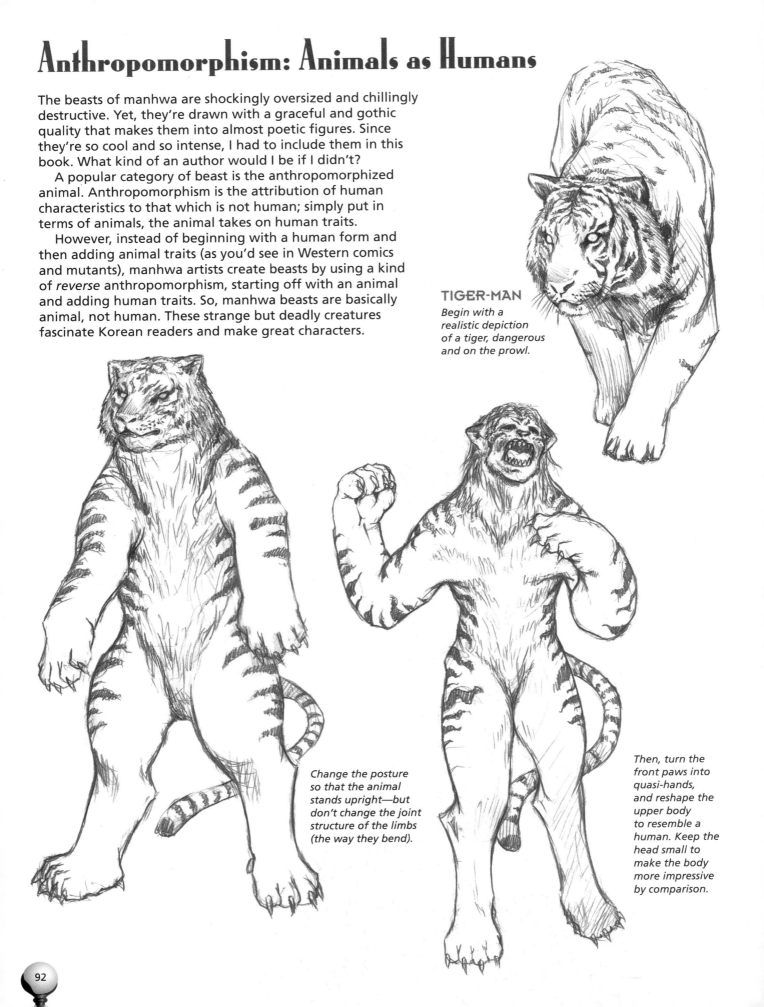

TIGER-MAN
Begin with a realistic depiction of a tiger, dangerous and on the prowl.

Change the posture so that the animal stands upright—but don't change the joint structure of the limbs (the way they bend).

Then, turn the front paws into quasi-hands, and reshape the upper body to resemble a human. Keep the head small to make the body more impressive by comparison.

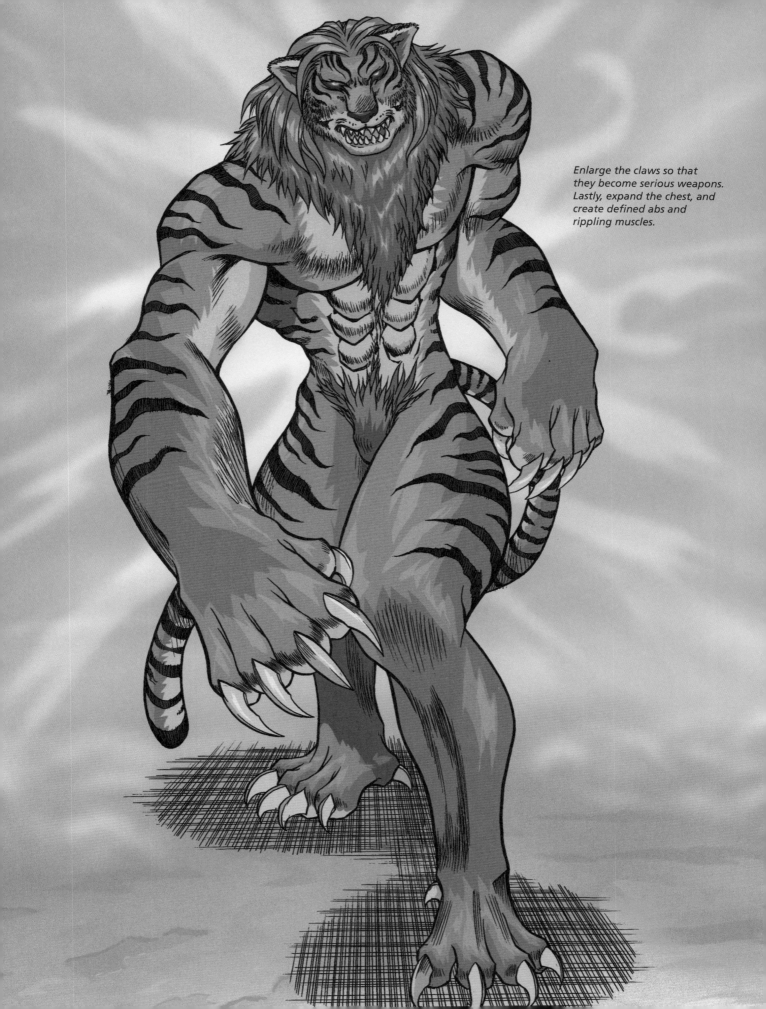

Enlarge the claws so that they become serious weapons. Lastly, expand the chest, and create defined abs and rippling muscles.

WOLF-WOMAN

With her looks, I doubt her Saturday nights are all booked up. It's just as well. She'd probably just kill her date and eat him anyway. Beasts derived from wolves have copious quantities of fur covering most, if not all, of their bodies. This prevents them from looking too human.

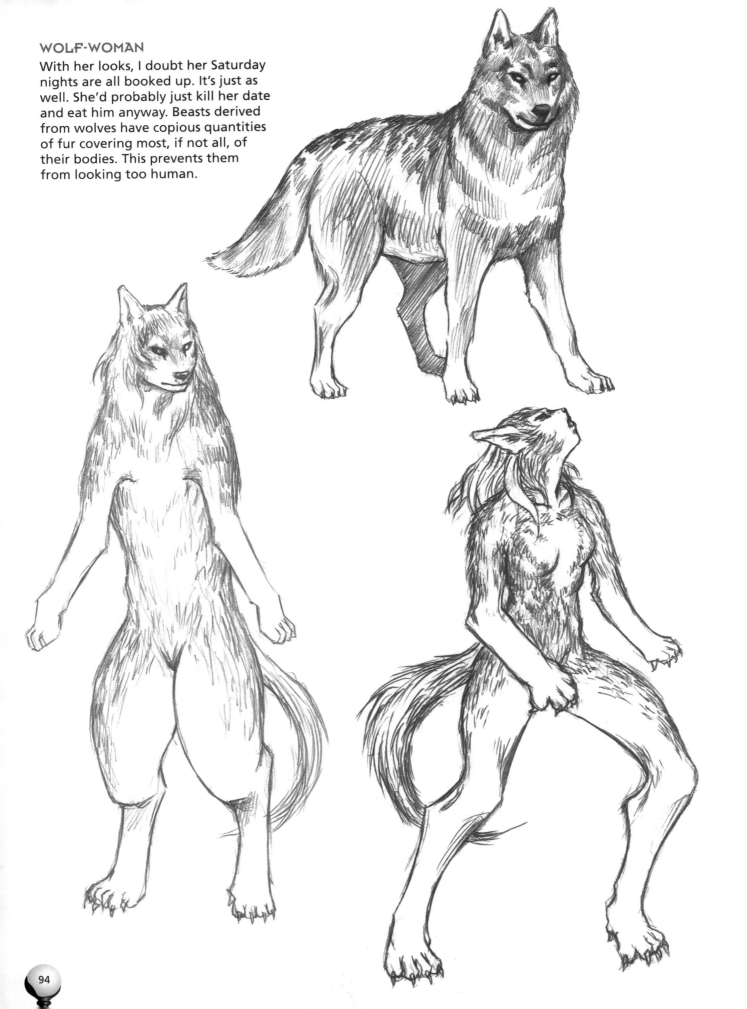

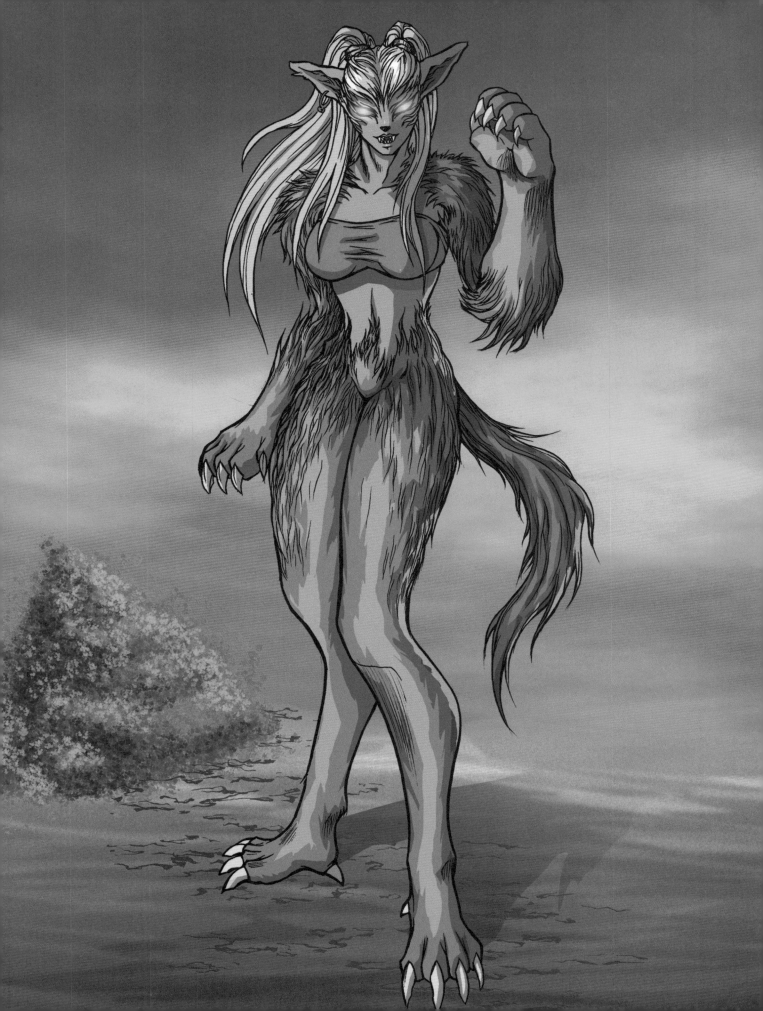

INSECT-MAN

If you get too many of these guys, you'll have to spray. Insect-based hybrids are among the most powerful and deadly of the anthropomorphized creatures. Insects are known for being incredibly strong for their size, capable of carrying many times their own bodyweight. But how impressive is it, really, to see an ant carry a breadcrumb five times its size? This ability becomes very dramatic, however, when the insect is twelve feet tall, and starts flinging cars and trucks.

The insect-man exterior takes on the look of heavy armor plates. The back/shoulder region is huge and rises well above the head, like a giant shoulder guard. The neck should not be visible—that's a rule for all brutish creatures. Don't forget the pincers and those small spikes off the shoulders and knees. Yuck!

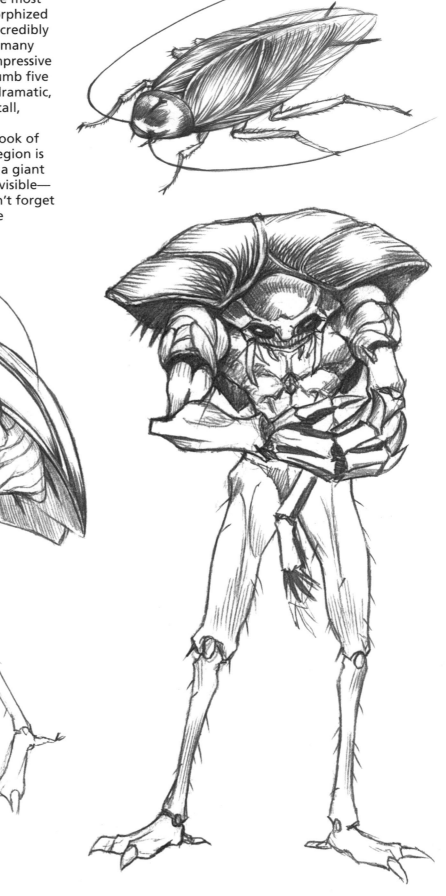

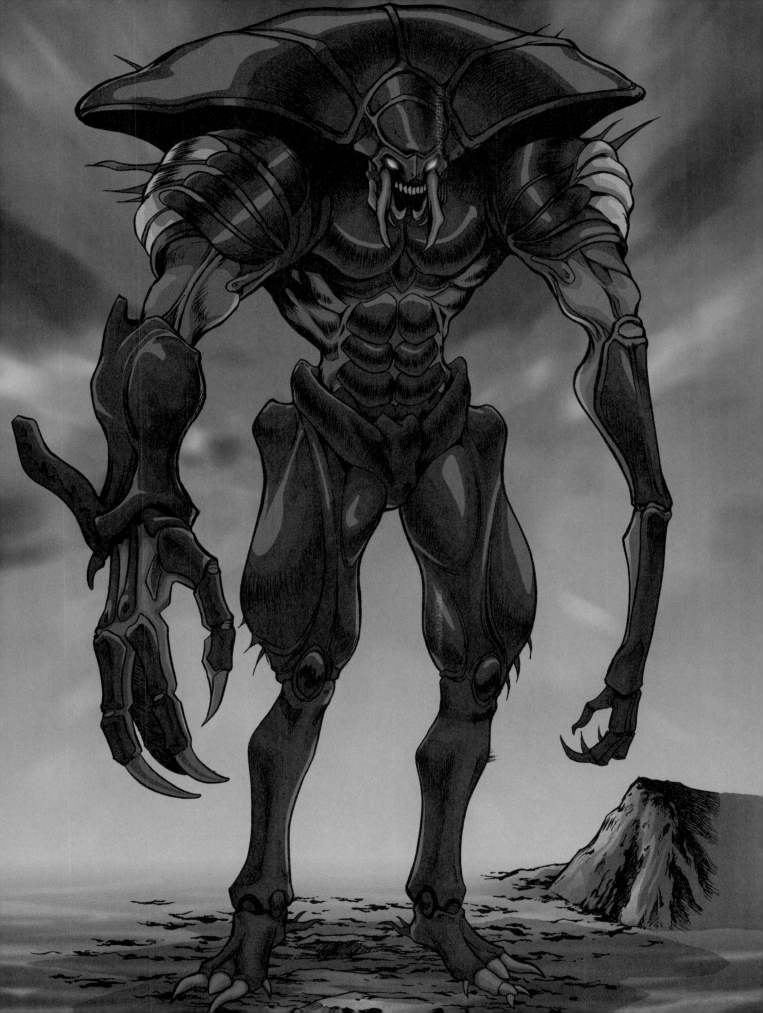

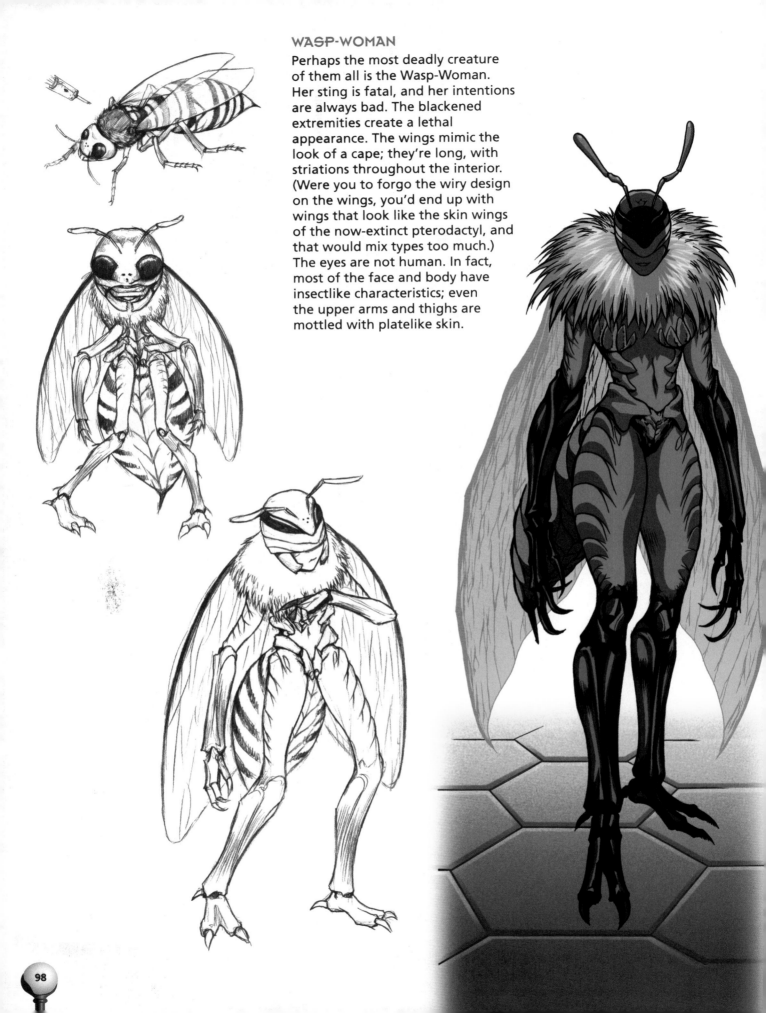

WASP-WOMAN

Perhaps the most deadly creature of them all is the Wasp-Woman. Her sting is fatal, and her intentions are always bad. The blackened extremities create a lethal appearance. The wings mimic the look of a cape; they're long, with striations throughout the interior. (Were you to forgo the wiry design on the wings, you'd end up with wings that look like the skin wings of the now-extinct pterodactyl, and that would mix types too much.) The eyes are not human. In fact, most of the face and body have insectlike characteristics; even the upper arms and thighs are mottled with platelike skin.

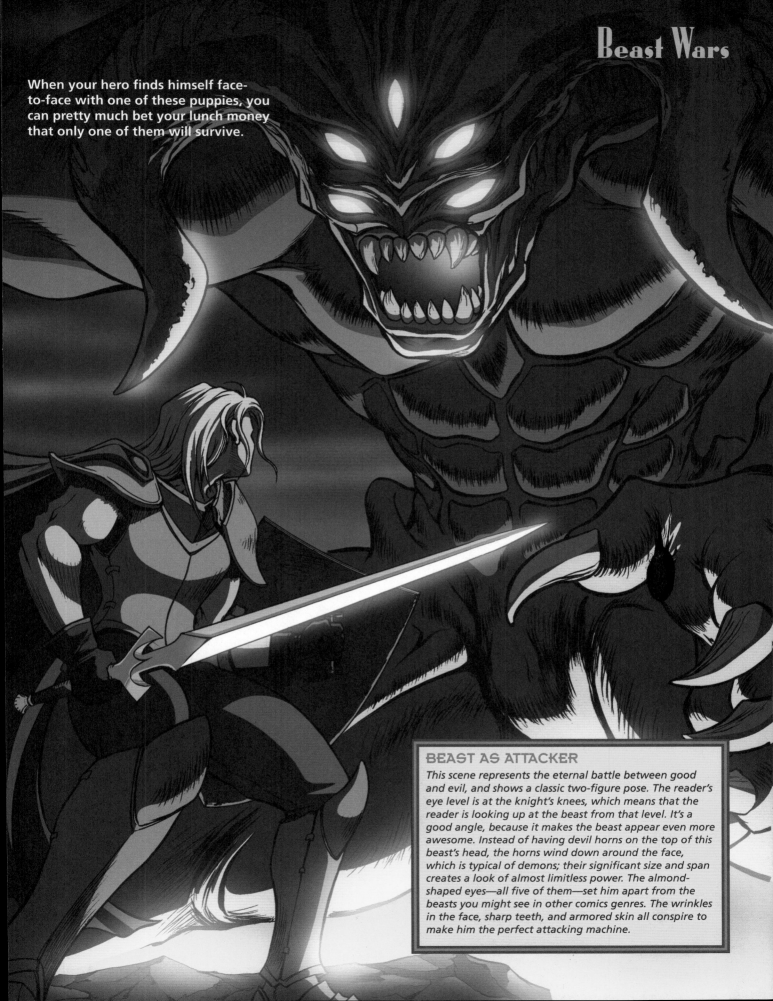

When your hero finds himself face-to-face with one of these puppies, you can pretty much bet your lunch money that only one of them will survive.

BEAST AS ATTACKER

This scene represents the eternal battle between good and evil, and shows a classic two-figure pose. The reader's eye level is at the knight's knees, which means that the reader is looking up at the beast from that level. It's a good angle, because it makes the beast appear even more awesome. Instead of having devil horns on the top of this beast's head, the horns wind down around the face, which is typical of demons; their significant size and span creates a look of almost limitless power. The almond-shaped eyes—all five of them—set him apart from the beasts you might see in other comics genres. The wrinkles in the face, sharp teeth, and armored skin all conspire to make him the perfect attacking machine.

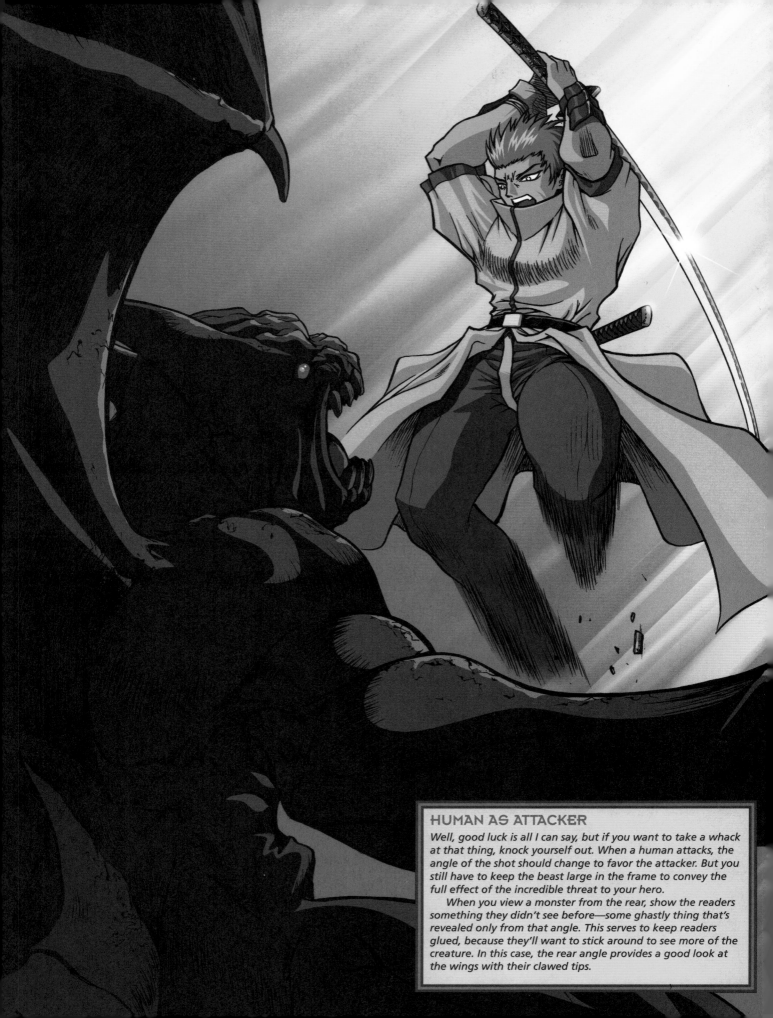

HUMAN AS ATTACKER

Well, good luck is all I can say, but if you want to take a whack at that thing, knock yourself out. When a human attacks, the angle of the shot should change to favor the attacker. But you still have to keep the beast large in the frame to convey the full effect of the incredible threat to your hero.

When you view a monster from the rear, show the readers something they didn't see before—some ghastly thing that's revealed only from that angle. This serves to keep readers glued, because they'll want to stick around to see more of the creature. In this case, the rear angle provides a good look at the wings with their clawed tips.

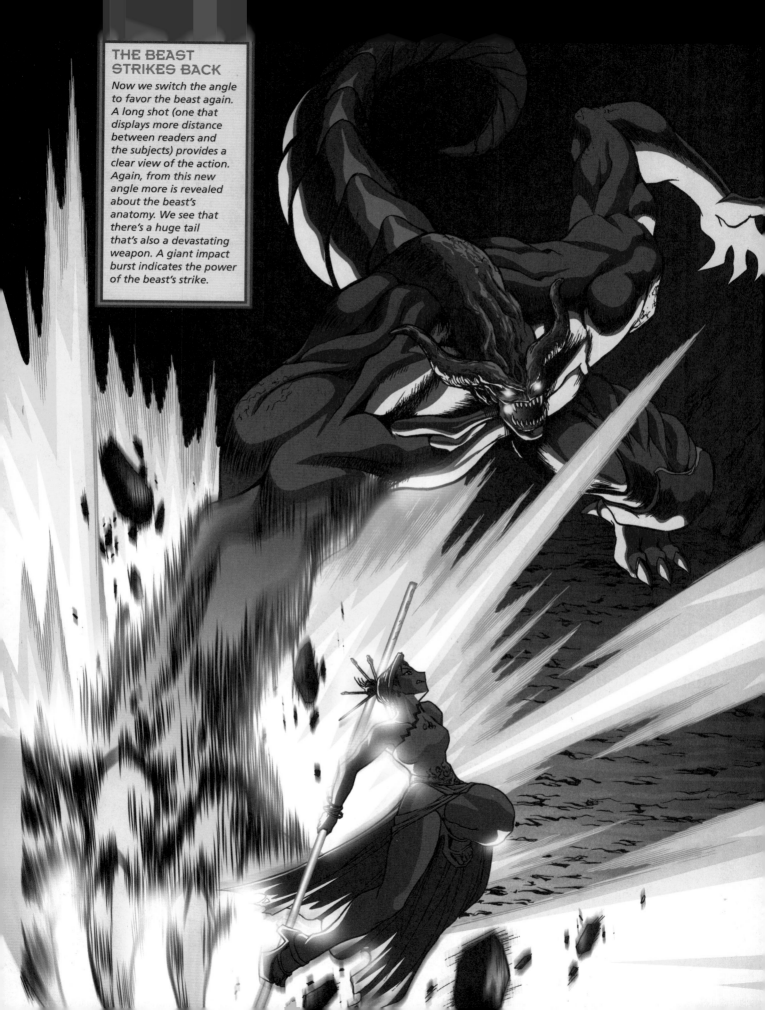

THE BEAST STRIKES BACK

Now we switch the angle to favor the beast again. A long shot (one that displays more distance between readers and the subjects) provides a clear view of the action. Again, from this new angle more is revealed about the beast's anatomy. We see that there's a huge tail that's also a devastating weapon. A giant impact burst indicates the power of the beast's strike.

DESIGNING THE COMIC BOOK PAGE

The principles involved in comic book layout and design are really just common sense. But these common-sense techniques are effective at directing your reader's attention. Does that mean you're trying to manipulate readers? Absolutely! You want to create specific emotions in your readers. You want them to feel the suspense as you build to a mega–fight scene. You want to focus attention on the important elements within a panel and not distract your readers. And you want to keep the eye moving effortlessly from panel to panel. Successful panel and page design allows you to build scenes to a crescendo.

A common mistake beginners make is to draw every character in full figure. They think this gives the characters more value, when actually, it gives them less. You need to come in close for head shots in order to show a character's emotions and to vary the rhythm of the scene. Nothing is so dull as a page of full-body shots. In addition, how is your character going to make a connection with readers if the readers are never close enough to get a clear look at the character's eyes? On the other hand, seeing too many head shots also becomes tedious. For this reason, it's best to mix up the angles.

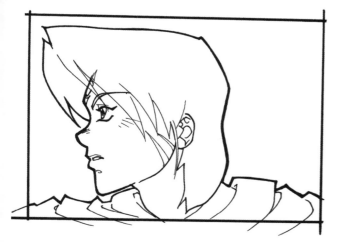

WRONG WAY

The face is pushed too close to the panel and looks cramped. You always want to leave more room in front of the face in the direction the character is looking. This guy is too close to the panel's left border.

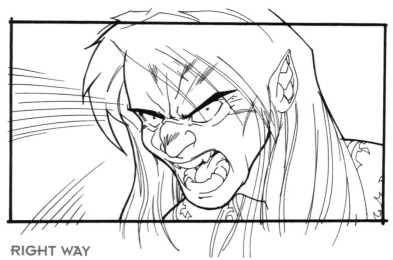

RIGHT WAY

Ah, this looks better. Now the image breathes a little better. The character is in the middle of the panel with a comfortable amount of room on either side of his head.

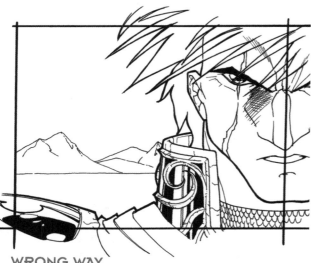

WRONG WAY

Big mistake! Don't split the head down the middle. It robs the expression of its power. There are better ways to create a mysterious effect: the face can be half covered in shadow, hooded, or partially masked by wild hair.

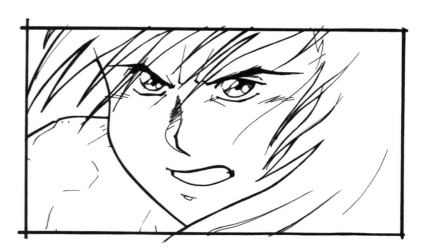

RIGHT WAY

Here's a better tight close-up. Tight close-ups require you to crop the character on the top and bottom.

Medium Shots

Medium shots generally focus on the character from the waist up. Use them when you want to establish a connection between your reader and a character but you don't want to stop the action with a close-up. (For all its impact, a close-up eliminates the background and all other characters in the scene. It halts the action to punctuate a character's state of mind. Sometimes that's important, but if you need to keep the action going, choose the medium shot.)

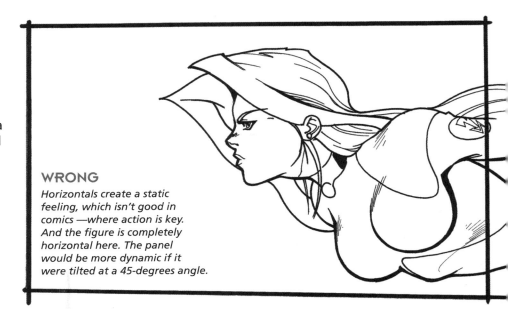

WRONG

Horizontals create a static feeling, which isn't good in comics —where action is key. And the figure is completely horizontal here. The panel would be more dynamic if it were tilted at a 45-degrees angle.

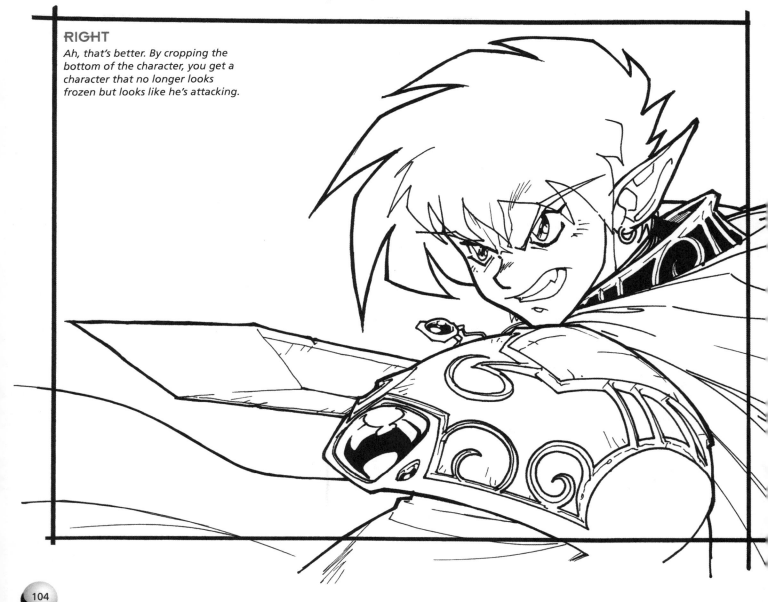

RIGHT

Ah, that's better. By cropping the bottom of the character, you get a character that no longer looks frozen but looks like he's attacking.

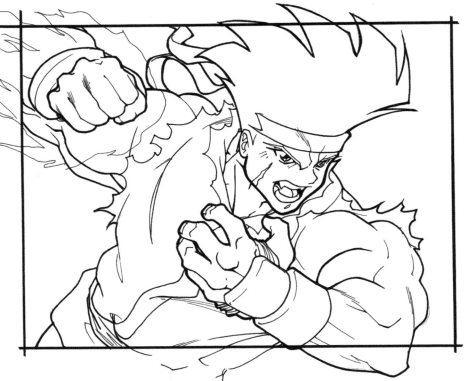

WRONG

This character practically touches all four corners of the panel with some part of his body. This is a comic book no-no. It boxes in the character. Each time characters touch a panel, it saps their appearance of strength. In addition, because this guy takes up so much room within the panel, his pose doesn't convey the feeling of motion. He looks frozen in time. The panel actually needs more empty space to appear dynamic!

RIGHT

The character only touches two of the four panel corners. His head and shoulders have ample room to breathe. The outline of the character is roughly a pyramid shape, which directs the reader's eye up to the character's face. This is an effective medium shot.

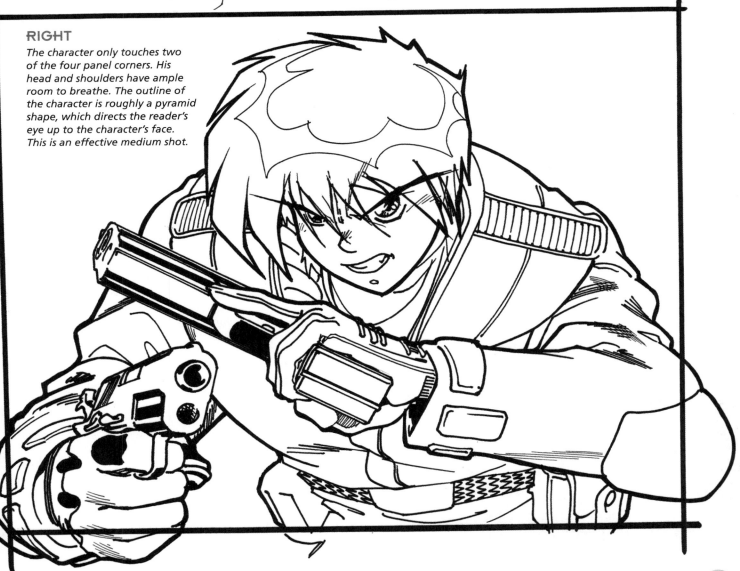

Full-Body Shots

Full-body shots are called for when the pose would lose its power if it were cut off by the panel borders. In these cases, medium shots, which cut out the legs, won't work. And with close-ups, you'd lose the arms and legs, too. When the entire body needs to convey an attitude, the full-body shot is the best choice.

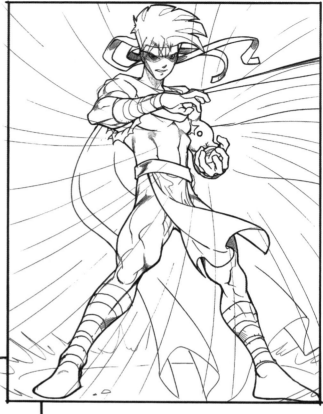

WRONG

The pose is certainly dynamic enough, so what's wrong with it? The feet and head are much too close to the panel borders. The panel is an imaginary border, but when your character looks as if he's standing on the panel line below him (or as if his head is touching the panel line above him), the panel lines become the floor (and ceiling), which is something you want to avoid. If this ever happens to one of your drawings, you can try enlarging the panel. But, if you've already laid out the comic book page, you might not be able to enlarge the panel without destroying adjacent ones. The best approach is to make a point of plotting out your drawings in advance, adjusting your character's size within the panel at the rough stage—before you're locked in to your drawing and reluctant to make the necessary changes.

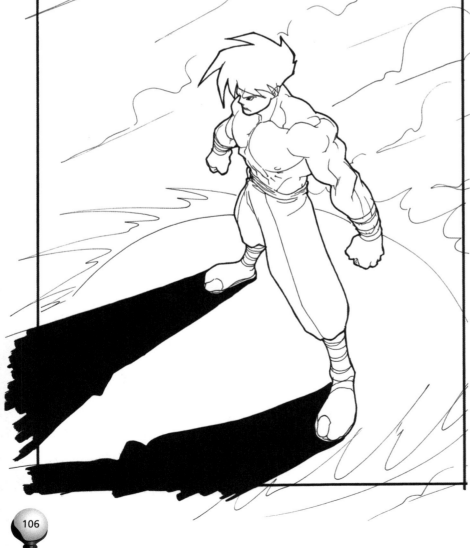

RIGHT

This figure falls completely within the panel lines. The fit is comfortable, and the pose is strong.

WRONG

Oops. A perfectly good picture falls prey once more to the villainous tangent. What's that foot doing touching the bottom panel border? Is that the ground? No, but it might look like that to some readers. If you want to draw the ground, then draw the ground, but the panel border isn't it.

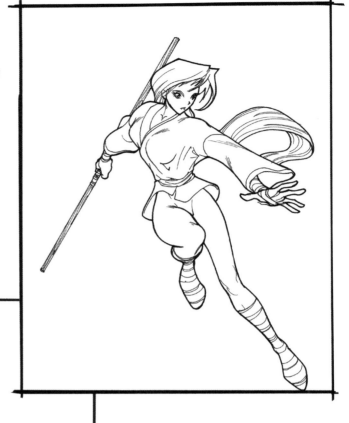

RIGHT

Better. Instead of showing her standing on the bottom of the panel, the artist placed a rock underneath her feet. It's a simple addition, but look at how much more dramatic it is.

Establishing Shots

An establishing shot does just what its name says: it establishes where everything is in an environment or scene. And, since you can't see where everything is unless you have some distance from the scene, establishing shots are always long shots. They're used at four different times: (1) to open a scene, (2) to close a scene, (3) to reestablish the surroundings during a scene, and (4) to add variety to the pacing.

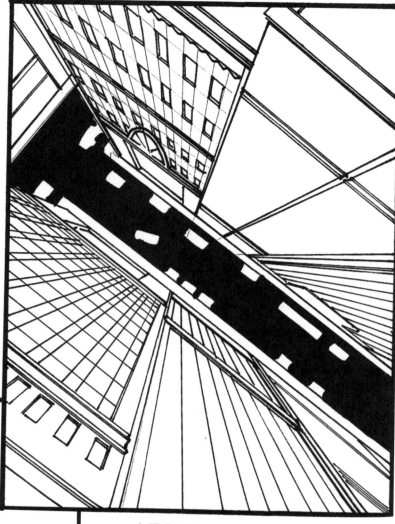

WRONG

This bird's-eye view of the street doesn't do much to introduce the scene. If you were to cut in closer to a driver in a car in the next shot, you still wouldn't get a sense of the street or environment. What you really need is an establishing shot that shows the street, sidewalk, storefronts, and pedestrians—all in a single panel.

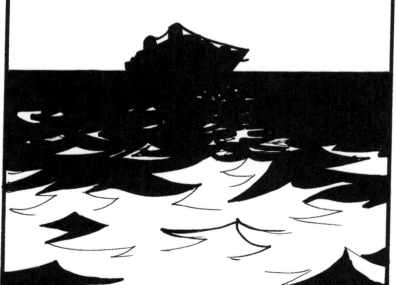

WRONG

Silhouettes make weak establishing shots because they don't show enough. If you can't see what's going on, it doesn't establish much. Also, this shot is so long that you'd have to cut in to a second, closer establishing shot before cutting in yet again to see any action taking place on the ship.

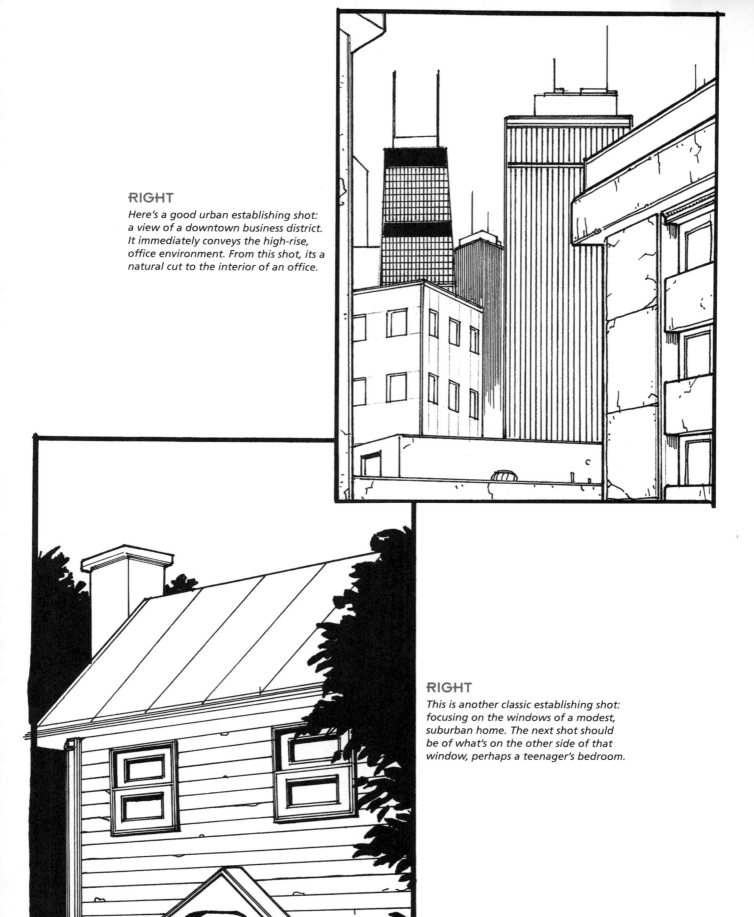

RIGHT

Here's a good urban establishing shot: a view of a downtown business district. It immediately conveys the high-rise, office environment. From this shot, its a natural cut to the interior of an office.

RIGHT

This is another classic establishing shot: focusing on the windows of a modest, suburban home. The next shot should be of what's on the other side of that window, perhaps a teenager's bedroom.

General Dos and Don'ts

Here are a few more tips to put in your arsenal of art techniques.

DO

tilt a scene to look like it's leaning toward the center of the page.

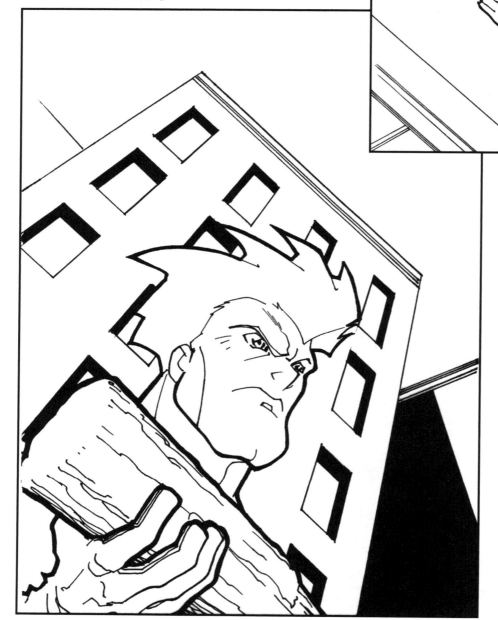

DON'T

tilt the panel so much that the character looks like she's going to fall out of the frame.

DON'T
cut off figures at odd places.

DO
use interesting high and low angles.

Panel Sequencing: Three Approaches

The same story can be drawn many different ways. As an artist, it's up to you to read, and reread, each script in order to decide on an approach that most effectively tells the story. Perhaps the story is crying out to be an actionfest. Maybe it doesn't need action at all, but suspense and mood. You must analyze the scene in a calculated way, building to the high points in the story and milking the dramatic moments. And even armed with all the right techniques, most of your storytelling decisions must come from inspiration. Visualize the scene several different ways, then ask yourself, Which way would *I* like to see it, if I were buying this comic to enjoy for myself?

STANDARD APPROACH (PAGE 113)

The tried-and-true method is in use here: The first shot establishes the scene with the boy in the forest. The second panel cuts in closer (with a close-up shot) as he reacts to the danger. This sets up the next shot as readers wonder what he's reacting to. The next panel pulls back to reveal the monster in the frame with him—very big by comparison. *Reveals* like this panel are effective techniques to introduce dramatic elements. We then go to a tight medium shot of the boy as he pulls out his weapon. This works because you want the shot to be wide enough to show what the boy's doing; you don't want a full shot, because you don't want to lose the intensity. The last panel on the page is a tense *two-shot* (a shot showing two characters). It's a cliffhanger— you've got readers where you want them: they have to turn the page to find out what happens next.

ATMOSPHERIC APPROACH (PAGE 114)

Shadows, silhouettes, and extreme angles are used to create tension. The action is implied. Emotions and suspense are heightened. The anticipation of the moment is stretched to the breaking point. This is a very cool approach—and is for slightly more mature readers, who won't lose patience if there isn't constant action.

ACTION APPROACH (PAGE 115)

In the previous two approaches, it takes a page to build up to the battle, which doesn't even take place yet at that point. With the action approach, however, the characters go at it right away. This works best if the villain isn't a fully realized character but just an obstacle to be overcome, for example, a demon guarding the forest. (On the other hand, if the demon is a recurring character that was introduced earlier in the story, he should have more stature and would deserve more of a build-up to the fight.)

You might also choose the action approach because, quite simply, you have a character that's very dynamic in fighting scenes and you want to let him (or her) shine at what he does best.

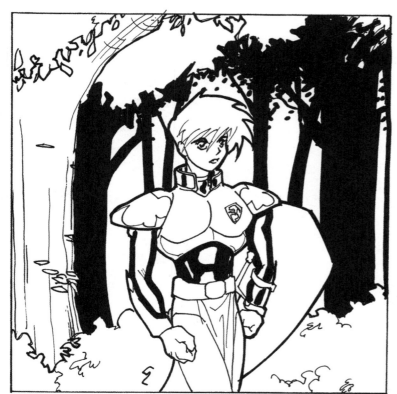

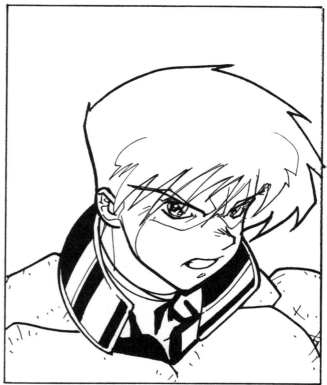

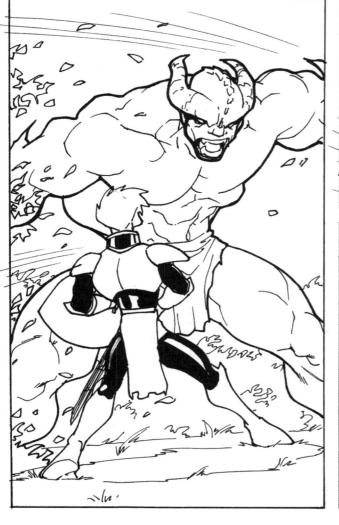

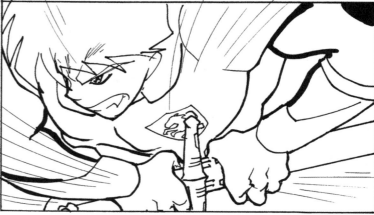

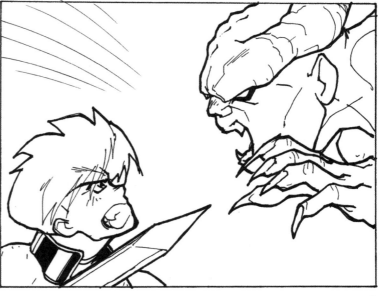

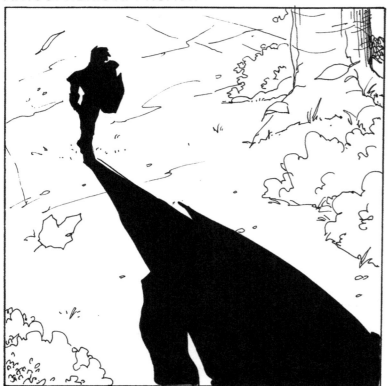
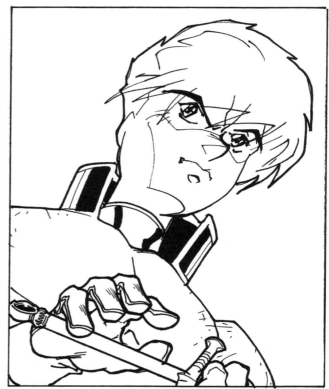
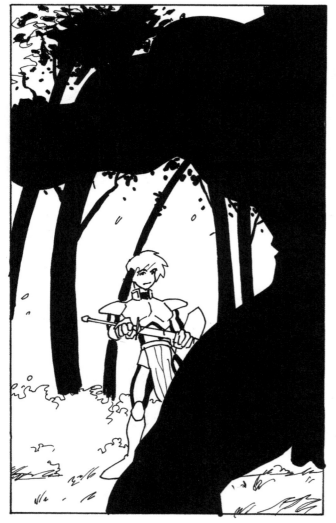

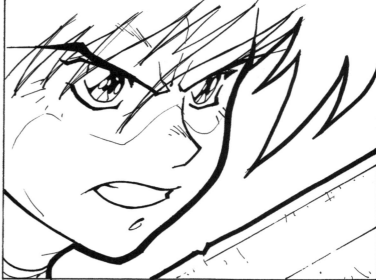

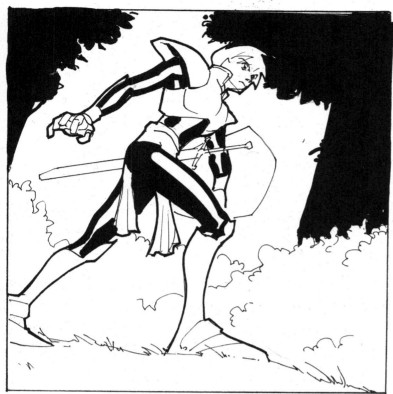

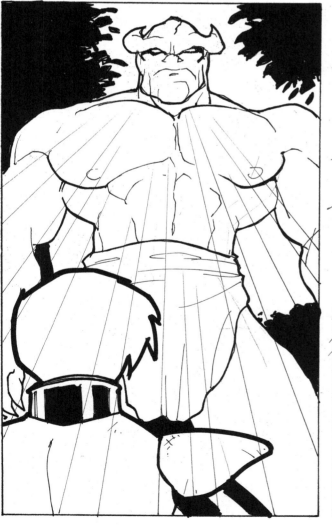

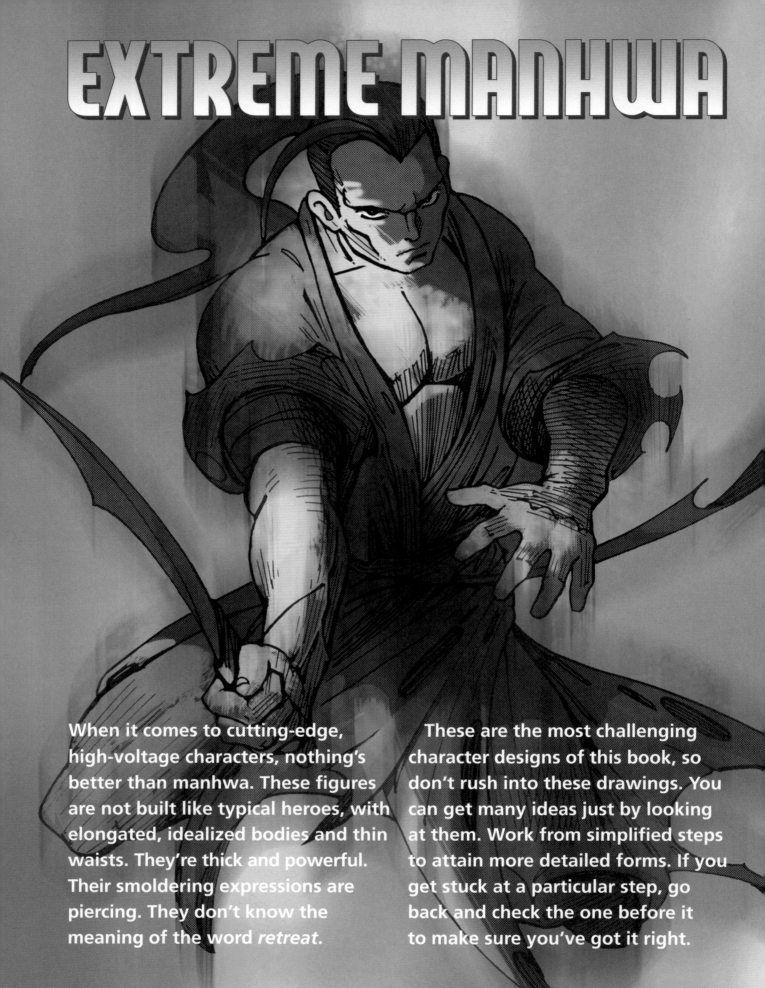

EXTREME MANHWA

When it comes to cutting-edge, high-voltage characters, nothing's better than manhwa. These figures are not built like typical heroes, with elongated, idealized bodies and thin waists. They're thick and powerful. Their smoldering expressions are piercing. They don't know the meaning of the word *retreat*.

These are the most challenging character designs of this book, so don't rush into these drawings. You can get many ideas just by looking at them. Work from simplified steps to attain more detailed forms. If you get stuck at a particular step, go back and check the one before it to make sure you've got it right.

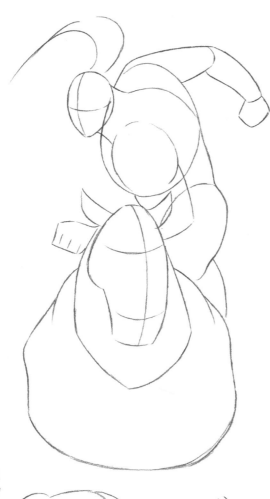

Warrior on Horseback

How do you create impact? You can make your characters big, and if that doesn't work, you can draw them bigger. But size alone won't make characters come alive. With the rider here, if you want him to be intimidating, in your face, and on the attack, you've got to put him in a highly dramatic pose. By twisting the upper body, the rider seems to coil back (see the far arm holding the weapon), ready to strike. In addition, this also results in a broad view of his back and shoulders, revealing his brutal musculature. The twisting also helps the figure lean forward in an aggressive posture, which would be much trickier to draw if he were facing the reader head on. *Note:* the horse must also be massive, so as to not be overpowered visually by the rider.

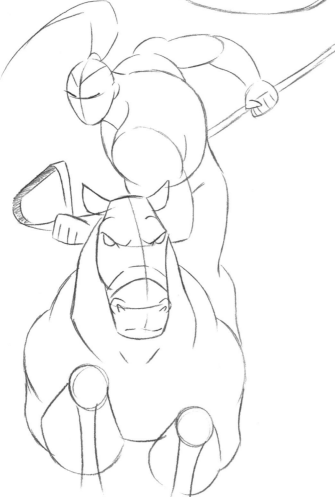

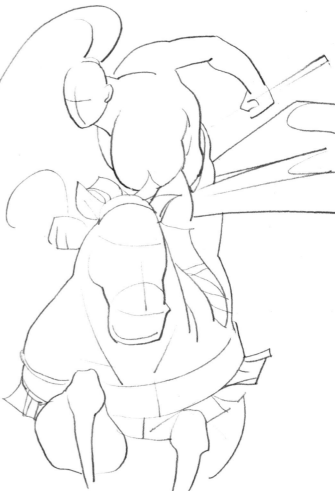

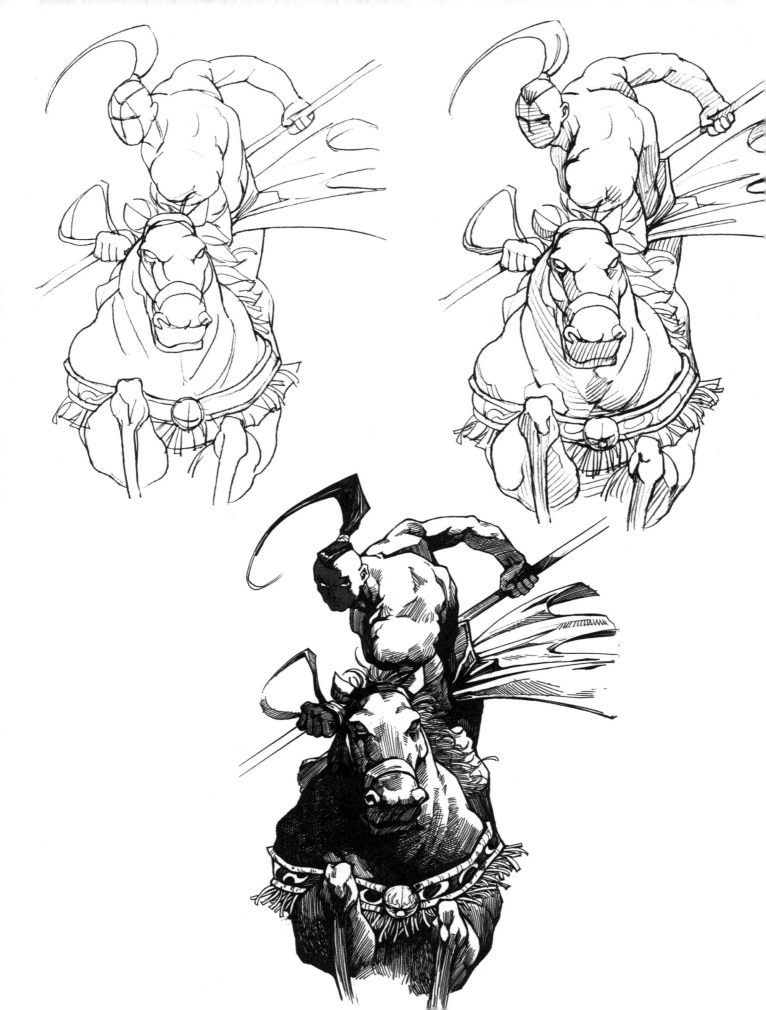

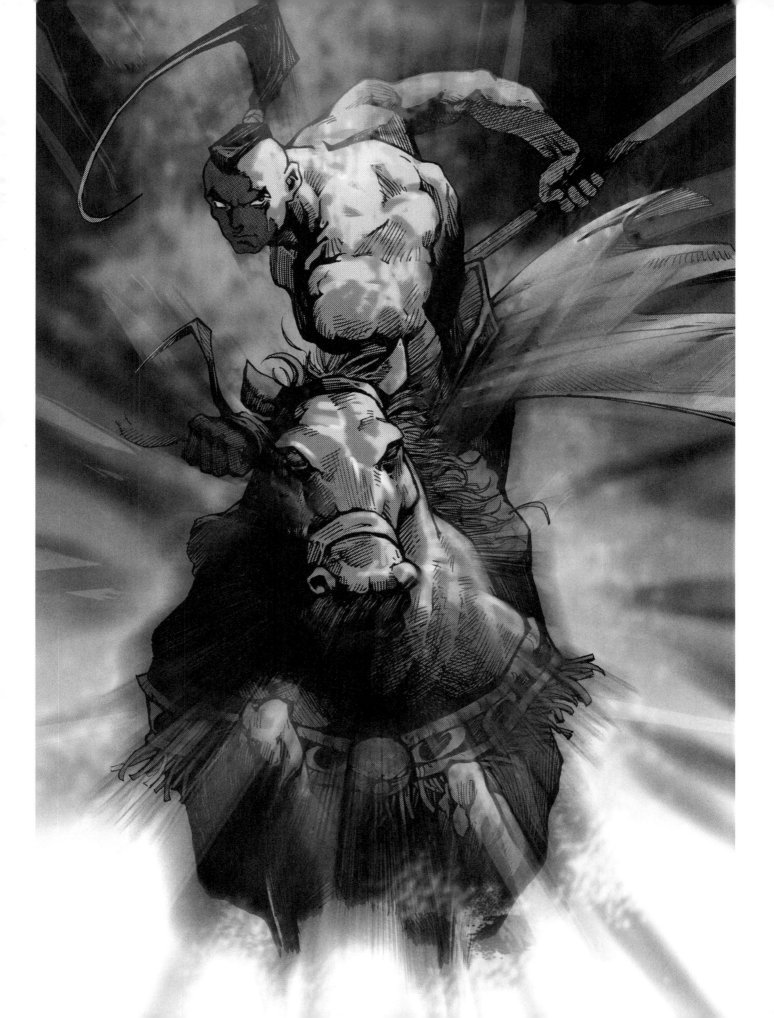

Traditional Fighter

Confident and steely-eyed, the traditional fighter is not to be messed with. If he doesn't have exact change, the bus driver lets him on anyway—*that's* how tough he is. The body armor is decidedly Asian, and has nothing in common with European armor of the Middle Ages. The uniform features layered shoulder guards, waist and hip guards, forearm and hand guards, and flaring pieces off the back. The sword is ever-present. Note the thickness of the neck, the chest, and the arms. The hair is usually tied in a topknot, with the ribbon trailing in the wind—a traditional martial arts look.

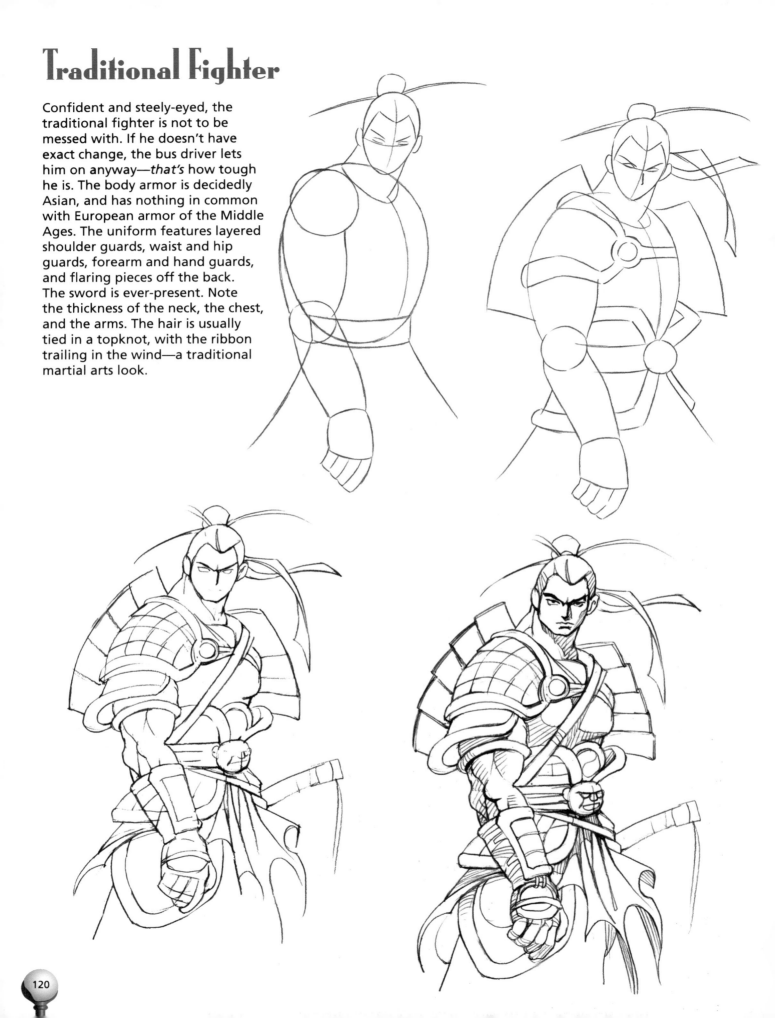

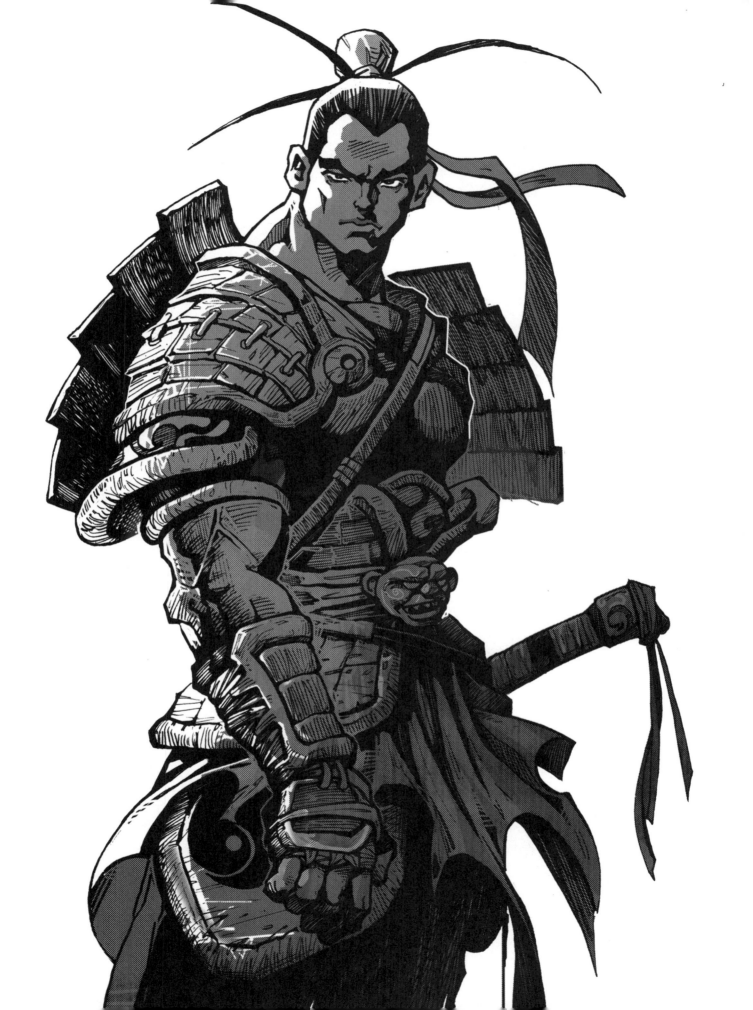

Loyal Warrior

The loyal warrior is an essential character in any story involving heavy action. He usually doesn't fight as part of a group. That's because he has traveled a little-known, dangerous path alone in his attempt to reach the enemy. He takes it upon himself to do this when his village has been decimated and his people have given up hope. And so, without any soldiers at his side, he ventures forth on a seemingly doomed mission, his country's last chance. But, bet on him.

Give him rugged good looks, a square chin, and a strong jawline. His hair should be short, which is typical for a good-guy character. He may start out the story wearing his entire outfit, but as the journey gets more harrowing—and he must fight off bandits, killers, and beasts along the way—he loses part of his uniform and goes shirtless.

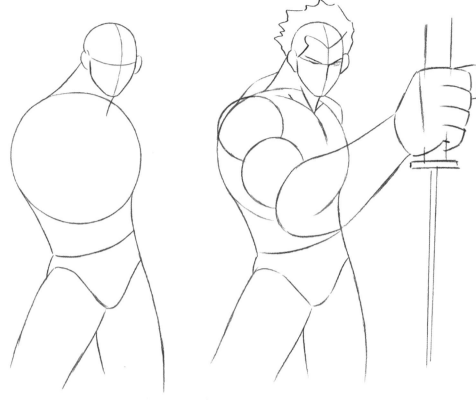

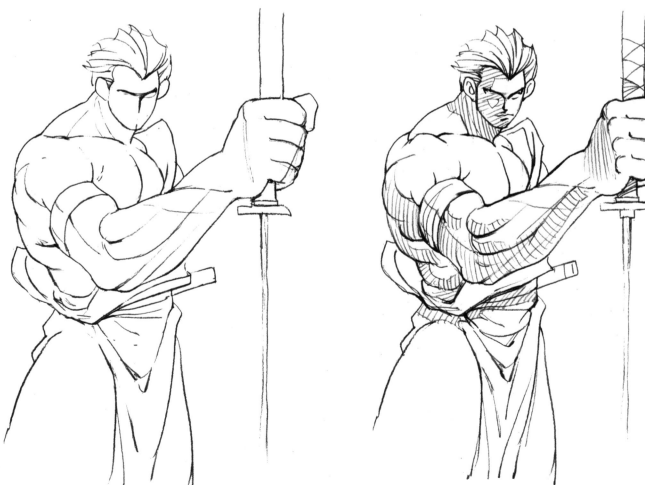

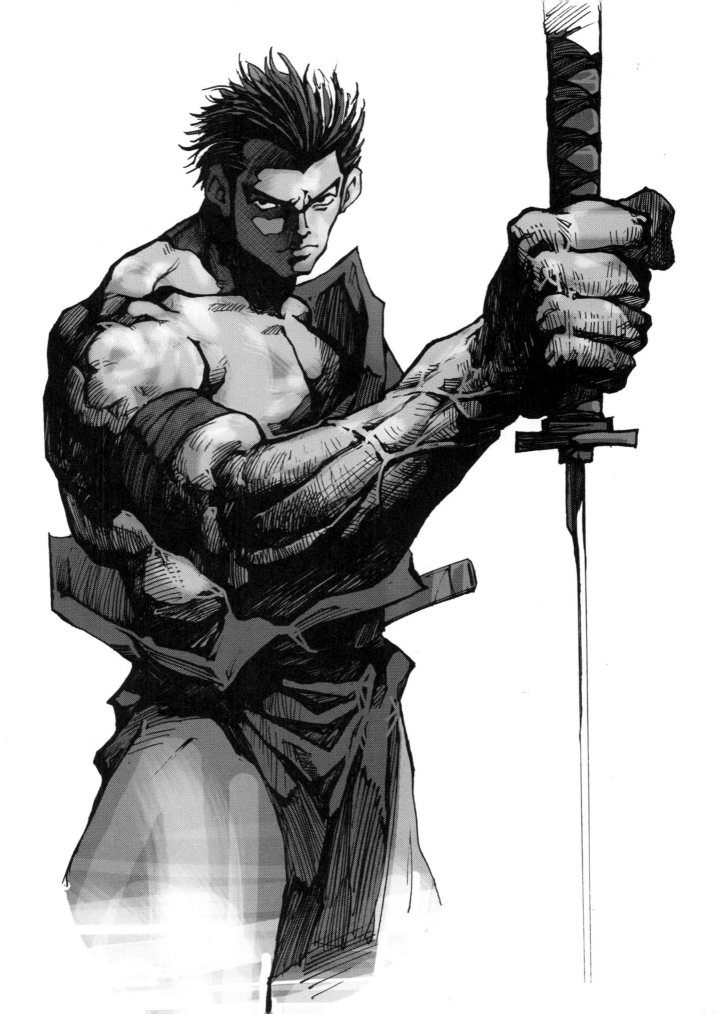

Master Blade Fighter

Martial arts weapons experts and mysterious assassins are always cloaked in secrecy. To guard his identity, only his eyes are visible. The poses are flamboyant. If you've ever seen a martial arts weaponry competition, it looks almost like a dance. This character is in the "ready" position, which he would assume either before attacking or after finishing off his opponent. Note the two scabbards behind his back that form a crisscross.

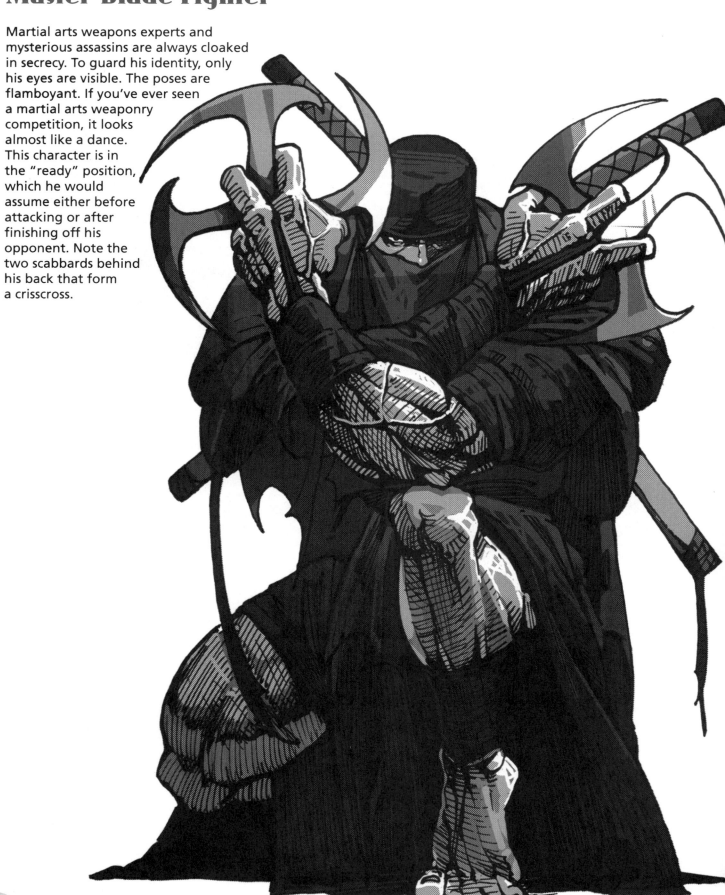

Tribal Chief

Mean, menacing, and prone to cruelty—no, I'm not talking about your gym teacher, I'm talking about manhwa's evil, tribal chief. He's not a happy camper, except when he's inflicting pain and misery on everyone under his control. How can you tell that this guy's the chief and not just a warrior? His clothes aren't tattered from combat, and he wears no armor and carries no weapons. He doesn't need to. He has soldiers to fight for him.

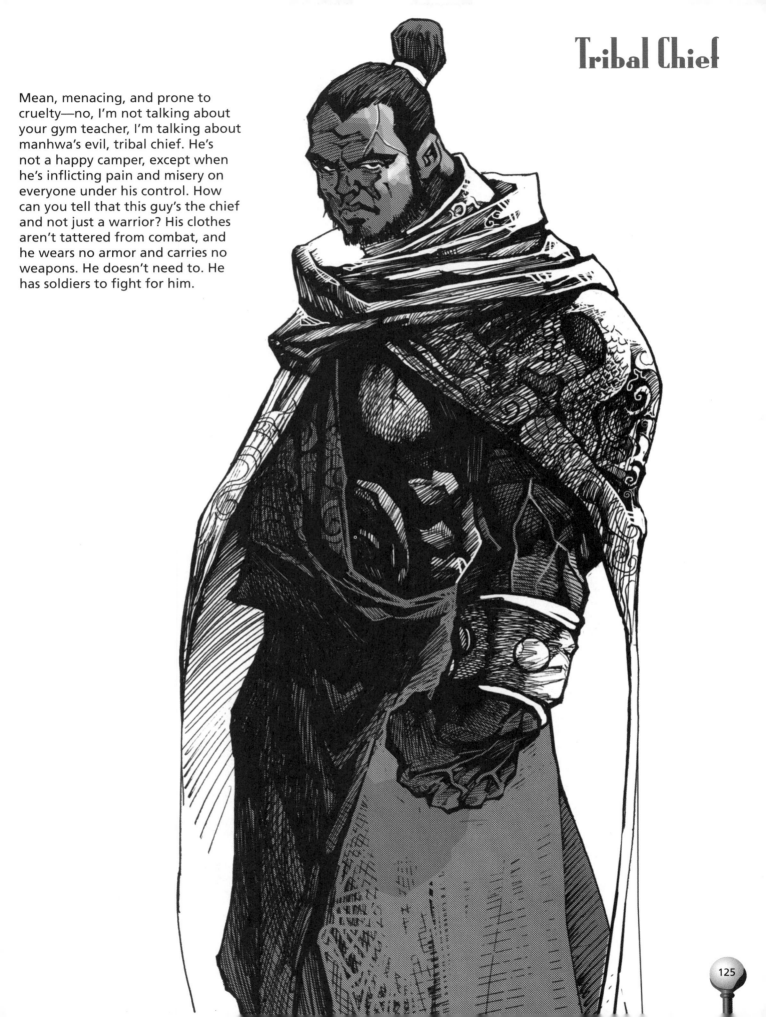

Rogue Fighter

Without a uniform to identify his country, class, or rank, he's a man alone. Think of him as a soldier of fortune. He has been through many battles and will fight many more. Each day may be his last. His clothes should be mangled, torn, and stitched together. He's not a shopper. His cape is, likewise, in tatters. He may have been someone of standing once, perhaps even a prince, but that was long ago in a different life. His well-groomed appearance—close-cropped hair, mustache, and goatee—suggest a ruling-class background.

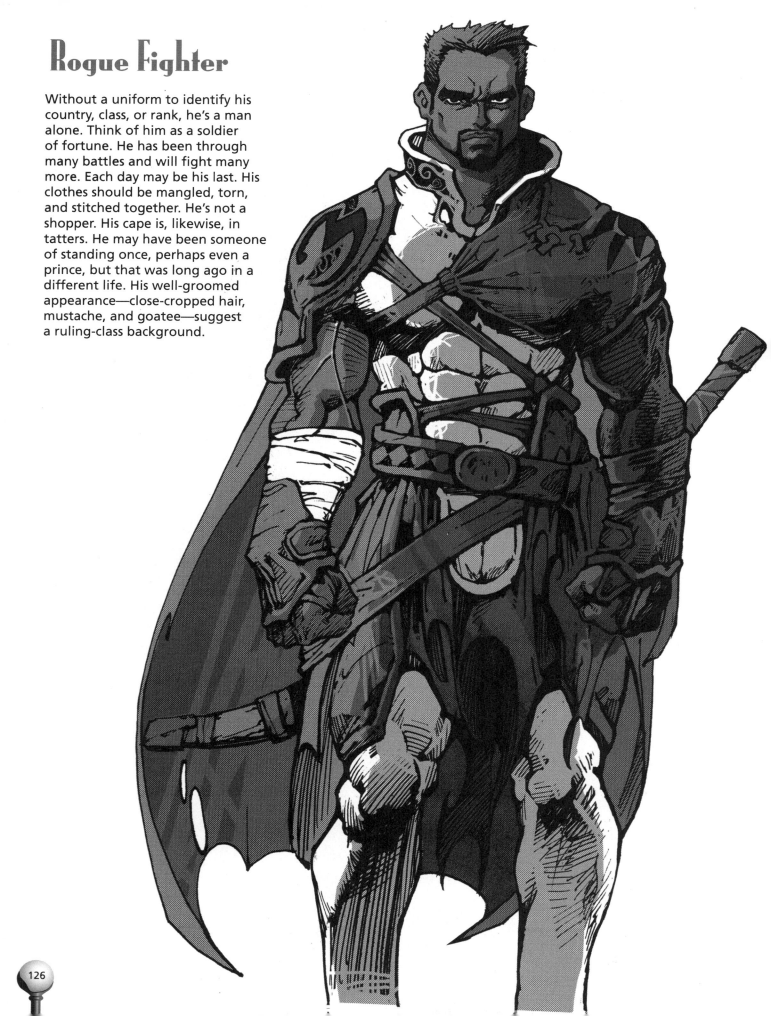

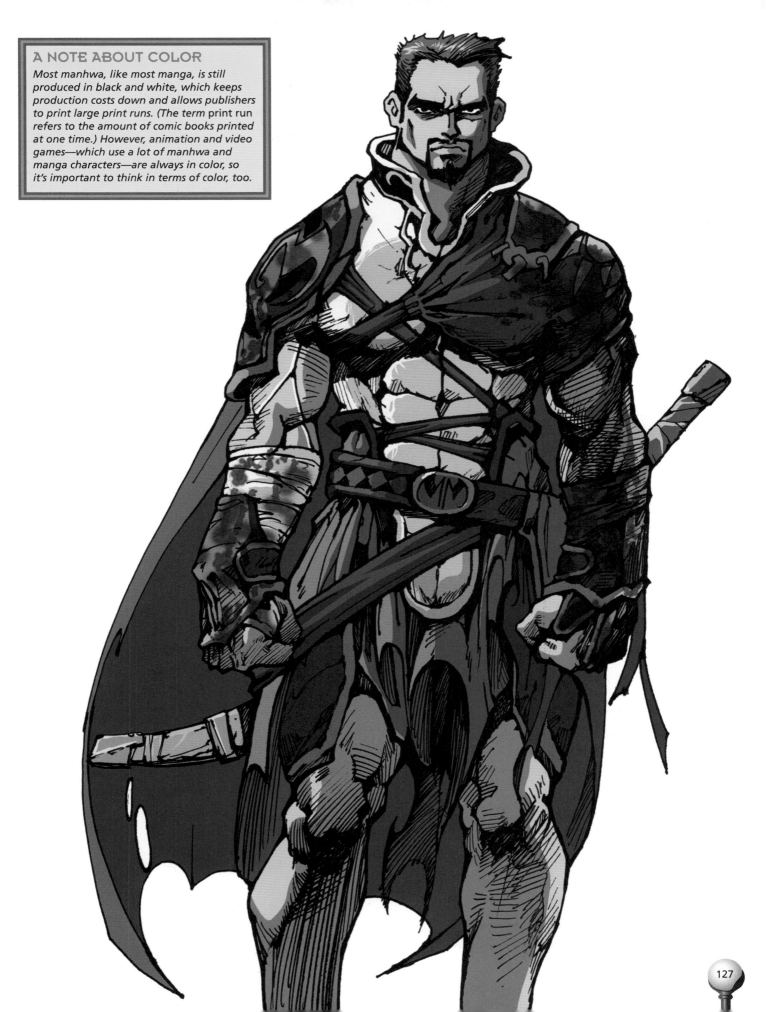

A NOTE ABOUT COLOR

Most manhwa, like most manga, is still produced in black and white, which keeps production costs down and allows publishers to print large print runs. (The term print run refers to the amount of comic books printed at one time.) However, animation and video games—which use a lot of manhwa and manga characters—are always in color, so it's important to think in terms of color, too.

Dark Overlord

Sinister in the extreme, the dark overlord is darkness incarnate. A character such as this typically rules not just over one province, but over a vast army and many conquered lands. Wherever he goes, darkness falls, and the human spirit is crushed. He's extremely thick and stocky, like the trunk of a redwood tree. The head is set low on the shoulders, with no visible neck. Although he has acquired—through his rampages—great fortune, he's not interested in pomp and circumstance; as his tattered and worn clothing clearly indicates, he would rather sleep in a mud hut and wage battle than preside over the land as a proper king.

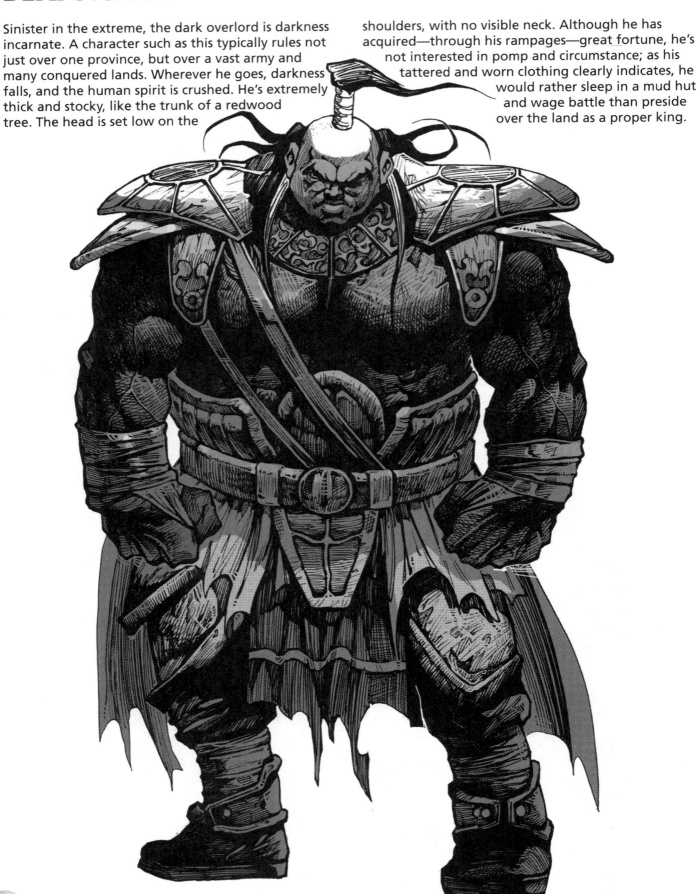

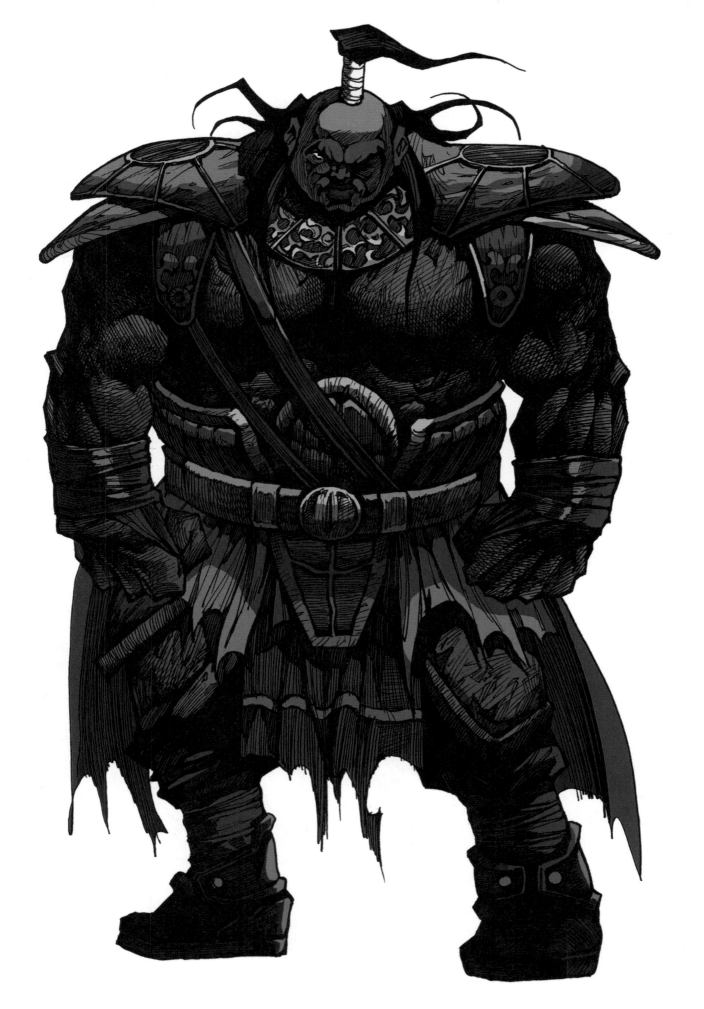

Young Warrior Villain

Any time you see a really big guy wearing face paint and carrying a blade longer than his body, it's usually a bad sign. The face paint lets us know that he's into ritualized killing. But hey, who am I to judge his culture? The piercing stare and tense, ruler-straight posture show that he's a hair trigger from blowing his stack. He's definitely a type A personality, and it won't make things better if you give him a hug—trust me on this.

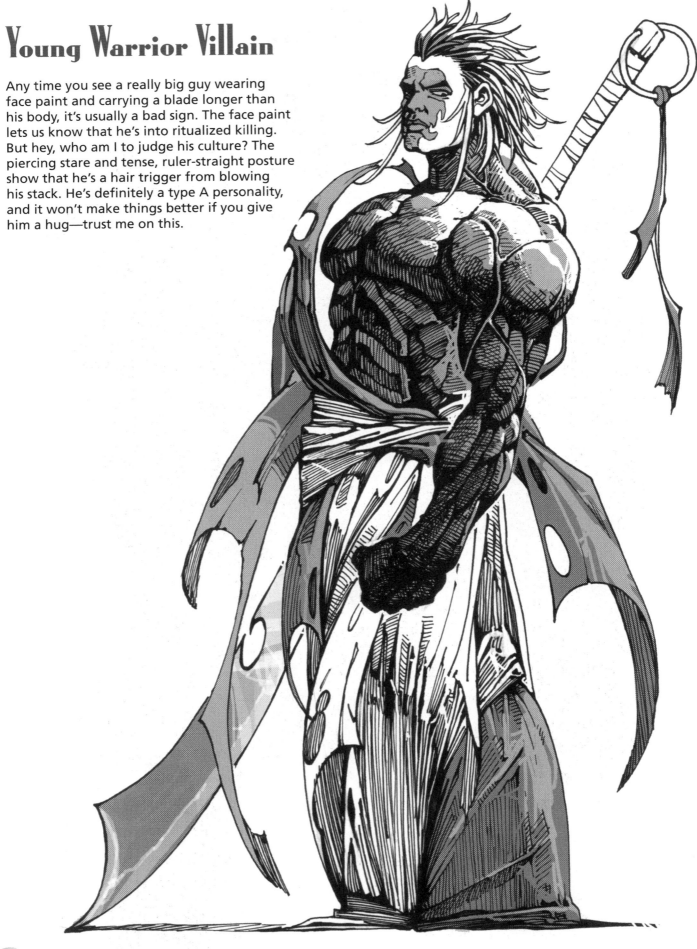

If you thought old meant some geezer reaching into a glass to retrieve his teeth, think again. Instead of extreme manhwa warriors growing old and frail, they fill out. They derive their power from strength and the magical forces they can summon—not from agility. The key to drawing a character like this is to give him a full head of white hair and a beard, in the style of an eccentric sea captain. His hairline must be significantly receded so that he'll look his age in spite of the fullness of his hair. His body must be built on a foundation of ultrawide shoulders. Also keep in mind that the stockier the character, the shorter the arms.

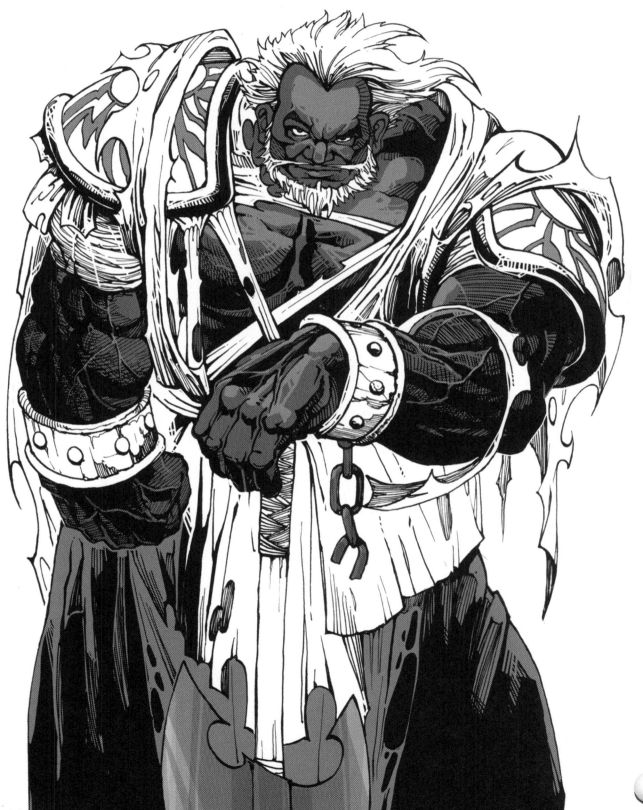

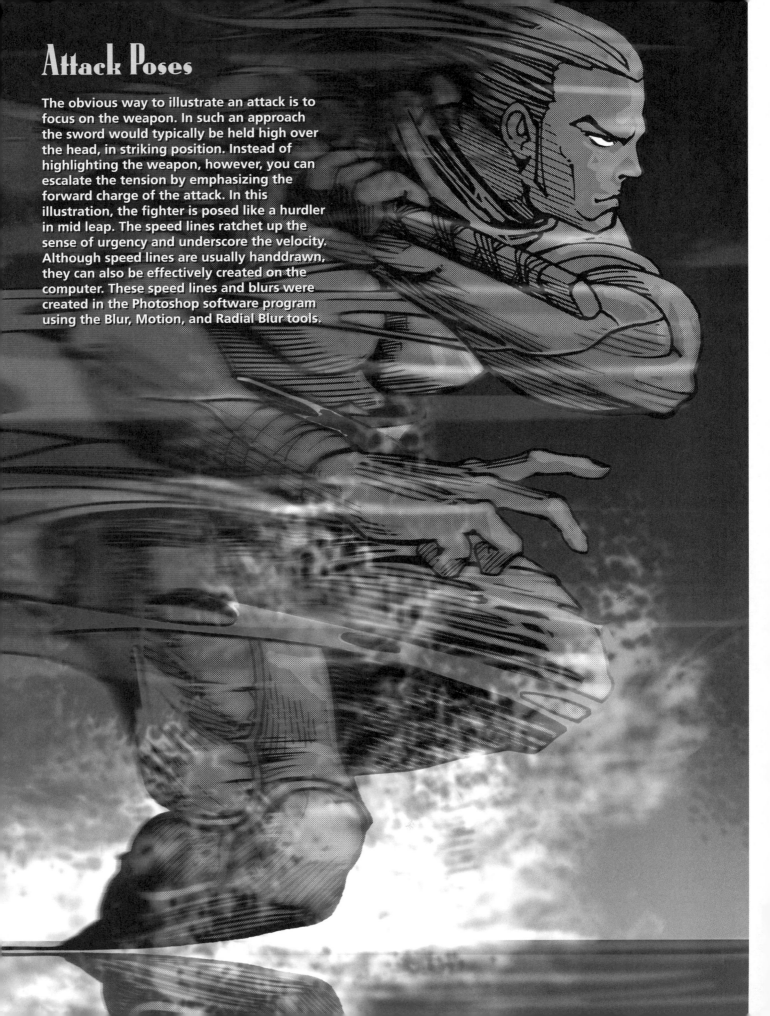

Attack Poses

The obvious way to illustrate an attack is to focus on the weapon. In such an approach the sword would typically be held high over the head, in striking position. Instead of highlighting the weapon, however, you can escalate the tension by emphasizing the forward charge of the attack. In this illustration, the fighter is posed like a hurdler in mid leap. The speed lines ratchet up the sense of urgency and underscore the velocity. Although speed lines are usually handdrawn, they can also be effectively created on the computer. These speed lines and blurs were created in the Photoshop software program using the Blur, Motion, and Radial Blur tools.

HAIR AND PANTS

Neat topknots—with long ties that seem to defy gravity—are a typical martial arts warrior look. Also typical are *hakama* pants tied at the waist with a thick, traditional sash. Hakama pants are loose, pleated pants that look almost like a long skirt and were worn by the samurai to conceal the lower body, thereby keeping their enemies guessing.

THE "READY" POSE

When a fighter completes his attack on one opponent, he may still have more combatants surrounding him, so he must maintain a "ready" position until the job is done. In the ready pose, the body should appear relaxed so that it can spring into action in a nanosecond. Here, the blade is angled toward the back of the figure, but is not holstered in the scabbard; it's carefully balanced against the forearm by the tips of the fingers. It takes only an instant to spin the blade over and strike.

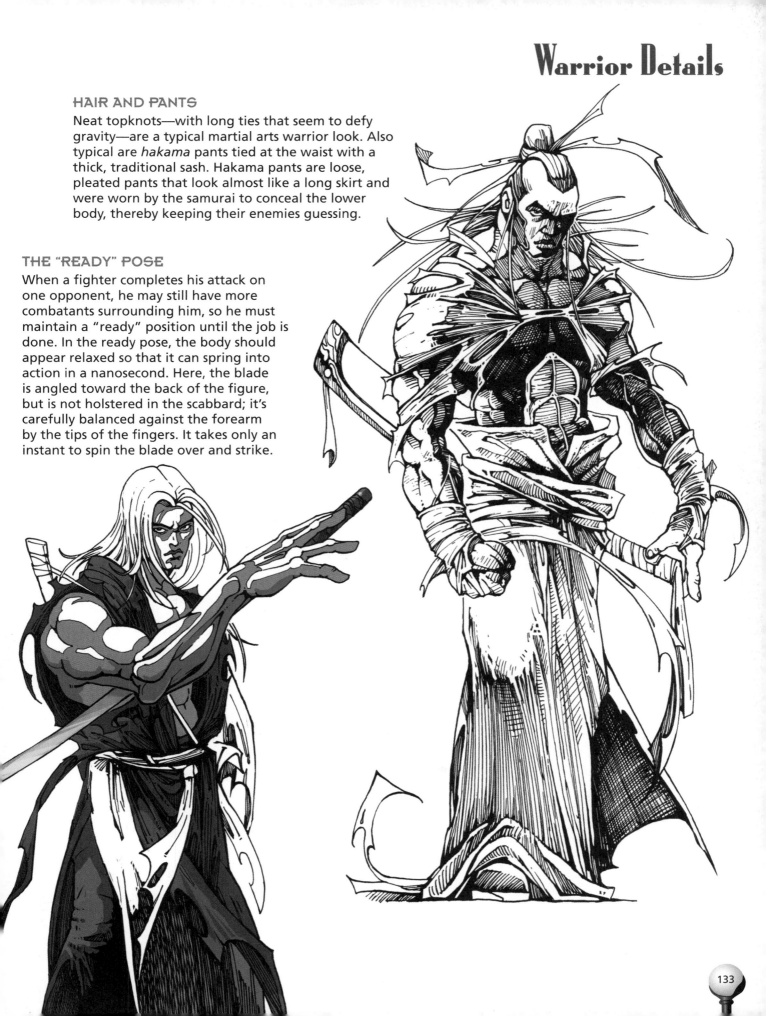

Traditional Female Fighter

Warrior women are popular fixtures in manhwa. Sometimes, you'll have a scene that calls for a female warrior to confront a big bad guy. What pose should you use? If you pose them facing each other in profile, the man will visually overpower the woman just because of his size. The solution? Position your warrior woman in a front view, staring at the reader, as if the reader were the opponent. This eliminates the male character, and brings the focus solely on her and her attitude.

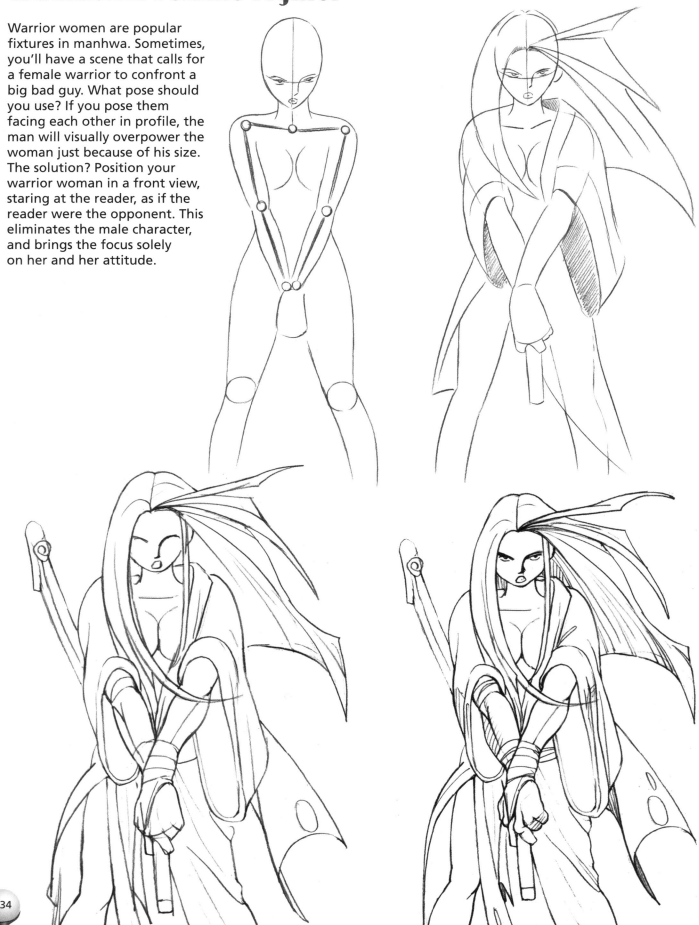

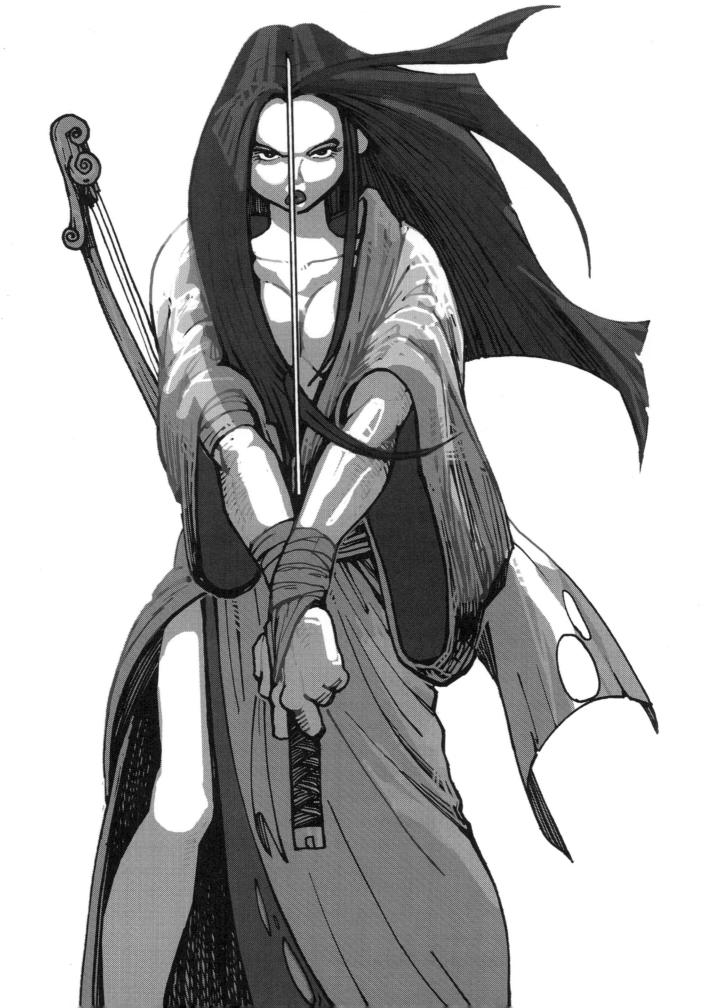

Swordswoman

A slight turn of a standing figure toward the reader creates a more interesting pose than either a true front view or a true side view, which are both flat views. Here, the character stands in a side view but turns her body, especially the upper torso, slightly toward the reader in a 3/4 view.

A NOTE ABOUT THE POSE

A pose must communicate an attitude. It should reflect the emotion of the character. Many artists don't even bother to draw the facial expression until they have the attitude of the pose locked into place. In other words, the pose drives the expressions, not the other way around.

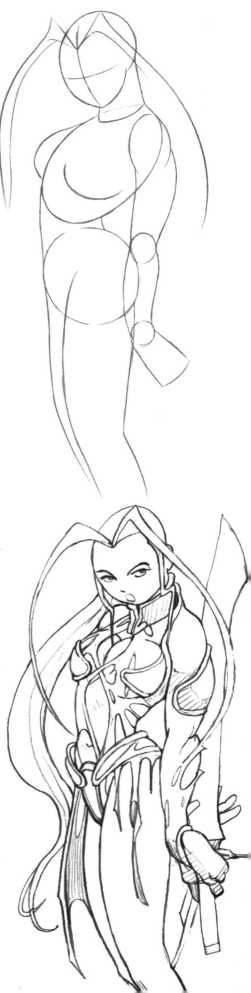

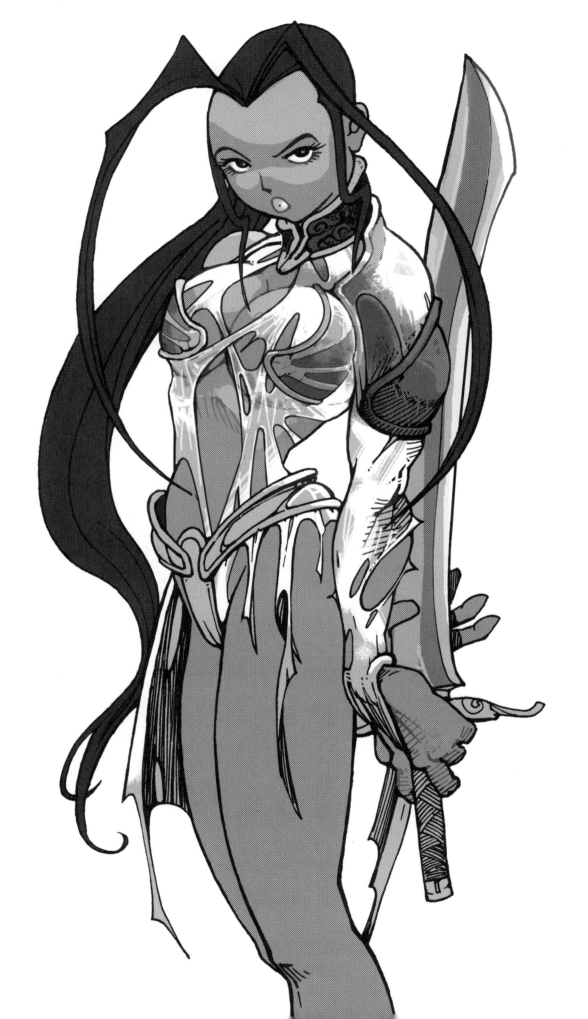

CROUCHING

This pose conveys that the character is ready to spring into action and fight. The arms crossed overhead add an air of mystery. The asymmetry also adds energy; symmetry is dull and is avoided here: The left side of the torso (the character's right side) stretches, while the right side crunches down upon itself. One leg faces front, the other sideways. The extravagant clothing provides additional energy, flaring out from all sides, like shards.

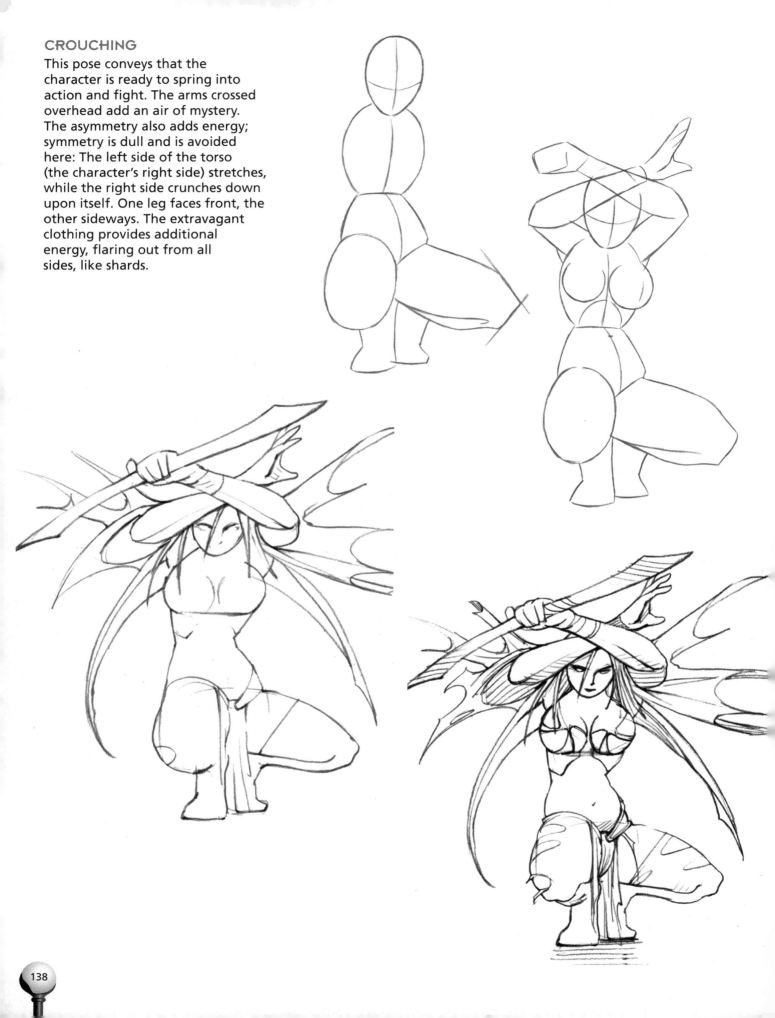

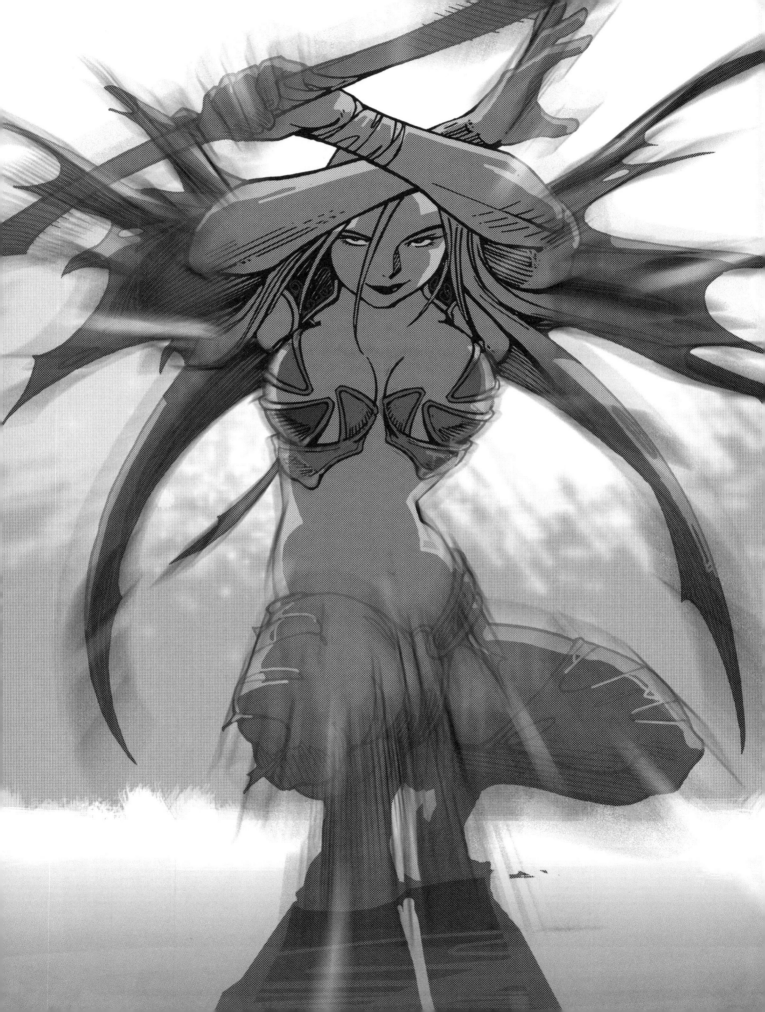

GLANCING BEHIND

Here's a very effective pose. The look over the shoulder is alluring and sensual. To get this right, the body must be turned away from the reader in a 3/4 rear view. If her back were turned more fully toward us, she wouldn't be able to turn her head enough to look behind her. Conversely, if she were in more of a side view, the pose would look flat. So, the 3/4 rear view is the perfect solution for this pose.

The torso must bend forward, not stick upright. And, here's a small but important detail: her hair should fall all the way around her far shoulder and behind her head—where we can see it—not behind her back and out of sight. When you have the opportunity to use elements (like the hair here) that add flair, style, and femininity to a drawing, definitely do it.

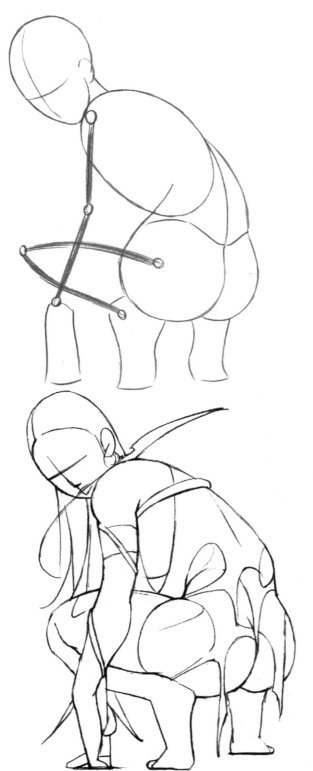
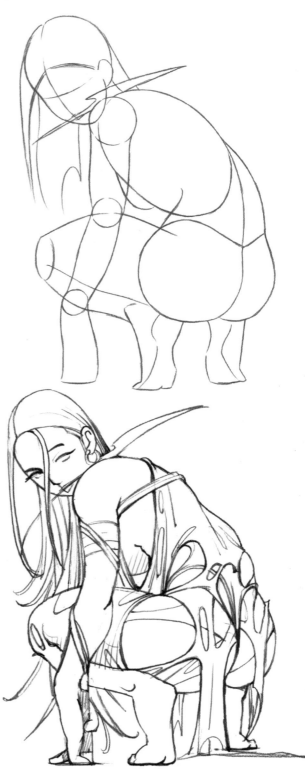

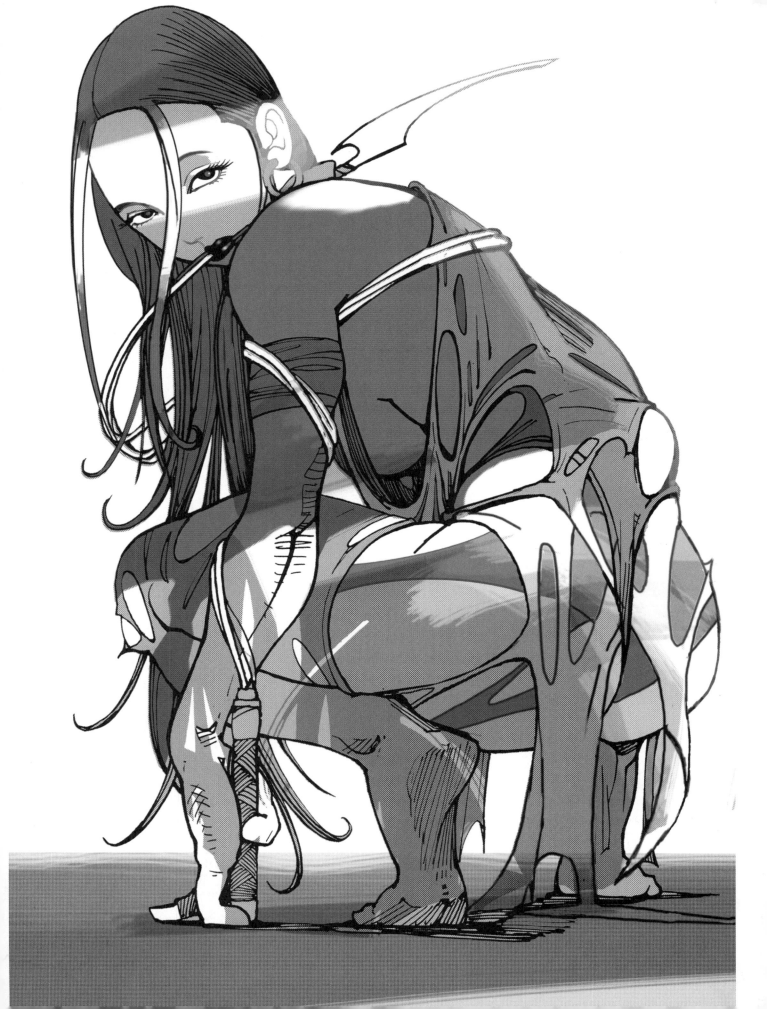

Blade Expert

Hidden throughout her costume are blades, knives, throwing stars, and poisonous darts. She's a master of deception; just when you're convinced she's been disarmed, she'll pull out a weapon from somewhere, throw it at her enemy, and pierce his armor with precision—and without remorse.

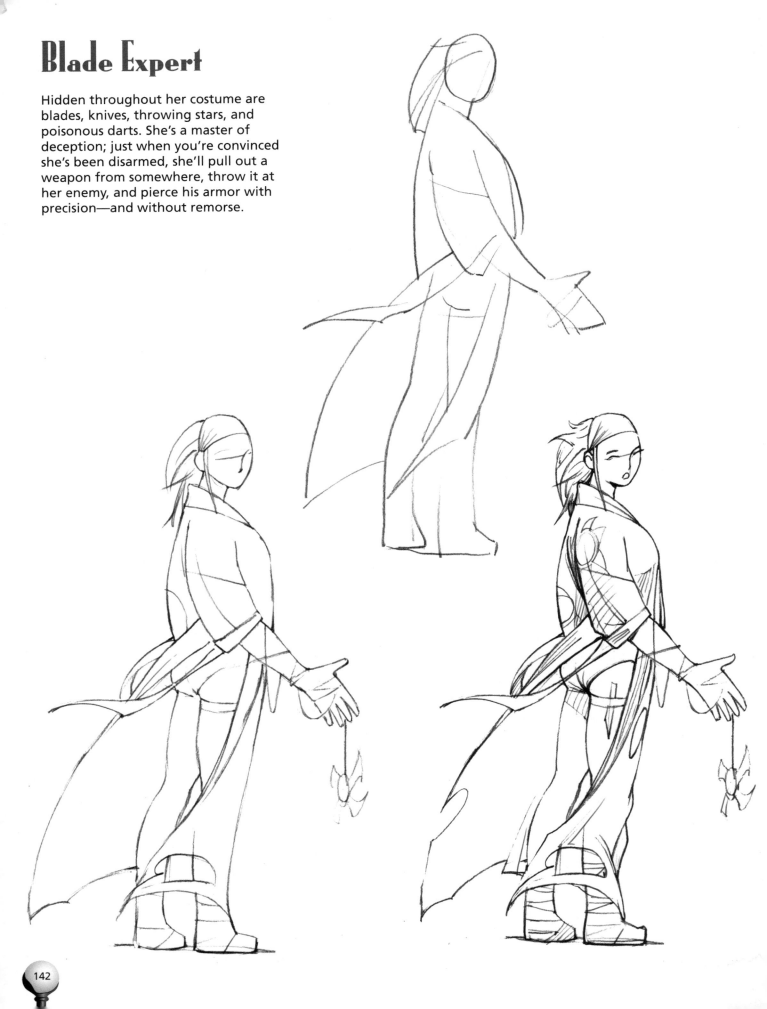

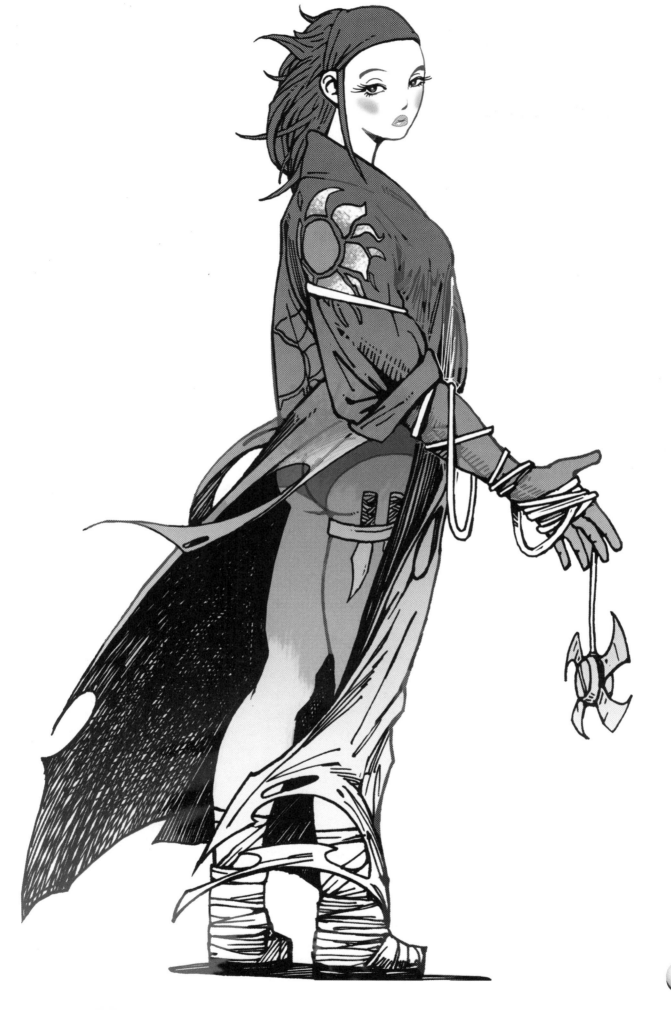

INDEX